WATERCOLOR PAINTING

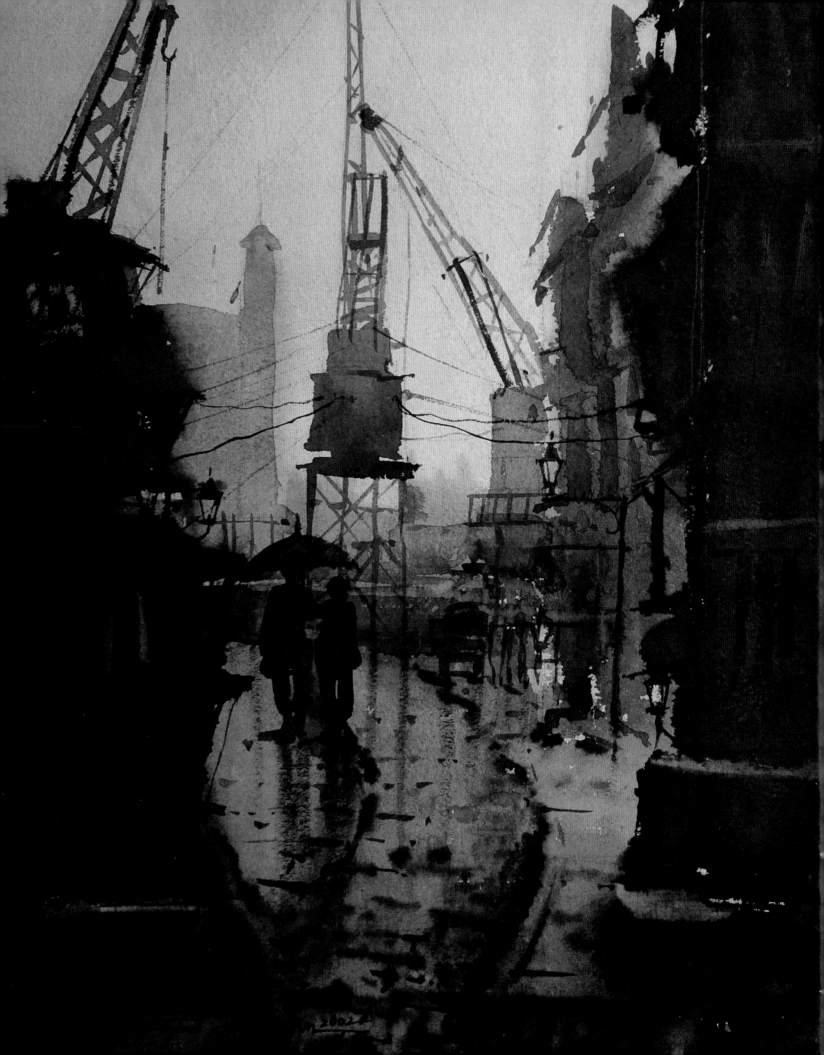

WATERCOLOR PAINTING

A COMPREHENSIVE APPROACH
TO MASTERING THE MEDIUM

TOM HOFFMANN

WATSON-GUPTILL PUBLICATIONS
NEW YORK

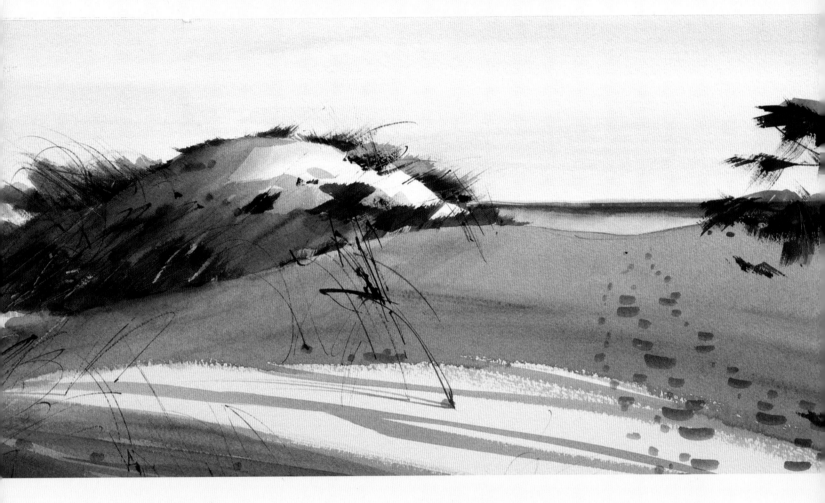

Published in the United States by Watson-Guptill Publications,
an imprint of the Crown Publishing Group,
a division of Random House, Inc., New York.

www.crownpublishing.com

www.watsonguptill.com

WATSON-GUPTILL and the WG and Horse designs are trademarks
of Random House, Inc.

Library of Congress Cataloging-in-Publication Data

Hoffmann, Tom (Thomas Burton)

Watercolor painting: a contemporary approach to mastering the medium /
Tom Hoffmann.

 p. cm.

Includes index.

Watercolor painting—Technique I. Title

ND2420.H63 2012

751.42'2—dc23

ISBN 978-0-8230-0673-1

eISBN 978-0-8230-0674-8 2011045489

Printed in China

Interior design: Rita Sowins / Sowins Design

Jacket design: Jess Morphew

Front cover art: Tom Hoffmann

10 9 8 7 6 5 4 3

First Edition

TO YOU, EILEEN

The idea for a book about becoming fluent in watercolor came from my students, as did the inspiration to stick my neck out. I am grateful to all for the risks they so willingly take.

Thanks, also, to my teachers, Douglas Jones and Carl Schmalz, who wound me up forty years ago and set me down on the track that could only have led right here.

Cynthia Hibbard, equal parts fine watercolor painter and insightful reader, gave indispensable guidance, without which there would be much more mud.

Thank you to Gary Faigin and Pamela Belyea, who encouraged this project more than once, and in many ways—most notably by building a community at Gage Academy where watercolor can thrive.

Many thanks to my Gage colleagues, Mitchell Albala and Suzanne Brooker, for help navigating the twists and turns of preparing a manuscript.

Thanks also to Alison Hagge, my patient and perceptive editor.

To all the artists whose work enriches this book, I am in your shadow.

I am especially grateful for the support of my wife, Eileen, who has always been the bridge that connects me to the rest of the world, and to our sons, Gus and Cal, who believe in me and tell me the truth.

Title Page Image:
JIAUR RAHMAN, *SILENT LOVE*, 2002
WATERCOLOR ON PAPER
30 × 22 INCHES (76 × 56 CM)

Above:
JAMES MICHAEL, *WINTER DUNES*, 2008
WATERCOLOR ON PAPER
22 × 48 INCHES (56 × 122 CM)

Contents Page Image:
TOM HOFFMANN, *NEW YEAR*
(detail), 2010
WATERCOLOR ON PAPER
22 × 30 INCHES (56 × 76 CM)

"The reason I paint is because it makes me sane."
—David Yaghjian

CONTENTS

TOM HOFFMANN, *WITHOUT US*, 2010
WATERCOLOR ON ARCHES HOT PRESS PAPER
11 × 15 INCHES (28 × 38 CM)

Watercolor invites us to find a balance between form and content, where we can see the washes and strokes as paint and as subject matter at the same time.

UNDERSTANDING WATERCOLOR

Watercolor has always attracted first-time painters. Its look of ease and spontaneity makes competence seem within reach. It is more portable than other forms of painting, and the fact that it dries quickly promises immediate gratification. Above all, there's the gorgeous paint, fluid and transparent, with its potential to render convincing light with very little apparent effort. All these qualities make it practically irresistible. No wonder everyone wants to give it a try.

Why is it, then, that so many would-be watercolor painters give up and retreat behind an opaque medium, like oil or acrylic? What scares them away?

The same qualities that make watercolor so attractive also make it difficult to control, and even harder to correct. Most of us quickly discover that with fast-drying, transparent paint there is no place to hide. Uncertain strokes and attempts to disguise mistakes remain visible in the finished painting. What at first looked so easy and spontaneous turns out to require either a great deal of thought or phenomenal luck.

With opaque paint each stroke can be experimental, applied with a let's-see-if-*this*-works attitude. If it's no good, you can scrape it off and try something else. Watercolor artists, on the other hand, have to apply the paint like they really mean it. No wonder it scares us away. Remember, though, that the oil painter and the acrylic artist did not get it right on the first try, either. Underneath the finished painting there are probably six or seven false starts. The only difference is that when watercolorists start over they have to reach for another piece of paper. So be it. Get used to using lots of paper, and while you're at it, make it *good* paper. You will have much better results on the real stuff.

Throughout this book a strong emphasis is placed on how to learn from your mistakes. The assumption, of course, is that mistakes will be made. Seeing failures as opportunities is a necessary first step toward rapid progress. As soon as you understand a problem in terms of the basic watercolor variables, you are halfway to a solution, but you can't move forward without sticking your neck out.

The key to taking the fear out of watercolor painting lies in knowing, within an acceptable range, what will happen when the brush touches the paper. The wider you can make that range of acceptable results, the more carefree your application of the stroke can be. While it is true that there are moments when sheer luck saves the day, more often a boldly applied, telling brushstroke is the result of considerable practice and thought.

The good news is that all this work need not be done every time you make a new painting. Some of it sticks, and eventually it becomes second nature. For instance, compressing the value range, as was done in the image opposite, helps keep the background where it belongs. After a few successes with that particular strategy it becomes part of your repertoire.

Add up enough experiences like this and soon many of your decisions are already made *before* your brush meets the paper. An experienced painter at work may appear to be reckless, but his progress is actually a series of choices based on years of thoughtful practice.

The feeling that brilliant watercolors should spring from a fountain of divine inspiration is a fallacy that leads to frustration. A virtuoso musician still needs to practice scales every day. Moments of total luck do happen, but it isn't wise to count on them. *Carefree* is not the same as *careless*.

The paintings I admire most have left room for the paint to assert its fluid nature, which means that the artist was not controlling every millimeter of its movement. Instead, when an artist makes conscious decisions *in advance*, he is much more likely to create an informed stroke, one that does not need correcting. A thoughtful approach leads to confident paint application, which in turn leads to that characteristic watercolor look of ease and spontaneity.

While we are painting we must juggle countless possibilities, including which brush to use, the direction of the strokes, the saturation of the paint, its color, the softness of the edges, whether to make a subject a single shape or a collection of individual marks, and so on. The list may seem endless, but, in fact, it can be condensed into a manageable set of four basic variables: value, wetness, color, and composition. Most of the choices you make will fit into one or another of these four categories. With such a short list, you can realistically consider your options one variable at a time. Watercolor does not have to be either uptight and overly controlled or fluid and formless. It really is possible to make conscious choices about how to use the fundamental watercolor tools without sacrificing the juiciness of the medium.

The key to taking the fear out of watercolor painting lies in knowing, within an acceptable range, what will happen when the brush touches the paper. The wider you can make that range of acceptable results, the more carefree your application of the stroke can be.

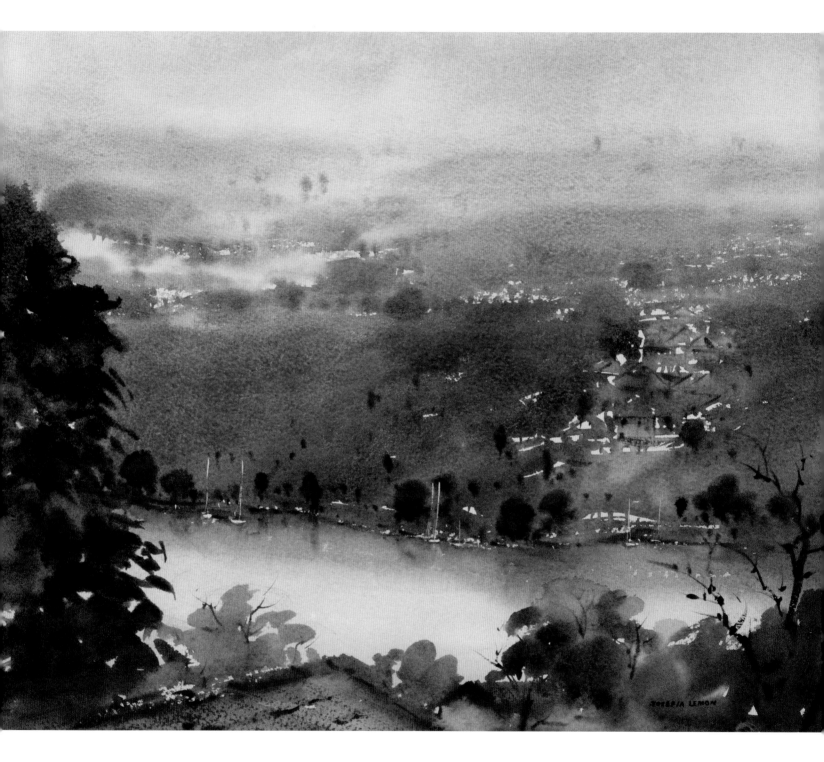

JOSEFIA LEMON, *MORNING LIGHT IN CAMERRAY*, 2010
WATERCOLOR ON PAPER
11¾ × 14½ INCHES (30 × 37 CM)

As we step from foreground to middle ground to background, the distance between the darkest dark and the lightest light (in other words, the range of values used) decreases, resulting in an illusion of vast space.

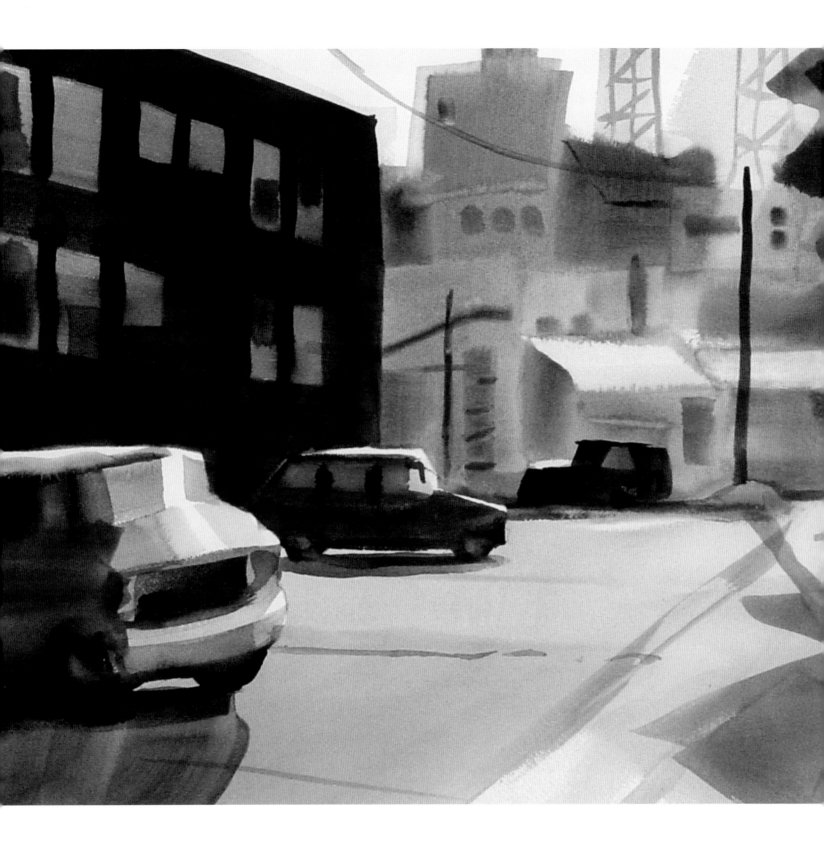

TOM HOFFMANN, *JIMMY'S BACKYARD*, 2007
WATERCOLOR ON ARCHES HOT PRESS PAPER
15 × 20 INCHES (38 × 51 CM)

In this cityscape the four main variables—value, wetness, color, and composition—have been manipulated to keep the background and middle ground separate.

Consider the space in *Jimmy's Backyard,* left. The background is a jumble of shapes that could easily have intruded on the middle ground. We can go down the list to see what was done, variable by variable, to keep that area back where it belongs.

VALUE: The shapes are relatively light compared to the cars, pole, leaves, and building—all of which are meant to be in front.

WETNESS: The edges between the background shapes are soft, making them all one form, while the middle-ground shapes that overlap them all have hard edges.

COLOR: The whole background was given a pale blue wash as a first layer, which ties it all together.

COMPOSITION: Placing the pole and the dark car in front of the background shape creates a barrier. The leaves and the purple building also overlap the background, leaving no doubt about where everything is in the pictorial space.

There are many fine books that emphasize the technical skills required for making watercolor "behave." The focus in this book is on *awareness* rather than technique. It is important to know *how* to make a warm, neutral, graded wash, but it takes a different set of skills to know *when* that particular technique is called for.

When you set up your gear in front of a new subject, how do you know what to do first? Should you start with the foreground and work your way back? Or maybe do the opposite? Should you start with the most attractive part of the scene—the aspect that drew you there in the first place? But how will you know how much emphasis it should have until the rest of the image is in place? With so many possible ways to go, and that pricey piece of spotless white paper staring you in the face, it can be tempting to just take a nap.

Translating an image or a scene into the language of watercolor need not be a hit-or-miss process. Remembering a few clear steps before you begin painting helps reveal the fundamental structure of the image and allows you to keep a good grip on what must remain true no matter where your individual style takes you.

To help discover what needs to be in the painting and what can be omitted, emphasis in this book is placed on the logic of proceeding from general to specific, and the benefit of seeing in layers. A brick wall, for example, is first of all a red rectangle. Once this fundamental reality is established you have the means for deciding how much of the more specific information that you can perceive—the individual bricks—needs to be added. The big shapes that make up the overall image can be represented in their simplest, most general form as a first layer. Texture and detail represent complexity that is appropriately added in subsequent layers.

When we see someone working with real confidence, whether an artist or an athlete, we often say that they "make it look easy." In fact, when all of the questions that attend each stroke have been answered in advance, it *is* easy. The hard part is remembering to ask those questions.

Toward that end, this book presents a series of questions to keep in mind for each of the following elements of watercolor painting:

- Translating a subject into the language of watercolor
- Knowing what not to paint
- Seeing in layers
- Understanding value
- Sharing control of wetness
- Getting the most out of color
- Developing an instinct for composition
- Becoming your own teacher

Learning to make informed decisions will have a profound effect on your painting practice. It will not, however, take all the risk out of working with watercolor. Wet paint will always involve an element of surprise, and that's the good news. As your awareness skills and your technique develop, you will find that you can let go more and more of control and specificity, allowing the paint to have its way. And, increasingly, what the paint does after you have made your choices will be just right. I think of this process as "broadening your standards," where the definition of *perfect* becomes more flexible as you develop your partnership with the paint.

TOM HOFFMANN, *WATMOUGH HEAD*, 2011
WATERCOLOR ON ARCHES HOT PRESS PAPER
15 × 11 INCHES (38 × 28 CM)

At three thirty on a midsummer afternoon the powerful pattern of light and dark on the face of this rock has an almost physical impact. It seemed fitting to let go of specific information and keep the brushwork simple, so the image could be taken in at a single glance.

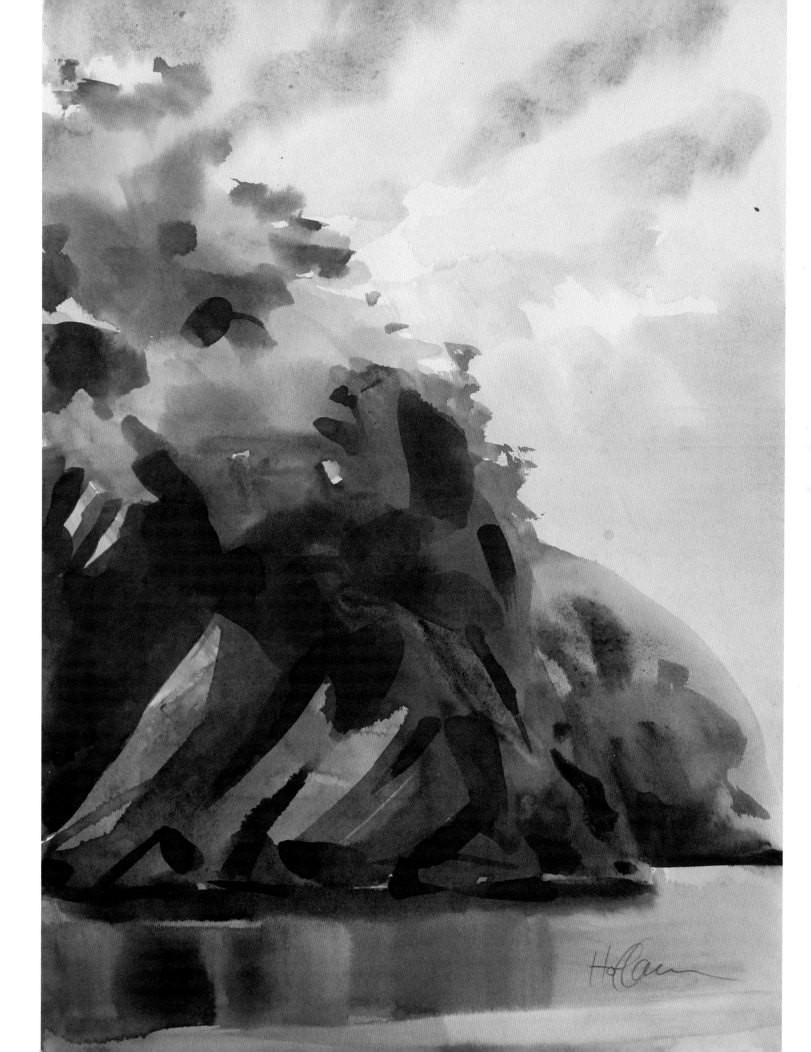

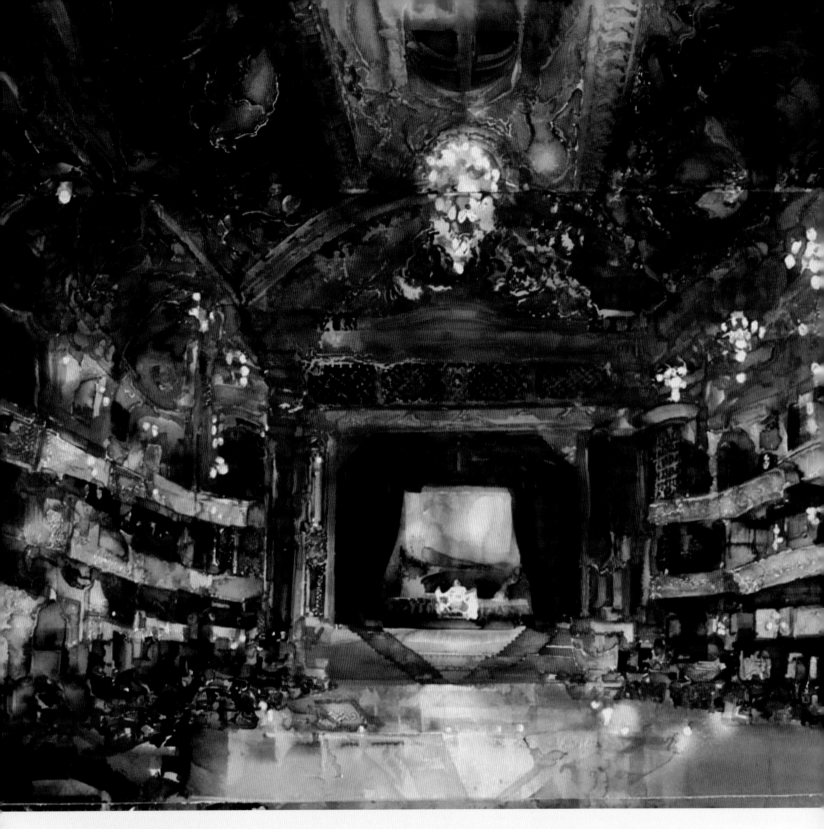

LARS LERIN, *OPERA*, 2010
WATERCOLOR ON PAPER
50 × 54⅜ INCHES (127 × 138 CM)

Lars Lerin's interpretation of an opera house brims with the feeling of grandeur and opulence. Ironically, he achieves this richness by deliberately limiting most of the major watercolor variables: the composition is simply symmetrical, the palette is limited to three colors, and almost all of the edges between shapes are hard. In the realm of value, however, the artist pulls out all the stops. Never merely black, his deepest darks remain full of color. He limits the lightest lights to just a few spots, making everything else seem to be lit by the low gleam of a lantern in a gilded cavern.

TRANSLATING A SUBJECT INTO THE LANGUAGE OF WATERCOLOR

The most pressing question for many first-time watercolor painters is often the most basic: *What should I paint?* When I set out to paint, I don't always know what my subject will be. I might head for a familiar location, like Fishermen's Terminal, where I can expect to find a subject that excites me. But until I see it, I don't know exactly what will speak to me on a given day.

The purposeful wandering that precedes actually sitting down to paint is often just as important and just as pleasurable as putting paint on paper. This is the transitional state between everyday life in the world of content and the rarified world of pure form. Painting is a process of deliberately moving back and forth between the two worlds, and the pictures that result, if they are any good, serve as the bridges that connect them.

Not every subject will invite interpretation. If I think too much about what I see, I start rejecting subjects left and right, for being too traditional, too difficult, too pretty, too ugly. This kind of hyper-selectivity eventually leads to the poisonous notion that I should choose something someone would want to buy. Once that thought enters my head, I might as well go home. It is always better to simply enjoy the walk and trust that something will present itself to me.

For me to be receptive to what wants to be painted it is helpful to let go of old agendas and simply listen with my eyes. If I am looking for a scene that will win a prize, I will most likely project past successes onto the location and end up choosing a subject very similar to one I've already painted. This is fine, and certainly not a total waste of time, but I especially enjoy the experience of letting the location determine what gets painted on any given day.

Painting is the most dependable way I've found to be solidly connected to my surroundings. By the time I understand a location well enough to gracefully translate it into washes and strokes, I have become fully comfortable there. Since this state of being at home in my surroundings is what is most important to me about painting, I prefer to let it lead the experience and trust that other people will want to look at what results. Painting must be more than just a way to make a living, or I'd probably be doing something else. (The fishermen at the terminal are making a lot more money than I am, for example.)

TOM HOFFMANN, *WET COMMUTE*, 2008
WATERCOLOR ON ARCHES HOT PRESS PAPER
14 × 20 INCHES (36 × 51 CM)

On this day rain spoiled the painting excursion, but not before I had made the shift from seeing content to seeing form. As a result, this everyday scene presented itself as a worthy painting subject.

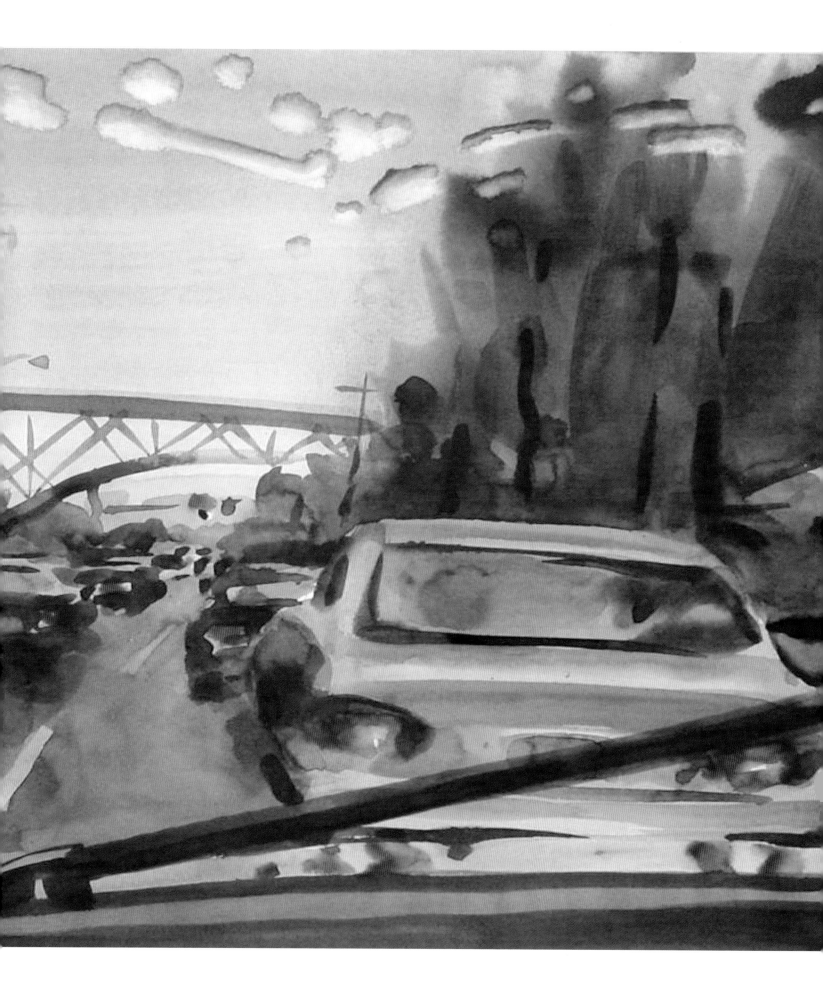

Being Mindful of Your Subject

Once you find a subject, be sure to ask yourself: *What attracts me to this image?* Motivation is an appropriate place to begin a discussion of the first steps toward translating a subject into paint. Before I start making decisions about how the painting will unfold, I want to make sure I am mindful of what brought me to this subject. This will help me to ensure that those features are present in the finished work.

Often the essential aspects of a given scene are matters of purely visual observation, but they can also be entirely emotional in nature. For instance, when I chose to paint the convent in Oaxaca, shown at right, it was clear that the dark/light contrast and the juxtaposition of a simple building with an elaborate one were essential *visual* elements. But I was also struck by a profound feeling of silence and dignity, and I needed to find a way to make sure these intangibles would be present in the final painting.

It is surprisingly easy to be distracted from even the most obvious aspects of a scene. Writing down what attracted you to the scene or saying it out loud will help you keep it in mind as the work progresses. As complex and wonderful as the human brain may be, it is no match for the vicissitudes of watercolor. I recommend making notes right on your preliminary studies.

Having identified light as an essential element of the scene, I wanted to see if simply looking at the photograph with the color removed would help reveal the role value plays, so I converted the image to black and white, as shown center. Although color enriches the sense of light in a scene, value does most of the work of creating a convincing illusion.

With so few major shapes in the image, it seemed possible to create convincing light with just a few values. Look at the image far right. Oversimplifying the study by reducing the number of values to three—white, middle gray, and black—made it possible to see if more subtlety was needed, and where.

It was a relief to learn that getting the relative values reasonably accurate took care of one of the features I wanted to include in the painting. As long as I didn't lose track of this simple value relationship, that important light would be there in the finished picture.

The other contrast—between simple and complex—seemed ensured as long as I didn't make the dark building too detailed or the light one too basic. Seeing the dark building represented as a single wash in the study below right gave me the idea that I should make it easy for the viewer to take it in all at once,

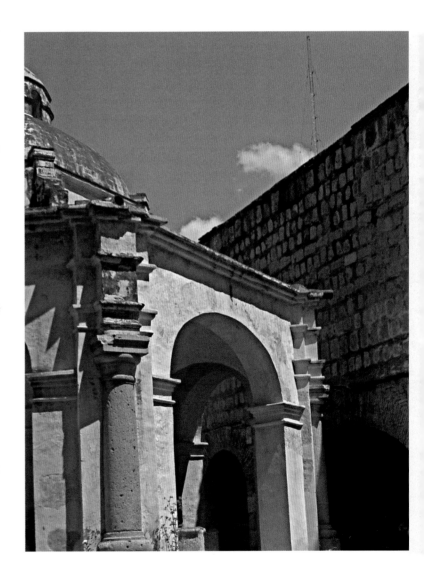

Observe the formal and emotional aspects of the subject.
The contrasts between light and dark shapes and between a complex structure and a simple one are the most significant formal aspects of this scene. I am also attracted by the weight and dignity of the four-hundred-year-old convent buildings. The feeling of peace and silence is unmistakable. Emotional content such as this is more difficult to understand in terms of form. Is it inherent in the composition? Can it be established deliberately?

without having to "assemble" it from several parts. I decided that an overall wash of color (purple!) and soft-edged forms within the big shape should do the trick. The finished painting appears on page 22.

As complex and wonderful as the human brain may be, it is no match for the vicissitudes of watercolor.

Determine how the shapes relate in terms of value.
Converting the color photograph to black and white helps make a value comparison fairly simple. The sky is darker than the sunlit building, but lighter than the shaded one. What about the shadows on the light building? What is lighter than they are? What is darker?

Create a three-value study of the light.
What do you think? Simple as it is, I can see that the sun is shining. Learning that a feeling of light is this easily achieved, I became confident that I could get it to be present in my painting without having to be too fussy. It was good to know I did not need to put in *all* the details of the more ornate building.

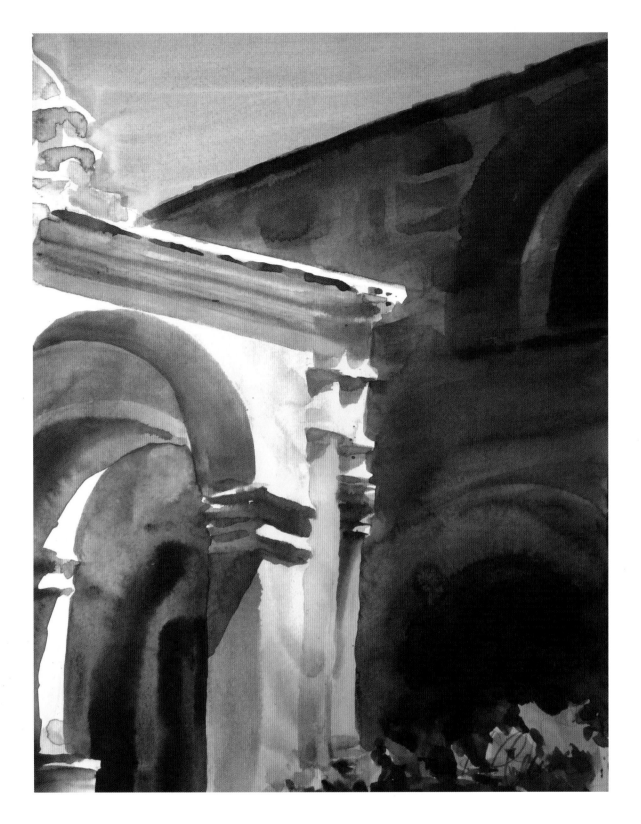

TOM HOFFMANN, *LAVANDERIA*, 2010
WATERCOLOR ON ARCHES HOT PRESS PAPER
14 × 10 INCHES (36 × 25 CM)

The contrasts I wanted are created mainly by virtue of the big, dark shadow. Its value and cooler color set it apart from the sunlit arches, and its soft edges keep it simple. Upon reflection, the sense of stillness would be more apparent if the setting were clearer, perhaps showing where the buildings meet the ground. I guess I'll just have to go back.

REVISITING YOUR PURPOSE

What needs to be true in the finished painting? The answer to this question is really the same as the answer to the previous one. Whatever attracted you to the scene should be present in your interpretation of it. I include it here as a separate question as a reminder to take stock of your finished work.

In terms of form, I wanted to see a strong contrast between the light and dark structures. Nothing in the shaded building is as light as the foreground lights, and nothing in the sunlit building is as dark as the background darks. That pretty much clinched it. However, I also wanted to feel the tension of juxtaposing a simple structure with a complicated one. I could have added more architectural details to the foreground building, but it seemed as if the story had been already told.

I haven't forgotten about those intangible qualities of silence and dignity. One reason I prefer painting from life to working from photos is that the feeling of a place is much more likely to be present in my on-site work. It is also more fun than being in the studio. Who wouldn't rather be actually sitting in that courtyard in Oaxaca than in my former garage?

This is not to say that studio paintings can't ever carry a good sense of the location. To some extent feelings such as dignity or silence can be understood in terms of watercolor variables. Adjusting color, value, wetness, and composition will certainly affect the mood of a picture. Many possible variations can be explored with a quick sketch or study, and some can be evaluated simply by imagining them. It is useful to consider, for example, how turning your paper horizontal or vertical would change the overall feeling of the page.

In general, though, I believe that the "spirit of place" we value so highly cannot entirely be put into a painting by design. No amount of analysis or planning will ensure that looking at the painting will *feel* like being there. When that does happen it is more a matter of the painter having been fully present in the place and not preoccupied by self-concern.

Maybe this is why the word *capture* makes me cringe when it is applied to painting. You've heard it, I'm sure: "The artist *captures* the moment in watercolor . . ." "The fleeting light is *captured* forever . . ." "The subject's personality is *captured* in a few swift strokes . . ." Captured, tortured, and held for ransom. What are we, pirates? I prefer to think of painting as an act of *translation*, a much more civilized activity.

IDENTIFYING THE TRICKY PARTS

Once the subject has presented itself and I have made a sketch or study, I have a pretty good sense of how the painting will proceed. I don't mean that I can see the finished product perfectly in my mind's eye. That would require too much control, and I hope to leave plenty of room for the paint to assert its fluidity.

The moment of beginning a new painting is thrilling. I am always enthusiastic and eager to start. But, in fact, I am not always really prepared. Sometimes I don't yet truly understand the subject in watercolor terms. If I take a minute to honestly assess my readiness, I can often see where I have been glossing over some tricky parts. Ideally, once I get started I want the painting to flow along without too many interruptions. But when I come to a part I've only been pretending to understand, the whole show grinds to a halt. Then I have to shift into a more analytical mode—thinking with my brush—which usually creates a very different look from the fluid momentum of the rest of the page. That initial enthusiasm is an important resource I don't want to waste, but neither do I want to let false confidence lead me too far out on a limb.

It's all about balance. Painting in watercolor is a high-wire act, with balance always foremost. Form and content, risk and control, spontaneity and planning, detachment and engagement—stroke by stroke we gauge the status of the equilibrium we seek. To find the balance between careful and carefree, then, I ask myself: *What*

> Painting in watercolor is a high-wire act, with balance always foremost. Form and content, risk and control, spontaneity and planning, detachment and engagement— stroke by stroke we gauge the status of the equilibrium we seek.

looks tricky? Once I've conceded that I may still have some preparation to do, the answer is usually obvious.

Sometimes looking for the tricky parts right away helps me know which type of study I should start with. For example, in the scene from southern Utah, shown in the image opposite, I liked the sweep of the land as it went around the bend in the river, but when I squinted at the vista the space flattened out. This is because, with the exception of the sunlit butte and the sky, all the shapes were the same value. In addition, all that texture made it hard to see how the big shapes relate. I needed to deliberately oversimplify the scene. I decided that a sketch that treats the major shapes as simple washes should clarify what would work.

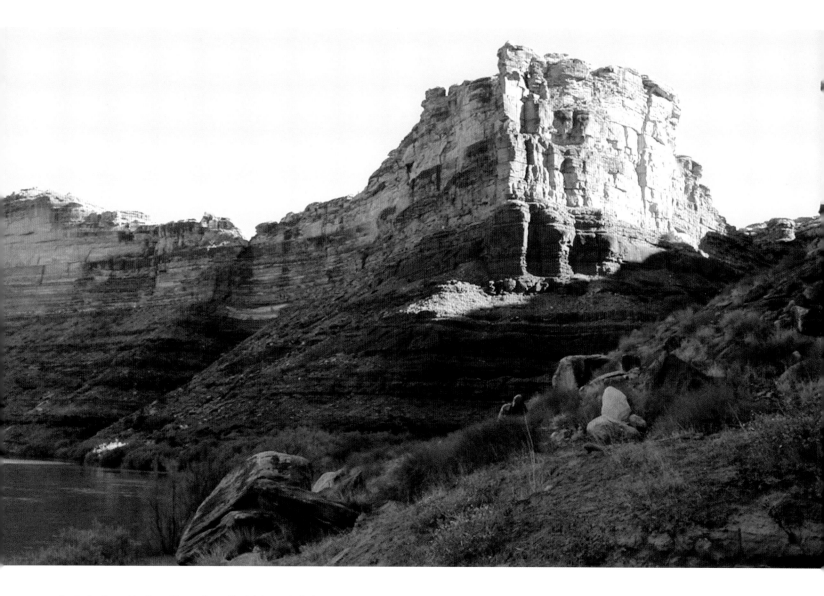

Evaluate the subject, and home in on the tricky parts before you start to paint.

Carefully studying my scene, I determine that I need to separate the foreground shape from the middle and background forms to make sure the full depth is apparent. If I lighten the foreground a bit, will that make enough of a difference? Or do I need to adjust the color as well?

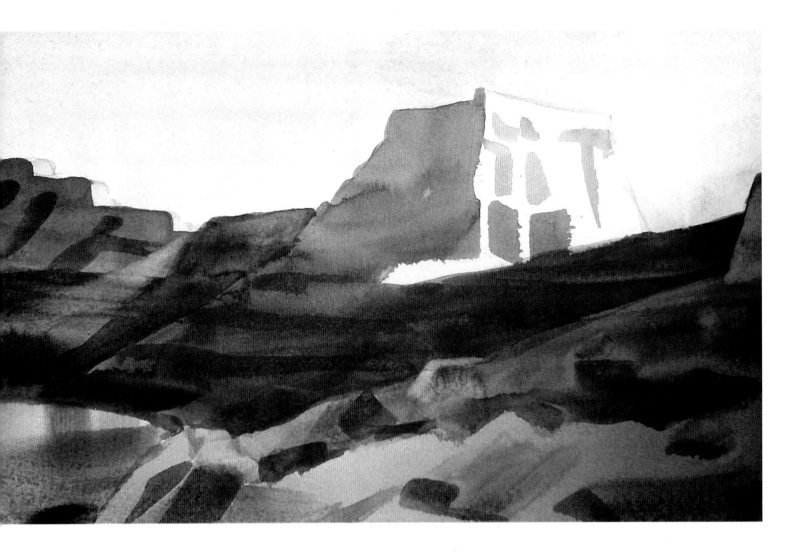

Focus on the aspects that provide answers to your questions.
With much of the texture eliminated, it is easier to see how the major shapes relate. Increasing the color difference between the foreground and the middle ground improves the feeling of depth.

In my initial sketch, as shown above, I meant to make it much simpler, but I couldn't resist adding some stripes. The temptation to make every piece of paper into a "winner" is powerful, but a sketch or a study is only meant to help you understand what needs to be true in the finished painting. Here, some of what I hoped to learn is obscured by my desire to make the sketch look good.

My second sketch, shown opposite, was more successful. Its simplicity helped me articulate the formal elements and better

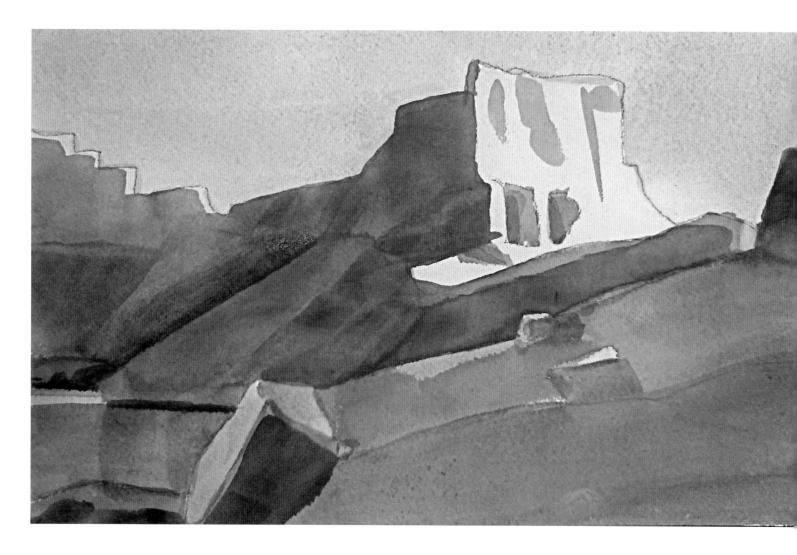

see what still needed to be finessed for the final painting. Comparing two sketches can be very useful. Notice the different treatment of the arm of the middle shape as it slants upward along the top of the foreground. It was too insistent in the first sketch, so I tried making it lighter in the second. Both sketches reveal that the composition feels cramped and would work better if more of the river was visible.

Refine your vision.

This version is easier to read than the first. I can see that the edge between the foreground and middle-ground shapes needs to be emphasized. With a clear, hard edge there, color and value differences between the foreground and the middle can be subtle. The foreground needs additional information, but not as much as in the fancy first sketch.

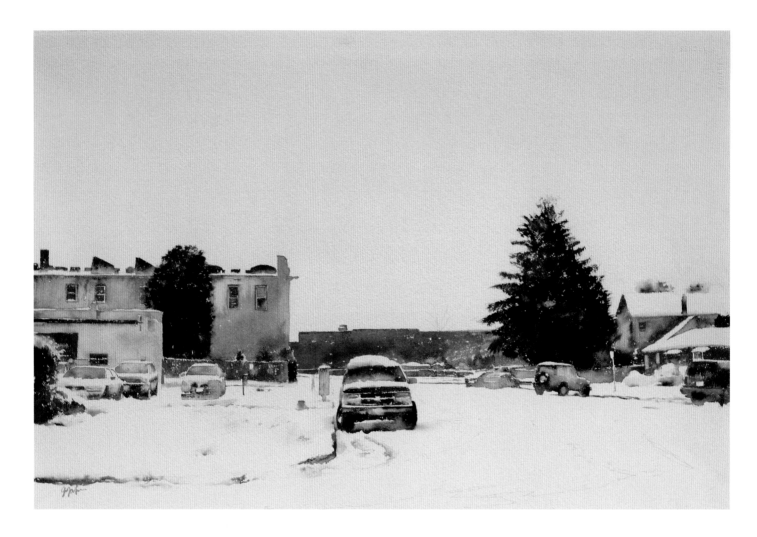

JONATHAN JANSON, *SNOW, MARYSVILLE, 2008*
WATERCOLOR ON PAPER
14½ × 22 INCHES (37 × 56 CM)

The sky in this elegant composition is a very smooth wash that must
have been applied with a big, wet brush. The tree on the right is a potent
dark with a complex profile. I can't imagine painting *around* the tree, and
I would have been nervous about letting the wash brush flow across it.
Painting the tree as a second layer after the sky is dry seems to be the
only way to go.

Knowing Where to Begin

Watercolor painters are always thinking about how what they are doing now will affect their options later on. Choices you make in the early stages of a painting can close doors permanently, so it is essential to consider the first step in terms of the freedom it will allow. Remember to be thinking a couple of layers ahead of yourself when you ask: *Where do I begin?*

My watercolors usually develop from light to dark, a progression that is suggested by the transparency of the medium. Darks cover lights more easily than the reverse. Some painters like to get the darkest darks down right from the start, so they can see where things fit within the total value range. I see the wisdom of this, but broad washes usually precede small, dark strokes, and I want to avoid laying a fluid wash over a strong dark, to prevent the dark from running.

Making a preliminary value study is always a good way to learn what I need to know about the darks—such as how dark they need to be, or how many of them really belong in the picture. In a study it seems fine to put the darks in whenever, since the only goal is to learn what needs to be true. If they run a bit when I apply a wash over them, it doesn't matter, since this is not a painting. When I am ready to begin a proper painting, I know the role of the darks well enough to suspend them in my mind until the picture is ready to receive them gracefully.

The light-to-dark progression works best for me, but if you can work around the darks, put them in whenever you want. The two different approaches will be with us as long as people paint in watercolor, which demonstrates the primary rule of making art: Do what works. (The Dalai Lama recommends this, too, in perhaps a broader sense.)

Proceeding from general toward specific is another progression that plays an essential part in determining how I begin a painting, as well as when I stop. For me, it is even more important for a watercolor to proceed from general to specific than from light to dark. I'll explain what I mean.

Generally speaking, a brick wall is a red rectangle. This is its fundamental visual reality. Specifically, it is made of a great many individual red rectangles. How much of the specific information

It is even more important for a watercolor to proceed from general to specific than from light to dark.

you choose to include in your painting is a matter of personal style and the role the wall plays in the big picture. A big red rectangle may turn out to be all the information you need, or you may want to suggest the texture of the individual bricks without actually delineating any of them. One artist might choose to include just a few scattered bricks, while another might not stop until every brick is visible. No matter how fully you want to describe the wall, it makes sense to begin by thinking in the most general terms. First, establish the simplest form of the subject, and then you are free to add information *incrementally*, stopping before you overload the picture.

In the images that appear on the following pages the artists have represented brick walls with varying degrees of specificity.

In each of these city scenes, the brick buildings began as simple washes, affording the artists the opportunity to add as little or as much texture as they wanted. Having different purposes and different styles, they all stopped at different points, but no one put in nearly as many bricks as they could actually see. Why not?

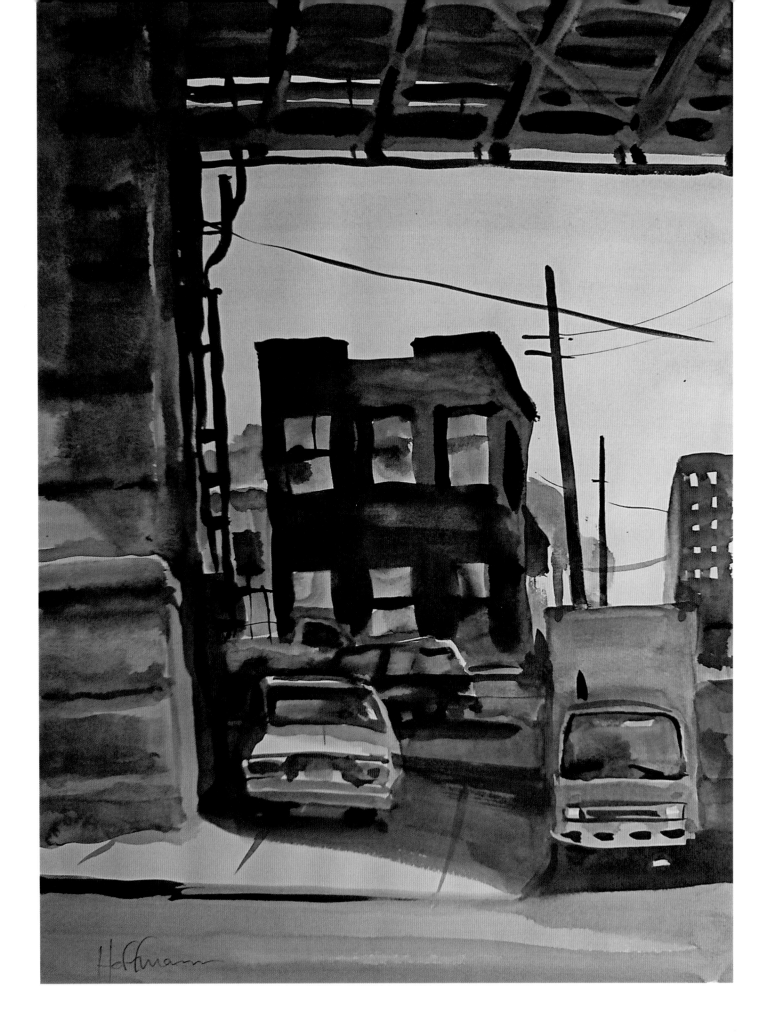

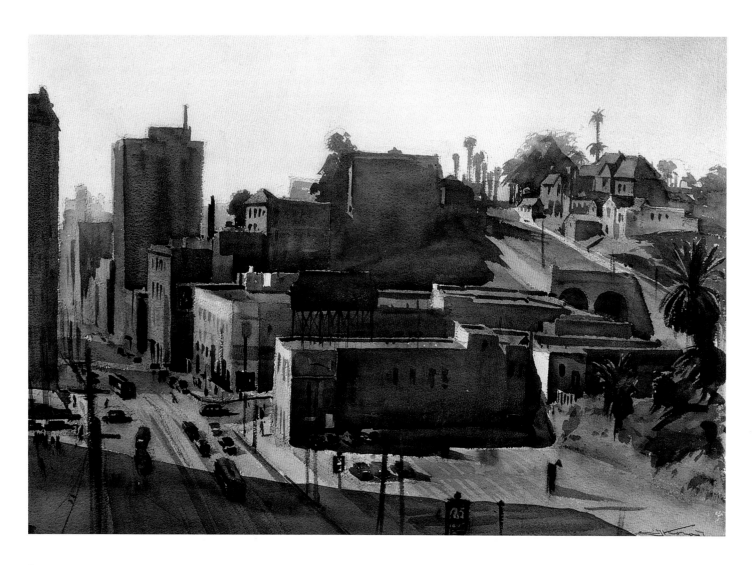

Opposite:

TOM HOFFMANN, *UNDER THE BRIDGE*, 1990
WATERCOLOR ON RIVES BFK PAPER
28 × 20 INCHES (71 × 51 CM)

The red building in the background on the right is treated so simply that it looks like a single giant brick, with windows. It is not meant to stand out in the big picture, and indicating individual bricks would have been distracting.

Above:

EMIL KOSA JR., *MOORE HILL, LOS ANGELES*, 1940
WATERCOLOR ON ROUGH PAPER
22½ × 30 INCHES (57 × 76 CM)
COURTESY OF CALIFORNIAWATERCOLOR.COM

The buildings in this scene are all far enough back in the pictorial space that we do not expect to see much detail. With no reason to call attention to any particular building, Emil Kosa Jr. stops well short of describing information as specific as individual bricks. Notice, though, that the granulation of his washes in the tall building toward the left suggests texture well enough for *us* to provide the bricks.

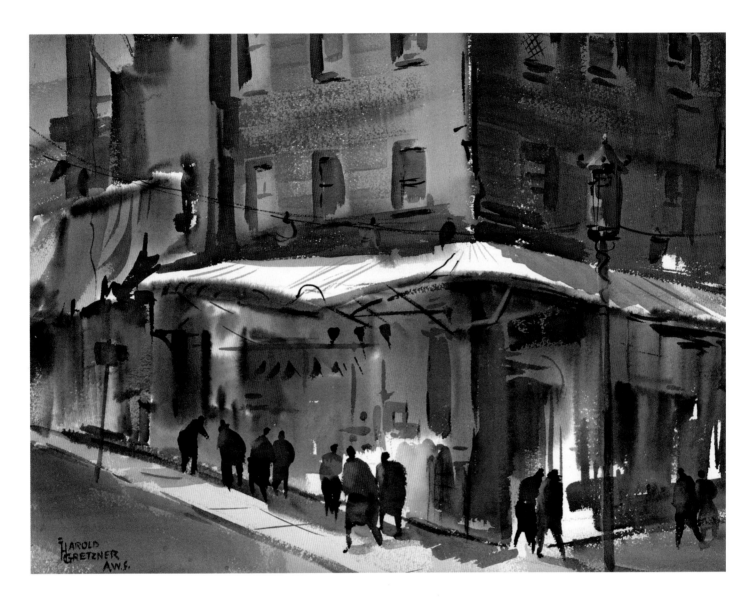

HAROLD GRETZNER,
CHINATOWN STREET CORNER, CIRCA 1950s
WATERCOLOR ON PAPER
18 × 24 INCHES (46 × 61 CM)
COURTESY OF CALIFORNIAWATERCOLOR.COM

Harold Gretzner also chose not to make individual bricks. Instead, he
dragged a damp brush across the ridges of the dry, rough paper to
imply a texture, inviting the viewer to meet him halfway. This second
layer represents a further step toward complexity than Kosa took with
his granulating washes.

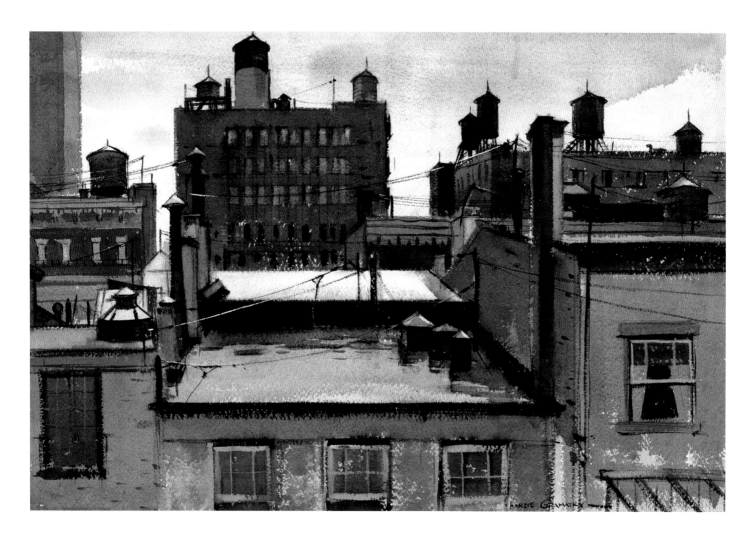

HARDIE GRAMATKY, *VIEW FROM THE ROOF, NEW YORK*, 1937
WATERCOLOR ON ROUGH PAPER
14 × 21 INCHES (36 × 53 CM)
COURTESY OF CALIFORNIAWATERCOLOR.COM

Hardie Gramatky goes one step further. His second layer of tiny rectangles leaves no room for misinterpretation. A brick is a brick, and it takes only a dozen of them to suggest that these are what make up the entire wall.

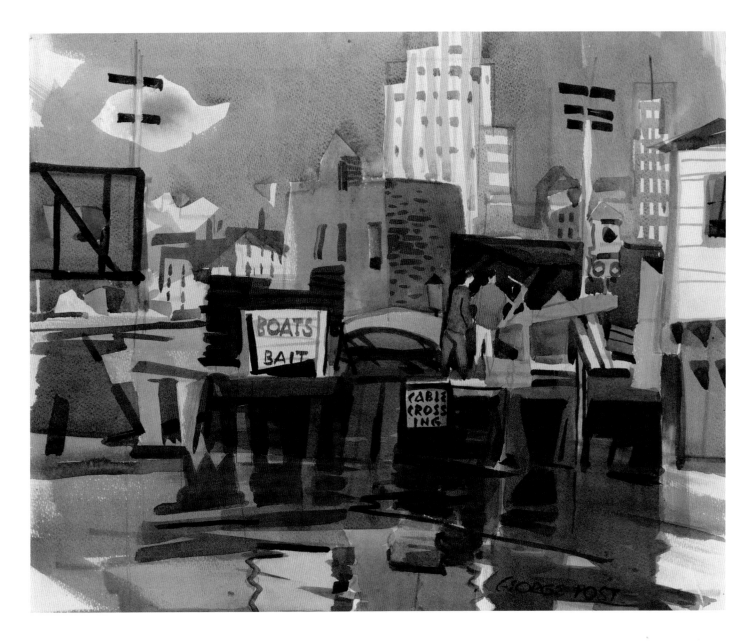

GEORGE POST, *CABLE CROSSING*
DATE UNKNOWN
WATERCOLOR ON PAPER
14½ × 17½ INCHES (37 × 44 CM)
COURTESY OF CALIFORNIAWATERCOLOR.COM

George Post enjoyed using patterns to refer to texture. He shows
specific bricks only on the shady side of his blue-eyed building, but their
presence does as much as the shadow to show that there is a change
of planes.

OGDEN PLEISSNER, *OLD MILL, WINCHENDON,*
MASSACHUSETTS, CIRCA 1960
WATERCOLOR ON PAPER
16 × 26 INCHES (41 × 66 CM)
COURTESY OF ADELSON GALLERIES, NEW YORK

After a lengthy search for a richly detailed treatment of a brick wall, I was
delighted to find one that provides lots of specific information without
overdoing it. Ogden Pleissner is very conscious of how much detail a
given surface can carry. The sunlit wall of the smaller brick building, with
its single window, has plenty of room for individual bricks. The sunlit wall
of the big building, however, is already chock-full of windows, shadows,
and stains, and it would be overloaded if it had a brick pattern as well.

KNOWING WHEN TO STOP

No matter where your personal preferences take you, some level of restraint is required to keep the painting from getting overloaded. There is simply too much information to ever cram it all into one painting. Even if I had the patience to paint all the bricks, all the mortar, and the shadows each brick casts, I wouldn't want to. People do try, but the paintings that result are rarely the ones I enjoy looking at. Personally, I need to know when I have given the viewer just enough information, and not too much. At some level of my thinking, I am always asking: *Is this enough?*

A painting is a conversation. Both parties—the artist and the viewer—have roles to play. When one does all the talking, it leaves the other with nothing to do. Part of the pleasure of a conversation is the mutual acknowledgement of common understanding. A well-chosen word refers to ideas and experiences that both participants appreciate, whereas describing *everything* implies that the other person has nothing to offer. Paintings that tell me too much always feel vaguely insulting, as if all that is wanted from me is to be impressed and say, "Wow!"

There is another element that bears consideration in the question of how much information is enough. It is easy to get all wrapped up in the portrayal of specifics and forget to be respectful of the paint. The transparency and fluid nature of watercolor is what attracts most of us to the medium in the first place, and to me nothing is more important than giving the watercolor room to display its tendency to flow. If I sacrifice the simple beauty of the paint for accuracy or complexity, I have made a bad bargain.

Any time I become engrossed in depicting detail, I want to take ever greater control of where the paint will go. If I could stand back and observe my own posture, I'd see a figure hunched over the paper, holding the brush way down on the ferrule, moving only the last joint of his fingers. This is not the guy who paints the kind of pictures I enjoy.

The fussier I am about what happens on the paper, the more I'm inclined to think that what I've just done is not right. Correcting watercolor is always a dicey proposition. Some people become very good at it, but rather than practice how to rescue my paintings, I prefer to develop the skills that will help me not make the mistake in the first place. That means giving as much of the control as possible back to the paint. If I can establish the range of brushwork that I know will do the job, then I can make my mark with confidence and leave it alone, just as Maurice Logan has done with the stack of logs in the image opposite.

Looking at a painting we admire, it is natural to assume that the artist meant for everything to be just as we see it. Quite often, though, having made the important choices in advance, he only needed to know *roughly* how the paint would behave.

I would define the ideal painting as one that has nothing missing, and not a single extra stroke. If the paint shows signs of having been messed with, the implication is that at some point one of those criteria was not met. Boldly applied paint, on the other hand, convinces us that everything is as it should be. Only the artist knows if everything at the original scene has really been represented, but with watercolor, every talented viewer can detect uncertainty.

The paintings in this book come from all over the world and from three different centuries. The common denominators are the confidence with which the paint was applied and the artist's respect for the medium.

MAURICE LOGAN, *THE CHICKEN HOUSE*
DATE UNKNOWN
WATERCOLOR ON COLD PRESS PAPER
20 × 26 INCHES (51 × 66 CM)
COURTESY OF CALIFORNIAWATERCOLOR.COM

In this down-home subject, Maurice Logan seemed to want a casual
feeling, as if the paint just slid into place by itself. With the stacked
logs on the right, for example, he knew the overall shape needed to be
roughly half light and half mid-value, and that the strokes needed to be
horizontal. It is possible to imagine other combinations of similar strokes
that would do the job equally well, but these are "perfect enough."

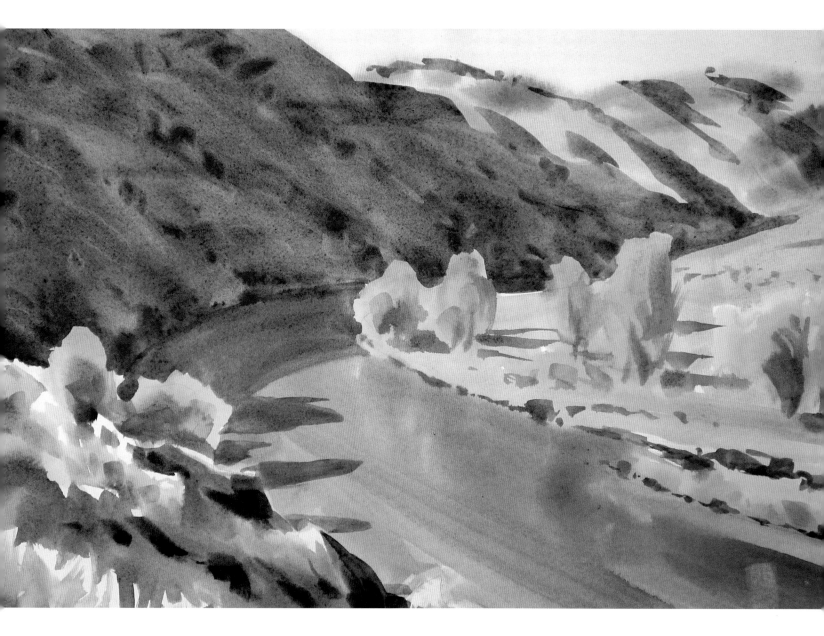

TOM HOFFMANN, *BEND*, 2011
WATERCOLOR ON ARCHES HOT PRESS PAPER
15 × 22 INCHES (38 × 56 CM)

In this painting the major shapes were blocked in with large, general washes. Notice how the sharp edge between the two green bushes on the left and the darker shadows behind them does the important work of locating the shapes in space, but it was not until late in the painting process that the edge was established. Before the shadow layer was applied, the hill behind the bushes was as light as the sunlight hills on the right.

Maintaining Intentionality with Your Marks

Sometimes the sheer pleasure of making brushstrokes can lead to an overloaded painting. I often see students repeating a stroke over and over, as if they are biding time while they wait for inspiration. Part of what's going on is that we *want* to keep adding more. We came to paint, after all, and it just plain feels good to swing the brush (until we notice that we've overdone it again). This is why it is important to ask: *Are my marks intentional?*

There are stages in the progress of a painting when it's fine to indulge in the sensual pleasure of moving the brush over the paper, but there comes a moment when it's wise to detach and perhaps slow down.

Given the dual progression of light toward dark and general toward specific, the first layer of a painting is often composed of the big shapes, blocked in with pale washes. Successive layers of middle values and darks will eventually cover much of the paint you apply at this stage, which may allow for casual brushwork. As the middle values begin to go on, however, and certainly when you get to the individual, very specific dark strokes, a different quality of attention is called for.

When the first layer of the painting at left was being applied, it was not important for me to contain the pale washes within their respective outlines. The marks could be made casually, since the second and third layers—shadows, shrubs, and rocks—would be dark enough to cover any overflow. If you follow the hard edge between foreground and background, you can see that one or the other is almost always deliberately darker.

Recognizing What Works

The more specific the marks you are making, the more you benefit from a kind of "detached engagement." While painting make sure to pause and ask: *Is this okay?* I think of this process as watching the painting develop stroke by stroke, as if someone else were painting it. If you were actually looking over another artist's shoulder it would be easy to know when to say "Hold it! That's fine just as it is." Being deep into your own agenda, though, can blind you to what is right before your eyes.

The trick is to be separated from your own intentions enough to see whether what you've just done *works*, regardless of whether it conforms to your original vision. It is always possible that what is happening in the moment might be just fine, even if it's not what you thought you wanted. Remembering to ask if the job is already done saves many pictures from becoming overpainted.

If you still decide it's not right, before you rush to correct it, ask yourself what is the *minimum* you could do to take it further. For example, if a hill in the distance feels too prominent, it is less invasive to change its color with a simple glaze than it would be to try to scrub it out entirely. If something about your painting bothers you, at least *consider* learning to love it. Doing nothing, after all, is the absolute minimum. Being suspicious of my immediate agenda, and knowing that I usually lose more than I gain by going back over a spot to "fix" it, I'm inclined to wait and see how it looks tomorrow.

In short, be flexible, and avoid "painting yourself into a corner." The transparency of watercolor demands that we hold off on getting very specific prematurely. That's the logic behind a light-to-dark and general-to-specific progression. By not committing to brushwork that is difficult to change cleanly, we keep our range of choices as open as possible.

With regard to their impact on the painting, there is a hierarchy of the marks you might make. Washes are more general than strokes. Soft edges are less specific than hard ones. Light is easier to cover than dark. Colors that are already present in the painting will be less obtrusive than new ones. You can always add another stroke a week later, if you decide it's called for, but you can't always take one away.

Using the Language of Form

One way to keep from getting specific too quickly is to stay abstract as long as possible. For me, this is mainly a matter of how I think about the subject. During the inner dialog that accompanies the painting process, I can describe the image by naming everything in terms of the content, or I can stick to the language of form.

For example, here is a content-based, narrative description of the photo below: This is a street scene in Mexico, late in the day. One side of the street is in sunlight, the other in shadow. A woman carrying shopping bags is crossing the street, while another is standing on the sidewalk. Several cars, some parked, some moving, are in the middle distance. A big tree shows above the sunlit buildings. A mountain in the distance stands out against the clear blue sky.

Here is the same scene described in the language of pure form: The right quarter and the bottom third of the page are rectangles of cool, dark neutral. A triangle comprising warm, very light, rectilinear forms begins at the center of the page and widens toward the left. A pattern of dark verticals is distributed across the triangle. Above it a semicircle of intense medium dark green is silhouetted against a middle-value blue, which fills the entire top left quadrant. Where the triangle and the dark strips converge, a mid-value purple-gray form widens upward, one third of the way into the blue.

How I choose to think about the picture can have a profound effect on the way I begin to paint it. In the early stages of a painting I usually want to establish the general structure of the image, without getting caught up in specificity. The painting has to work first of all as an arrangement of big shapes, and at this level it is more important for the pattern of darks and lights to be strong than for any specific information about content to be present. This is why it is important to ask: *How long can I stay abstract?*

Until I have taken care of the fundamental needs of the painting, I don't have sufficient basis for deciding how much information to include. It is easy to get involved in the proportions of the woman crossing the street, for example, and

lose track of the fact that she is primarily part of a big shadow. If I were actually standing in the scene, I would be aware of the figures, but I would probably not be studying them in any detail. In the painting, I want the elements of the picture to have an emotional presence similar to the actual experience, which is not necessarily the same thing as seeing them in a photograph.

Photos exert a powerful influence. It is easy to assume that the painting will feel right only if I duplicate the photo exactly, especially if I am already thinking of the elements of the picture as people, buildings, cars, and trees. When I am thinking in terms of big, abstract shapes, however, there are no people, no sidewalks, no shopping bags—just a few somewhat darker and lighter strokes within the big shadow. This leaves me free to decide what role I want each part to play.

Opposite is a painting of the scene done from this point of view. The individual components (people, buildings, cars, and trees) are minimally described and, out of context, might be difficult to recognize, but all together add up to a "realistic" interpretation. A content-based approach would have invited all the associations that attend the names of every part of the scene. Like many realist artists, I am susceptible to an imperative to do justice to each subject. I could easily have gotten wrapped up in accurately rendering postures, hairstyles, body parts, and on and on, until the figures had taken on too much importance in the scene.

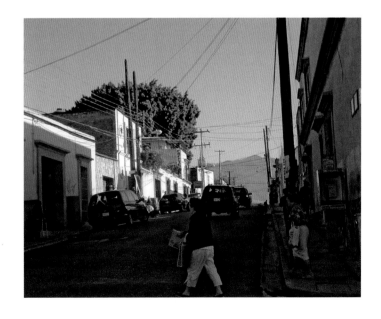

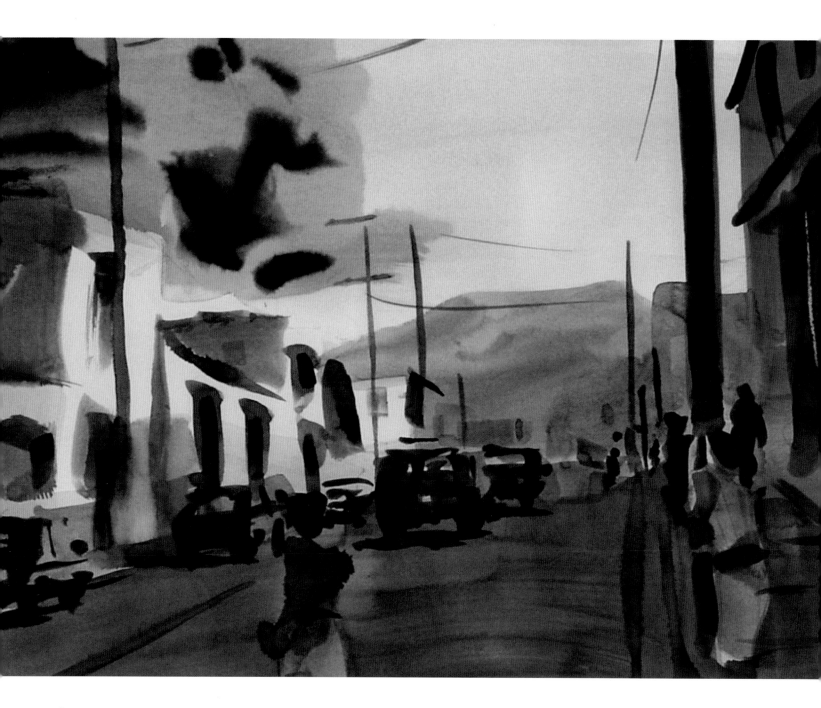

Opposite:

The vegetation in this photograph can be described either as "a big tree that shows above the sunlit buildings" or as "a semicircle of intense medium green silhouetted against a middle-value blue," depending upon whether the language of content or the language of form is used.

Above:

TOM HOFFMANN, *TINOCO Y PALACIOS*, 2010
WATERCOLOR ON ARCHES HOT PRESS PAPER
11 × 15 INCHES (28 × 38 CM)

The figures in the foreground have a presence appropriate to the role they play in the big picture. Thinking abstractly allowed me to stop as soon as I saw that they had done their job.

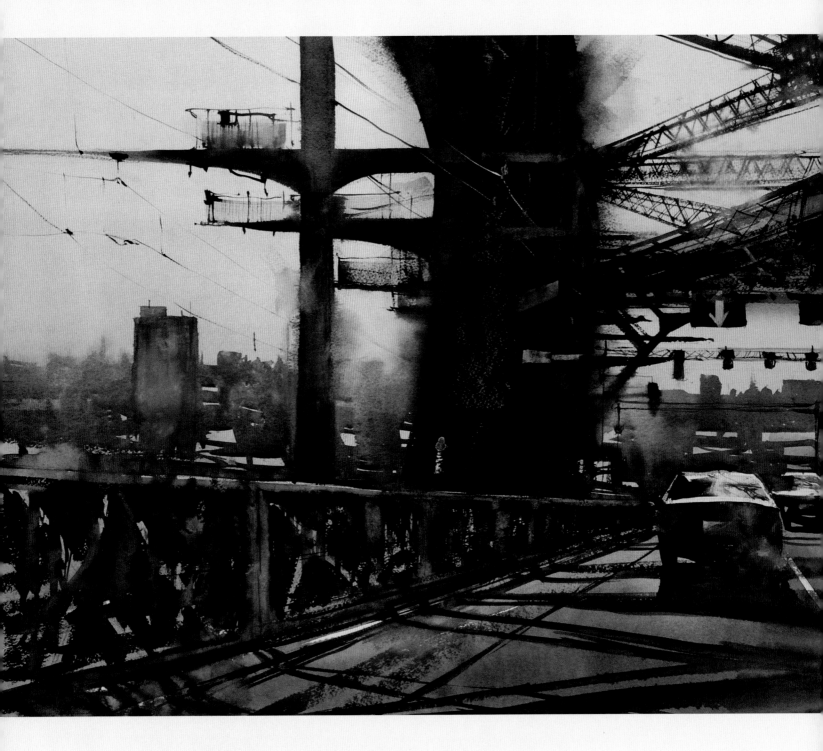

ALVARO CASTAGNET, *HARBOR BRIDGE, SYDNEY*, 2008
WATERCOLOR ON PAPER
26 × 40 INCHES (66 × 102 CM)

The overall effect of Alvaro Castagnet's interpretation of this everyday scene is one of stunning realism.
Looking at the painting shape by shape, however, it becomes clear that he has not indulged in a
duplication of photographic detail. Instead, he has selected the relatively few elements of each part of
the image that are most telling, and eliminated all the rest. Having learned what *not* to paint, the artist
makes his statement without hesitation.

KNOWING WHAT NOT TO PAINT

Imagine that the amount of information we choose to put into a painting exists on a scale—with "way too much" on one side and "not nearly enough" on the other. If you were to place your failed pictures on one side or the other, which way would the scale tip? I'm guessing the "too much" side would drop fast. If so, you are in the great majority. If not, I salute you. It is easier to add to a watercolor painting than to take strokes away.

Why are we so inclined to overload our pictures? Again and again I hear students say, "I want to keep it simple, but I always end up putting in too much detail." The inner voices that encourage us to keep adding more information are very convincing. Even if you are sure that the paintings you want to make are bold interpretations of just the essential aspects of your subject, you may still be prone to overpainting.

In the early stages of learning about a new subject, we are susceptible to the assumption that if the painting in progress doesn't feel quite right, it must need something *more*. Having not yet internalized the basic structure of the image, we look to the photo or the scene to see if there is something we've left out. And, of course, there always is. When it still seems wrong, we find another bit to add, and in this way we keep cramming in more and more information, when the real problem may well be that we already have *too much*.

Whether we set up before a plein air subject or a still life, or work from photos, we are faced with a nearly infinite amount of visual information. This is why is it so important, at the beginning of the painting process, to ask yourself: *How can I simplify the source material?*

The human eye can register wonderfully subtle variations in color and value, and it is a real pleasure to indulge this ability, but remember, it can be a *separate* activity from painting. We are not obliged to put all that information into the picture. Ironically, our job as realist painters most often is to edit out the majority of what we can perceive.

Some information is essential, but most of it is optional. Discovering which is which is largely a matter of getting out of your own way. For example, my first impulse as a painter is to record *everything*. It feels like it's my job to do justice to each separate bit of the scene by including as much information as I can observe. I am *supposed* to do it. I would need a note from the authorities *not* to. And yet, the paintings that result from that kind of attention do not appeal to me.

> Some information is essential, but most of it is optional. Discovering which is which is largely a matter of getting out of your own way.

How can we get "permission" to paint the pictures we really intend to paint? Since so many of us spend more time on the way-too-much side of the information scale, it makes sense to explore the rest of the territory, but this can be intimidating. If we believe we're not supposed to go there, it feels like trespassing.

I find it effective to set up an exercise that is clearly not a painting. When there is no expectation that this piece of paper might become a "keeper," the usual self-imposed restrictions do not apply. It is liberating to make an *intentionally oversimplified* version of the scene, as a temporary license to enter forbidden territory. In the process, you will also discover a great deal about which features of the subject are the essential ones.

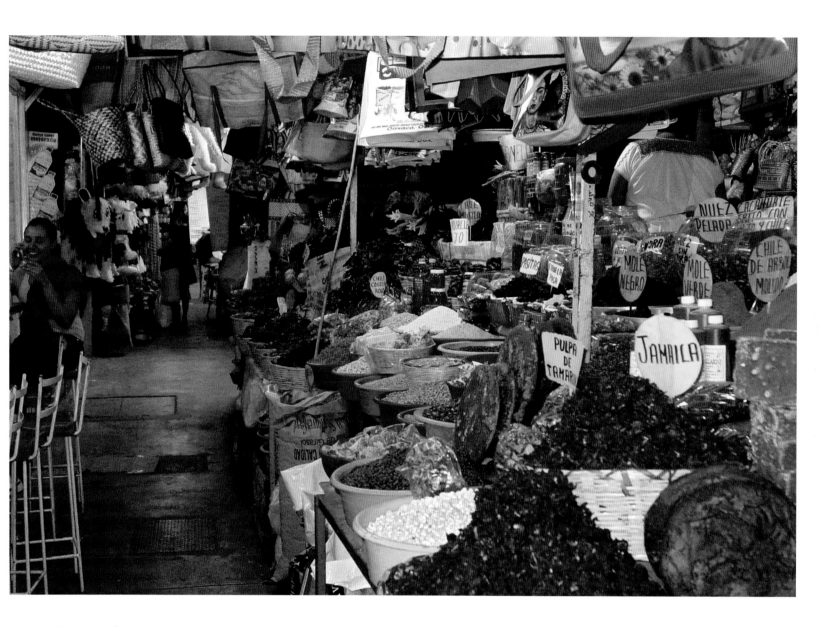

How much of what you can see in this photo of the Juarez Market in Oaxaca would you need to include in a painting? The information that registers at first glance is usually enough to tell you what ought to be communicated about a scene. If you find yourself leaning closer to see exactly what all that stuff is, you probably don't really need to know.

BILL TEITSWORTH, STUDY FOR *FROM THE BRIDGE*, 2010
PERMANENT MARKER ON SKETCH PAPER
5 × 8 INCHES (13 × 20 CM)

This preliminary sketch, which has no more than five values, reveals how little specific information will be needed to tell the story.

IDENTIFYING THE MAJOR SHAPES

You've no doubt heard that it is wise to begin a new subject with a quick sketch or a small study, to help distill the scene down to a manageable number of strokes and washes. Every good teacher I've come across recommends some form or other of finding the "bones" of the image first.

Many different kinds of preliminary studies can help reduce the image to a very simple form. In this chapter we will look at three examples: a five-value monochrome study, a two-layer geometric sketch, and a three-layer thumbnail sketch. The first step in all three exercises is to identify the major shapes.

I define the major shapes as those that need to be separated from each other for the illusion of space to be effective. To decide whether a particular shape plays an important role in describing the space in a scene, try asking yourself if it would matter if it were merged with the adjacent shapes. Would you still be able to tell where everything is in the pictorial space?

In the photograph at right, for instance, it would be fine, perhaps even best, to think of the stones as a single shape. As a whole, the pile needs to be separated from the workers and the wall, but the individual blocks can be subjugated to the overall shape of the pile.

Do the preliminary studies discussed in this chapter on small paper, no bigger than 8 × 10 inches (20 × 25 cm), so you won't become attached to them as paintings. Their purpose is to help you see what you can leave out of the proper painting. If you discover that something is missing, or you believe something should have been done differently, leave the study as it is. Rather than add to it or correct it, write your ideas directly on the study. Articulating your thoughts will make them easier to remember. In each case, you can use the finished study to decide where you need more specificity or subtlety. You may also discover places where what seemed like too little information turns out to be enough.

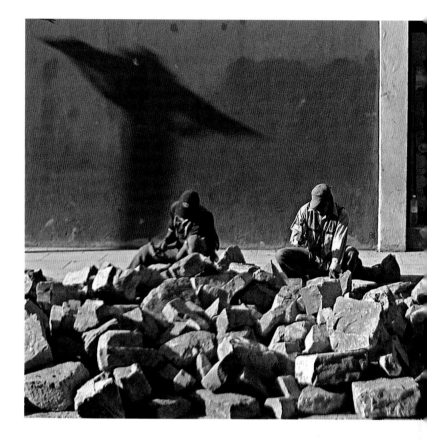

The jumble of stone blocks in this picture looks like a complicated painting subject at first, but remembering to ask if the individual stones *need* to be separated from each other greatly simplifies the job.

Creating a Five-Value Monochrome Study

As a first treatment of a new subject, it would be hard to find a better exercise than a value study. Understanding the dark/light relationships between the big shapes in your composition is an essential first step to making a painting that is cohesive. A five-value version (white, light gray, middle gray, dark gray, black) can be done quite quickly over a simple drawing of the big shapes. It also provides good practice for seeing in layers.

This exercise will answer the question: *What role does value play in the relationships between the big shapes?* To start, choose a color (just one) straight from the tube that can get dark enough to represent black. It's better not to make a color by mixing, since that introduces another variable. This exercise is designed to focus on value only. Similarly, all paint should be applied to dry paper, to keep wetness from distracting your attention away from value.

> The best way to find out if something needs to be in the picture is to leave it out.

If you are tempted to get fussy about edge quality, or texture, or any kind of detail, remember, this is *not a painting,* and it is supposed to be too simple. A door may be important, but the doorknob probably isn't. I have seen some so-called value studies that are, in fact, very carefully observed monochrome paintings. They are quite beautiful, but as tools designed to reveal the essential elements of the scene, they are not very useful. The best way to find out if something needs to be in the picture is to leave it out.

After each step of your study, while you're waiting for the paper to dry, assess how complete the illusion of light and space and substance feels.

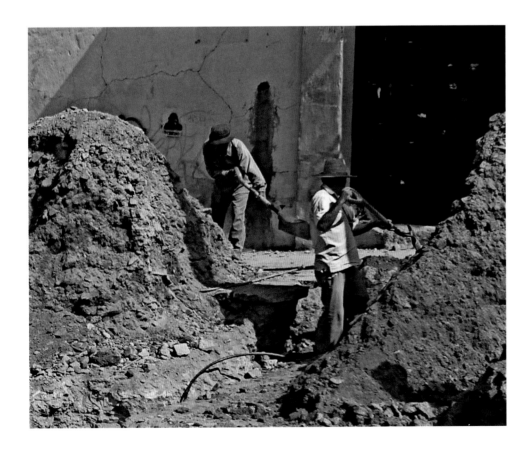

Evaluate the subject.
Light is an important component of this image. Isolating the variable of *value* should reveal the role it plays in creating the illusion of sun and shadow.

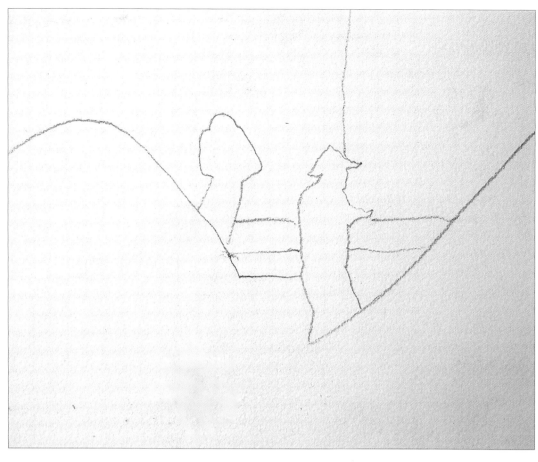

Locate the major shapes in the image.
Draw the big shapes, keeping the number down to ten or fewer. The profile of each shape is all you need to draw. The idea is to *locate* the shapes, not to describe them.

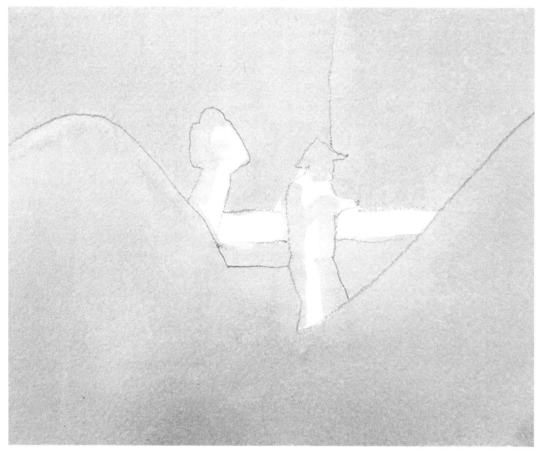

Reserve the white areas while applying the lightest lights.
Starting with the lightest gray, paint the entire page, except for any shapes that need to stay white. Is there a feeling of light in the study? What about space? Substance?

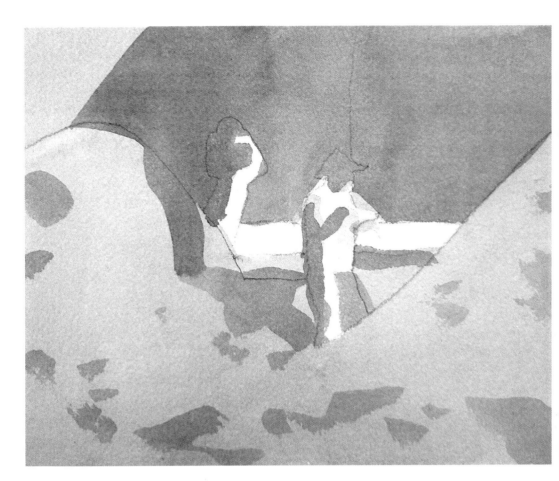

Add the middle grays.

If you can't decide whether a shape should be light or middle, round it off one way or the other. The finished study will reveal whether you made the right choice. If you give in to the temptation to embellish a bit (as I did with the spots of shadow in the dirt piles), keep it very simple. Again, assess the state of the illusion: Light? Space? Substance?

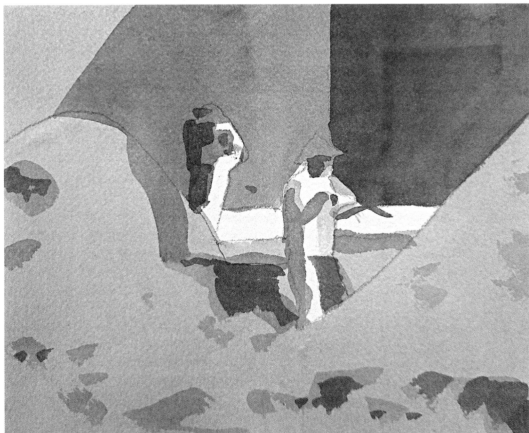

Add the dark grays.

When the second layer is dry, apply the dark gray over everything except the middle gray, light, and white shapes. Now that the background figure has a dark gray layer, and the section of wall behind him does not, notice how effectively the two separate, compared to the previous stage.

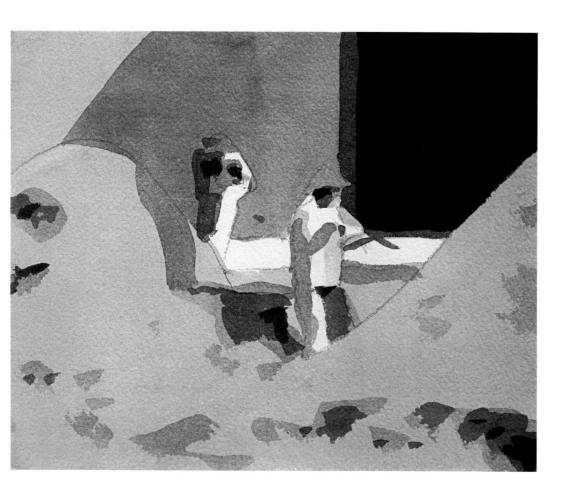

Paint in the darkest darks.
The role of the darkest darks in creating an illusion of light, space, and substance is clear, even in a radically oversimplified image.

EVALUATING A SIMPLIFIED STUDY

When the value study is finished, it can be compared to the source image or the scene to see where adjustments need to be made. Having come way over into the realm of too little information, we now have a basis for judging how much more needs to be included. Ask yourself: *Where do I need more subtlety or specificity?* Don't skip this step. A study, as the name implies, is a learning tool. Your painting process will be more efficient and your paintings more cohesive if you extract all the lessons you can from your preliminary work.

In the photo on page 48, the two mounds of dirt are so similar in color and value it seemed sensible to treat them as a single shape. But the study reveals that it would be better to separate them, making it clearer that the one on the right is in front. The study also reveals that the mound on the left does not separate

sufficiently from the wall in the background. It looks okay where there is a shadow behind it, but where the wall is sunlit only the pencil line separates the two shapes. Perhaps lightening the left mound a little could solve both of these problems. Five values, in this case, are not quite enough. There should be a step between light and middle. This is an example of the need for more subtlety.

The little raised frame beside the doorway that catches the sun is a fine feature of the photo that I miss. It does an important job, describing the light. It is a bit of specific information that will add significantly to the picture without becoming a distraction.

It is surprisingly easy to see what is missing and what needs to be changed when the image has been oversimplified. If I had made a complex first attempt it would be difficult to know which of the (too) many elements were not necessary.

CREATING A TWO-LAYER GEOMETRIC SKETCH

This is a good exercise to try after you become confident of your ability to read values well. As in the five-value monochrome study, this approach is designed to reveal how much of the information in the scene needs to be included in the actual painting that will follow. It adds color to the equation, but in a deliberately oversimplified form. It helps you answer the question: *How does color work with value?*

Each of the major shapes in your composition is simplified almost to the level of basic geometric forms. A fir tree is, roughly, a green triangle. Clouds may be elongated ovals. A hill can be a half circle. It's fine for the shapes to be approximate. They don't need to be pure geometric forms. Just don't let them become too specific. Focus instead on getting the values right.

Assign a color and value to each shape. Try to summarize the information you can see within a given shape, so that it can be expressed in its simplest form. Let go of texture and detail. A tree is a single shape, rather than a collection of leaves. The finished sketch will look like a collage made of cut pieces of colored paper.

Since this exercise involves two variables (color and value), keep it simple by limiting your palette to three colors: one red, one yellow, and one blue. Mixing these is fine, but if you want a green, make it by combining the blue and yellow, rather than by introducing a fourth color. You are making a learning tool, not a painting, so if your colors don't make a good purple, or the green is not intense enough, let it be. You will still be well informed about what the final painting needs.

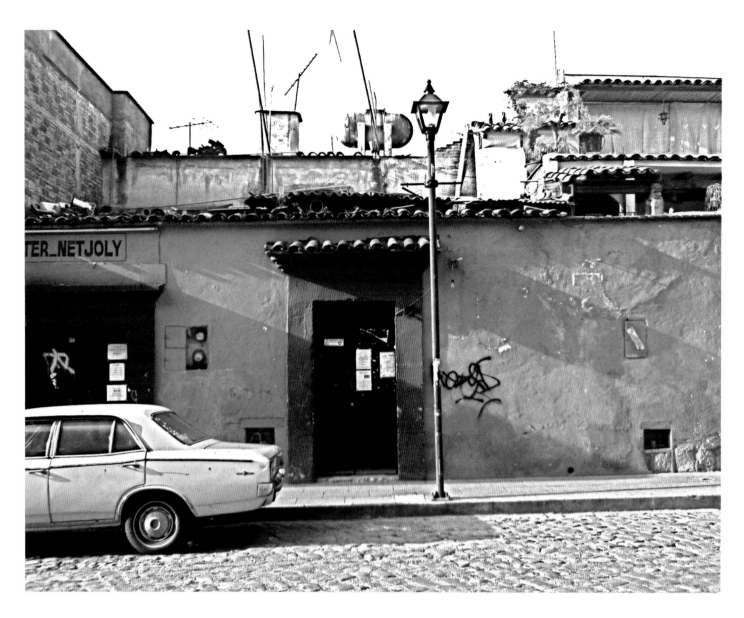

Evaluate the subject.

The doors in this picture are small shapes contained within a bigger shape (the yellow wall). They do not need to be there to create a feeling of space, so I want to include them only if they feel essential to the painting. I know I want the door on the right, but I'm not sure the scene needs the other door.

Block in the major shapes.
Give each shape a first layer wash representing its lightest shade. The overlapping shapes begin to suggest a feeling of space. If you're uncertain about a shape, leave it out. The finished study will reveal whether the picture could do without it.

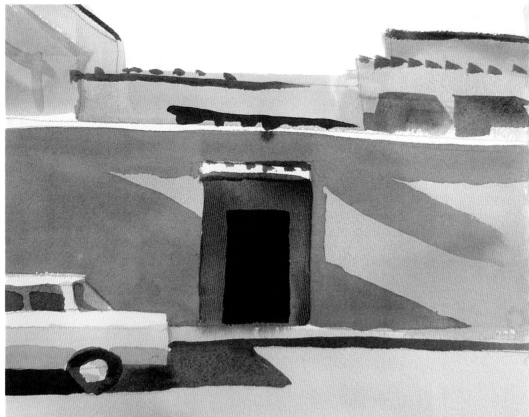

Apply a second layer where needed.
Since this study aims to ignore texture and detail, little more than the shadows needed to be added. Even simplified to this degree, shadows go a long way toward establishing a convincing sense of light.

Stopping after two layers provides a means of assessing where and how much further information needs to be added. Any remaining questions can be directed to the finished sketch, and, hopefully, the answers will be apparent. For example: What do you think about the second door? How much more (or less) of the complexity of the upper story would you include? If you chose to represent the cobblestones in the street, how many would you need to show? What about the cast shadow of the roof? Is it important to show that it is made of tiles? What if the sky were blue? Would you put the lamppost back in?

You can see how the fact that the information is *not* here makes it easy to decide whether you want to put it in your painting. Where the long diagonal shadow crosses the doorway, I forgot to darken the red frame. I would definitely want that in the proper painting. And (*ahem*), the shadow of the awning has slid way off to the right. But, basically, the shapes work, and the sun is shining.

THINKING ABOUT STOPPING

Both of the previous exercises encourage intentionally leaving out all but the most basic information. Most of the time, you will want to include more. It is unusual to be content with just one color, or with shapes that have no texture. But the benefit of seeing the image in its minimal form is that you can move back toward your comfort zone by increments, stopping as soon as the *essential* information is present. This greatly increases the odds that you won't overpaint the picture.

When I am convinced that part of the picture needs more information, I practice a minimalist approach, asking: *What is the smallest change I can make that will move the picture in the right direction?* In the early stages of getting to know a new subject I want to err on the side of too little information, since I am better at adding than taking away. From this point of view, it bears repeating that there is a hierarchy of the marks I might make, based on the impact they can have. A pale stroke, for example, is less insistent than a dark one, and a soft edge is gentler than a hard one. Using colors that are similar in hue and intensity to what is already there is less obtrusive than introducing new ones. The idea is to leave the door open for adding more only if necessary.

Once you understand your subject well in terms of the language of watercolor, it is not necessary to be so cautious. A thoughtful approach to painting may seem very cerebral at first, but over time it becomes instinctive.

I sometimes wish that a detached observer could come along and present me with this sign at just the right moment. It frequently takes just such an intrusion to get us to detach from our agenda. I have often regretted not stopping sooner in a painting, but I've never looked at a finished painting with regrets that I stopped too soon.

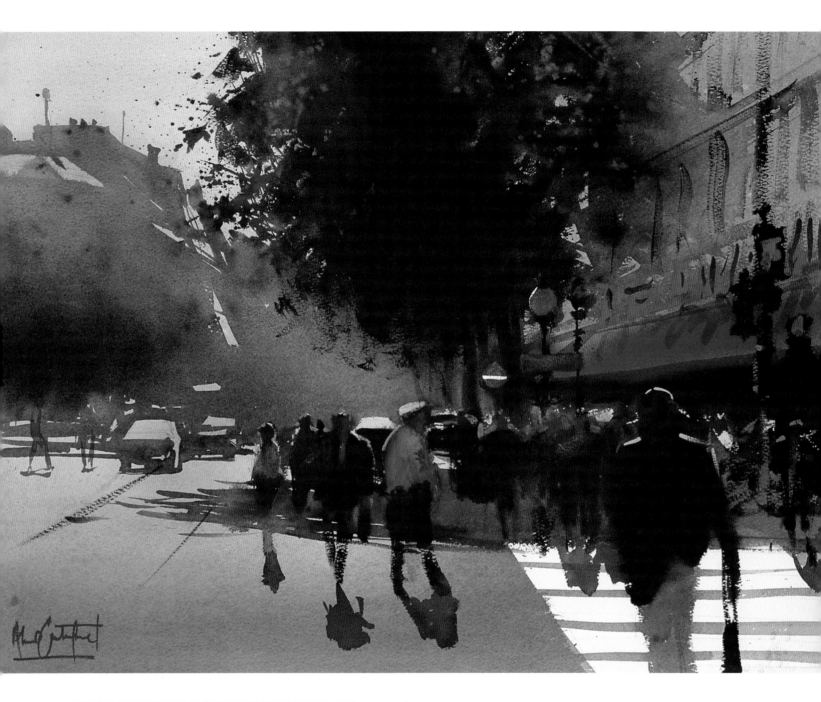

ALVARO CASTAGNET, *BOULEVARD SAINT MICHEL*, 2008
WATERCOLOR ON PAPER
22 × 30 INCHES (56 × 76 CM)

This scene of intense light and shadow is so thoroughly convincing that the simplicity of execution is not immediately apparent. In any given shape, how many layers do you see? Even in the most complex areas, I count no more than three.

Looking more closely at this section of Alvaro Castagnet's street scene, it becomes clear that he has taken what could have been a very complex passage and made it into a single shape. Several buildings, cars, and figures are suggested with a varied wash and a few reserved lights. The artist knew this was just enough information to prompt us to supply the details.

CREATING A THREE-LAYER THUMBNAIL SKETCH

When does the painting become specific? By now it must be obvious that when I am trying to learn which elements of an image are essential and which are optional, I am especially suspicious of the specific bits. Developing the skills that allow me to look right through detail to see the *general* visual information greatly expands the range of images that seem "paintable."

The elaborate carvings on the façade of the cathedral at right, for example, make it seem a daunting subject. So much information makes it difficult to imagine where to begin. Proceeding from light to dark and from general to specific should help me find a simple way to interpret a complex subject.

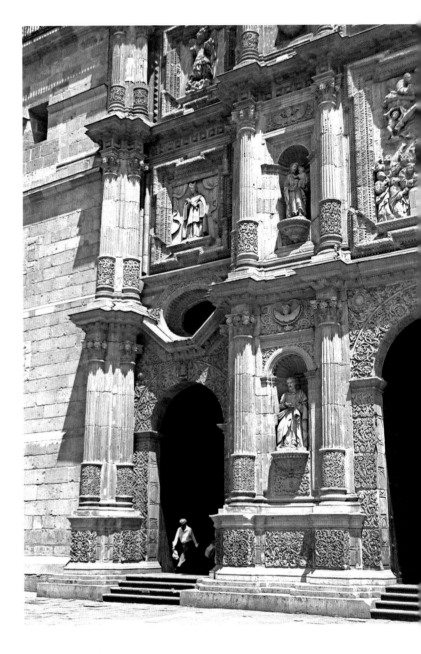

Evaluate the subject.
When I squint hard at the photograph of the cathedral, the complex carvings lose specificity, becoming simpler, more general shapes. I can begin to see them as a layer of middle-value forms laid on top of a lighter layer.

With a progression of layers in mind, I can "look through" the distracting detail to see the underlying structure of the lights. In the image at right, the first layer is a collection of pale, warm, neutral strokes. The whites that are reserved between those strokes make a similar abstract pattern. I was able to identify where the strokes would occur, how many there would be, and what kinds of marks would be appropriate by asking very general questions about proportion, distribution, and pattern. Before painting this stage, I asked myself: *What percentage of the page is white? What is the fundamental orientation of the whites? Horizontal? Vertical? Diagonal? Do the whites occur in predictable locations?*

The answers to these questions provided basic guidelines that were not overly specific. I knew, roughly speaking, that the whites would make up a little less than half the page, that they would mainly be horizontal and vertical lines, and that they would correspond to the upward- and right-facing edges of shapes. As long as these general requirements were met, I could stay abstract and progress gradually from general to specific information.

By themselves, the pale, first-layer washes do very little to create an effective illusion of light or space or substance. They are very general, like the rough outline of a piece of writing—mostly nouns, a couple of verbs, and no adjectives. Because these shapes will be partly covered by increasingly descriptive layers, they can often be applied quickly and casually.

Identify the lights and add the first layer.
At this stage of the study, it is not necessary to be concerned with content. To keep from getting specific prematurely, trust that the middle values and dark layers will provide all the meaning.

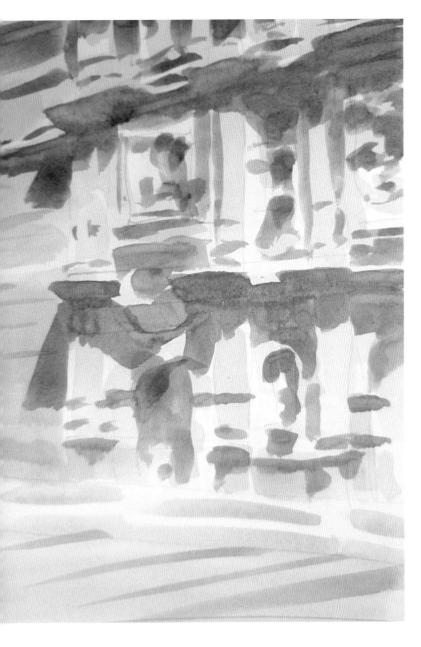

The second layer, as seen at left, is also a pattern of strokes guided by the same sort of general question I asked previously. These cool neutrals cover about 20 percent of the page, and occur below the whites and along the left side of the light strokes. Can you see the pattern that determines where the warm strokes were touched into the larger cools? On a sunny day, the downward-facing surfaces of light-colored objects catch reflected sunlight and appear noticeably warmer than the surfaces that face up or out.

By the time I had completed the image at right, much of the complexity of the scene that had made it initially intimidating had been distilled down to three loosely applied layers. Yet, there is a sense of light and space, which is essential. At this point in the process I could have called the painting finished, or I could have kept adding ever more specific information. The door was open.

Add the middle values.
More care is needed at this point to *locate* the strokes, but it is still not necessary to *describe* specific forms. We need to know where the middle values go, but we don't need to know precisely what they are.

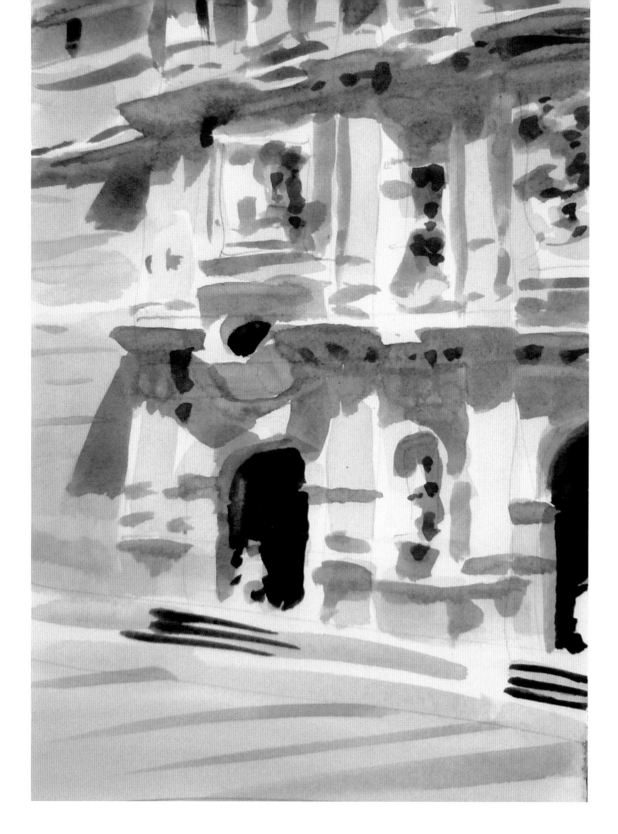

Apply the darks.

The relatively few darks should be more carefully located than the first two layers.
They describe openings and deep recesses, which need to be in specific places.

TOM HOFFMANN, *CATEDRAL
METROPOLITANA DE OAXACA*, 2011
WATERCOLOR ON ARCHES HOT PRESS PAPER
11 × 7½ INCHES (28 × 19 CM)

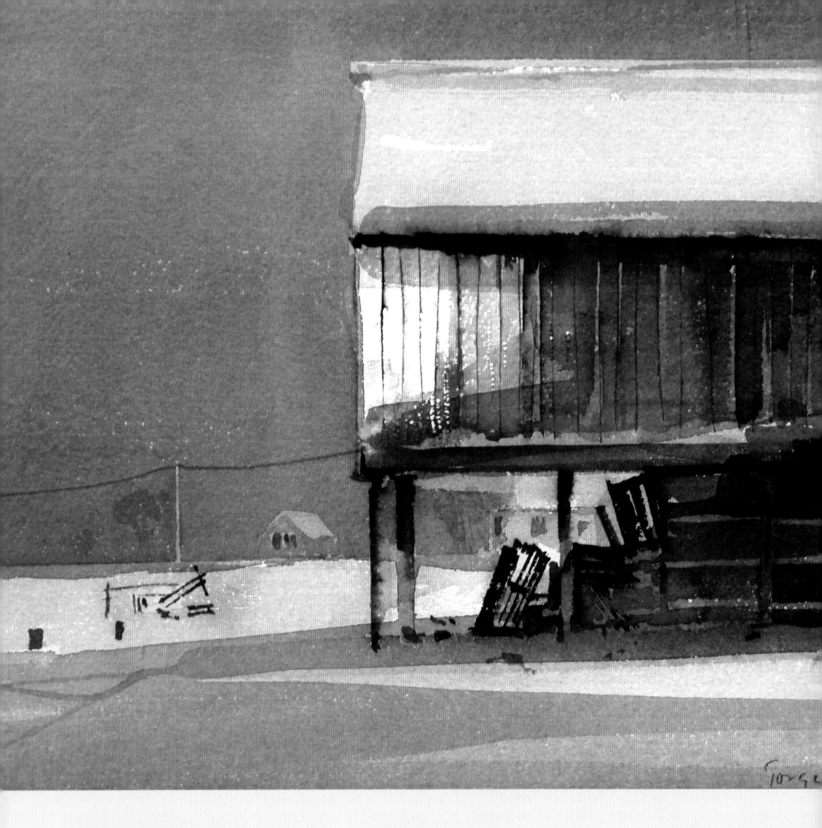

TORGEIR SCHJØLBERG, *FJØSVEGG*, 2005
WATERCOLOR ON PAPER
15¾ × 21¾ INCHES (40 × 55 CM)

Simplicity of treatment in this Norwegian landscape is essential to the overall feeling of stillness.
Looking at one major shape at a time, it becomes clear that there are no more than three layers in any
area. The roof, for example, started out as a very pale rectangle (light). The shadow above the bottom
edge was a second layer (middle), and the edge itself was the third (dark). Count the layers that make
up the small house in the background: roof, siding, windows.

SEEING IN LAYERS

How many layers will it take to tell the story? Theoretically, there is no limit to the number of layers of watercolor paint you can put one on top of another and still observe a cumulative effect. Since each thin layer is transparent, the preceding layers will be at least partly visible, even if the paper has long since been completely obscured. There comes a point, however, beyond which the paint begins to lose its natural luminosity. When the light can no longer pass through all the paint and reflect back from the white paper to the viewer's eye, the surface looks dull and lifeless. This alone would be a good enough reason not to pile on too many layers, but there is an even more compelling case for efficiency.

In a way, the individual artist's understanding of his subject *is* the subject. What we see when we look at a painting is the way the painter has interpreted the scene. Much of the pleasure of our experience as viewers, whether or not we are conscious of it, is seeing into the artist's mind. When we are shown only the essential aspects of the subject

with nothing extra, we see the world fully translated into a few washes and strokes. There is a sense of collaboration between artist and viewer, as if we are being counted on to fill in the blanks.

How does the artist know when such a simple treatment would work? The skills involved in recognizing what is essential and what is optional are *awareness* skills. While John Yardley's *My New Shoes*, opposite, certainly displays a deft hand, it is not the brushwork that is most impressive. He knew which were the truly telling aspects of his subject, and he gave us credit for being able to keep up with him. As viewers, we feel respected.

With a fundamental economy of means in mind, I begin my translation of a subject by trying to understand it as a series of layers. I imagine a succession of transparent films that will add up to the appropriate degree of complexity for the subject. To get in the habit of seeing this way, it is useful to impose a limit on the number of layers you are trying to identify. Roughly speaking, I envision a first layer of the lights, a second of the middle values, and a third of the darks. Although it is sometimes necessary to be subtler, I find that most subjects can be brought to life with just these three. Looking at the detail of *My New Shoes*, below, notice how the sandals are painted with three simple layers on white paper: blue shadow (light), pink stripes (middle), and brown stripes (dark).

What we see when we look at a painting is the way the painter has interpreted the scene. Much of the pleasure of our experience as viewers, whether or not we are conscious of it, is seeing into the artist's mind.

Below:
This detail of *My New Shoes* shows the efficiency with which John Yardley presents his subject, which is part of the appeal of the painting. Everything we need to know is here, with nothing extra. The artist stopped as soon as the story was told. We are presented with the essential information and invited to imagine the rest.

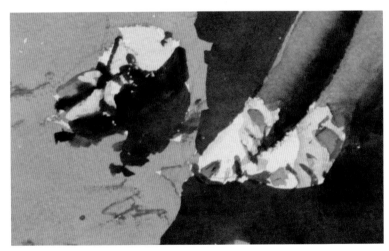

Opposite:
JOHN YARDLEY, *MY NEW SHOES*, 2011
WATERCOLOR ON PAPER
16 × 12 INCHES (41 × 30 CM)

There is no question that this is a satisfying painting—both in form and in content. Framing the backlit figures with a cool, dark neutral highlights their radiance and focuses our attention on the dark-haired girl's fascination with her wonderful new shoes. A closer look, feature by feature, reveals that the painting could hardly have been simpler.

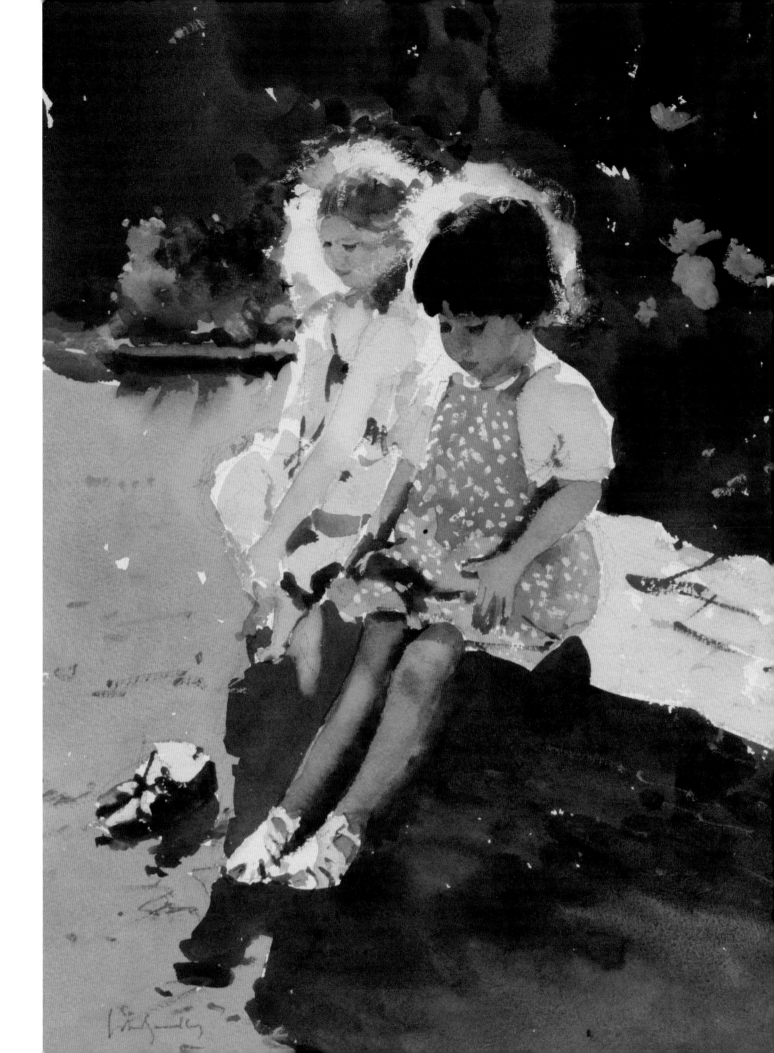

Resolving an Image through Layers

It is an unusual picture that can begin with a first layer wash that covers the whole page. Usually there is some reason to reserve whites, or to refrain from putting the initial color under something that will come later. It is usually necessary, therefore, to consider the image as a collection of shapes and to envision the progression of layers for each one. Keeping the overall number of shapes to a minimum will help prevent confusion, for both artist and viewer. Therefore, when you're assessing your subject, it is important to ask: *How will the image resolve into layers?*

However many shapes you can gracefully juggle in your work, I recommend staying focused on the big picture. For me, it does not work to bring one shape out to full realization while the rest of the shapes are still white paper. To help keep the whole picture tied together, block in the entire image with a first layer early in the process. I confess this is where I most often fail to follow my own advice, since I can't resist seeing how the part I'm painting right now will look with the next layer on. One problem with jumping ahead, though, is that I am making choices about color, value, and amount of detail based on proximity to white paper, which is not what will be there once I finish the first layer. Plus, if I complete each segment of a painting before moving to the next area, the finished picture will be a collection of separate little paintings on the same page.

I try to work the whole page one layer at a time, not putting a second layer anywhere until I've put the first layer everywhere. This is not an absolute rule. It is not even always possible. But the idea is to keep the shapes all working together. For instance, in the photograph opposite, the blue of the sky could not go under the warm colors of the walls, and even the palest pink of the door trim would compromise the purity of the blue. Since neither one would work as a preliminary wash for the entire page, I had no choice with this painting but to work shape by shape.

There are three critical questions that you should ask yourself before you paint each layer. I will pose these questions in turn as we watch a segment of a painting come to full realization. The first: *Is there a way to paint the entire shape with a wash that can underlie everything that will come later?*

Blocking in each of the major shapes with its lightest tone leaves the door open to adding middle-value forms later and then applying darks, as needed. It is usually easy enough to tell which of the colors in a major shape will be the best for an overall first layer. Start by looking for the lightest tone. For instance, in the image far right, could you paint the whole shape the lightest pink that shows on the left-facing surfaces of the door trim? If you decided that the light pink could safely underlie everything else on that wall (doorway, blue letters, peach wall, shadows), you are ready to prepare the supply of paint. Be sure to mix up a little more of the first layer color than you think you need, so you won't run out in the middle of applying the wash.

Before the first layer goes on, however, there is a second question to consider: *Is there anything I need to paint around?* If there are areas within a big shape that must remain lighter than the overall first wash, they need to be reserved. Similarly, if there are areas that would be polluted by the color of the first wash, they must also be reserved, even if they are not lighter. You might be concerned, for example, that the pale green blocks of stone on the left would not turn out green if the pale pink were under them. If you are unsure about the effect your choices will have on future layers, try the color progression on your practice paper. In this case, the pink is so light I am sure it can safely underlie even the pale green. When you know what needs to be reserved you are ready to apply the first layer.

How carefully the initial layer needs to be applied depends on several variables: First, your style. Is it casual or painstaking? Second, your subject. Is it an old, stained stucco wall or a brand-new house? Third, subsequent layers. How much of the first layer will be visible after all the other layers have been applied? And fourth, the areas that need to be reserved. How complex are the parts that cannot receive the overall layer? Thinking and seeing in layers is, in a sense, simply following the path of least resistance. Putting darker, more specific strokes on top of broad, light washes is the easiest way to build a painting, and with watercolor, the easy way is the right way.

Once the first layer is painted, ask yourself: *Is there anything I should do while this layer is still wet?* In many situations, you may want to vary the color of the wash, or touch in a pattern of soft-edged marks while the first wash is still wet. How long you expect these

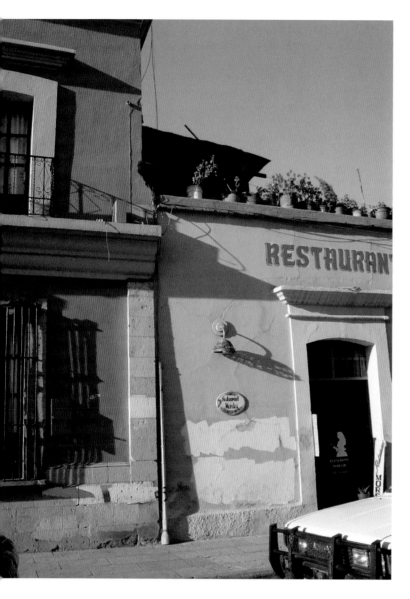

Evaluate the subject.

This street scene is basically an arrangement of four big rectangles; the sky, the peach-colored restaurant, and the first and second floors of the persimmon-colored house. The main color of each building is different enough from those of the other shapes that it would not be wise to start the painting with a single overall wash.

In this demonstration, we will focus on the largest portion of the scene that can utilize a common underlayer. What would your choice be for the first layer? The lightest area that is the left-facing edge of the doorframe works. It is so pale—almost white—that it could surely underlie all the colors yet to come.

steps to take will determine how wet you need to make the wash.

Texture and detail are often more suitably implied rather than specified. If I am unsure how much information the picture will ultimately require, I know I can keep my options open by sticking to soft edges until I see the need for a more specific description. Consider suggesting a texture when the initial layer is wet. Chapter 5 covers these matters more fully.

When the first layer is dry, you can address these same three questions to the second layer. The difference with later layers is that as the painting gets more complex, more individual shapes may appear. For instance, in the image below right, the area that was one big shape is now three, separated by color differences—pink door, orange wall, and green column. There was no way to use the same color as layer two for all three of these areas. For each of these shapes, however, the same three questions guide how they develop. Try asking the questions for the orange wall, for example: *Is there a way to paint the entire shape with a wash that can underlie everything that will come later? Is there anything I need to paint around? Is there anything I should do while this layer is still wet?*

With each successive layer, when you ask if there is anything you should reserve, less of the picture gets painted. When the first layer is applied, some of the white paper may need to be reserved. When the second layer goes on, these same whites will be saved, *plus* however much of the first layer you wish to reserve. And so forth. You can think of the layers as sheets of paint with holes

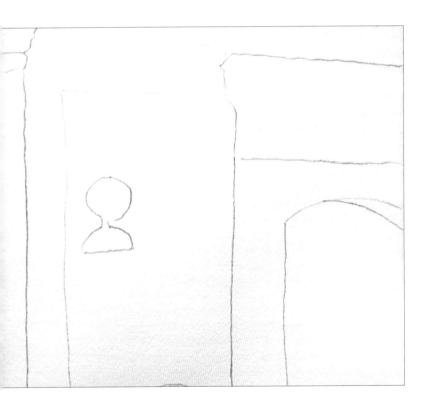

Locate the major shapes and apply the lightest lights.
Since there is no white at all in the scene, the lightest pink on the left-facing sides of the doorframe works as a first wash on the whole façade of the restaurant. Almost all of this layer will eventually be covered. Even so, I chose to put it everywhere, since it is much easier to paint the next layer *on top*, rather than *next to* the pale pink.

Add the second layer, shape by shape.
Because the door, wall, and column are such different colors, they cannot share the same second-layer wash. Once the second layer is applied, all that is left of the first layer are the thin strip of light on the left face of the doorframe and the highlights on the lamp. The variation in the orange wall color is added while this second layer is still wet.

that reveal some of each of the previous layers.

I am a lazy painter—I'm always looking for the easiest way to get the job done. For example, I try to avoid having to "color in" one shape right beside another. If I am not very careful, there will be some places where the two shapes overlap, making a third color, and other places where they don't quite meet, leaving a tiny white spot. It is much easier to simply paint one color right on top of the other. Look at the cast shadows on the peach wall, for example. It would be foolish to leave them white when I paint the wall, and try to color them in later. It is true that their color is not the same as the wall color, but the two are closely and meaningfully related. In this situation, it is not only easier to paint the shadow as a second layer on top of the wall color; it

will also make a more believable shadow. A single brushstroke, applied with confidence, feels like a shadow, while a shape made with many overlapping strokes has too much texture and feels like a tarp tacked onto the wall. Notice the horizontal shadow of the cap of the column in the image below right. It has a patchy look compared to the vertical part, making it seem a little too substantive. I should have applied it wetter, so the strokes would have flowed together.

I think of shadows as one-time-only strokes. Going back over them to correct something usually means sacrificing the essential insubstantiality of a shadow for accuracy. This is surely a net loss. I prefer to learn to love the first result. Better still, try them out on practice paper to be sure of the color and value.

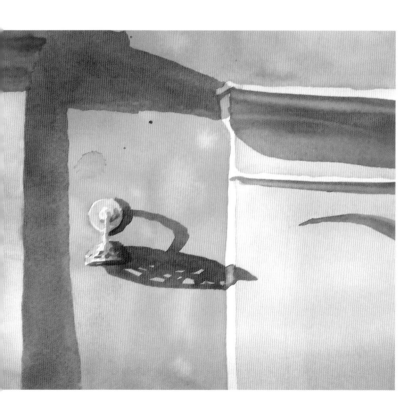

Add the third layer on top of the second.
The shadows on the door, wall, and column are applied directly on top of the previous layers. Since shadows are usually a darker, more neutral version of the surface on which they fall, it works best to paint the shadow color over the sunlit color. The transparency of the paint allows the previous layer to show through, keeping the two colors related. This creates the illusion of light and shade.

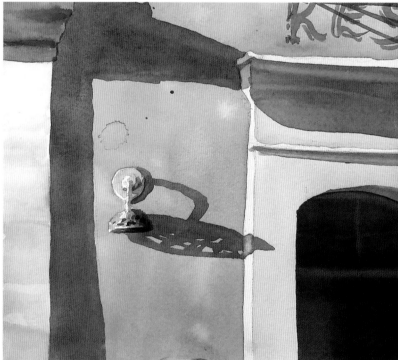

Add the finishing touches.
The illusion of light was realized as soon as the shadows were applied in the previous step, but the darkest darks and the calligraphic details of the final layer provide substance and personality to the scene.

Learning to Exercise Restraint

How do I know when to stop? Knowing when to stand back from your painting involves skills that have very little to do with technical prowess. While finesse and a steady hand are required to paint the fine branches of a winter tree, it takes something else entirely to know enough not to try to include them all. Considering our common tendency to overload our paintings and to become unnecessarily specific, a kind of restraint is what is really needed. Our attempts to anticipate and overcome our bad habits can be strengthened by taking a broader view of the work in progress.

The detachment that lets you keep an eye on the big picture is a habit that can be learned. Just remember to ask: *What role does the part I'm about to paint play in the big picture?* This will keep you from being prematurely drawn into specifics. *The Way Back,* shown opposite, is an example of an image for which I forgot to ask this important question.

When I begin to work on a new area of a painting I tend to give that part of the scene all my attention. I can very quickly be drawn into detail and complexity, noticing individual leaves when the painting only calls for a simple green shape. Before I know it, in my determination to do justice to whatever I am focused on,

I have made too many marks. The result is more like a collection of paintings on the same piece of paper than a cohesive whole.

There are warning signs that should tell you when you are approaching a good place to stop, or at least to pause and stand back. Recognizing this moment may be the most important watercolor skill of all. The signs are not the same for everyone, since each of us has a different sense of how much information is enough, but the process of identifying the red flags should work for anyone.

The first step is to find the patterns in your practice. Do you tend to begin overpainting at a particular stage of your paintings? Chances are the first couple of layers are general enough that you stay out of trouble there, but many painters are seduced by the power of the small, dark strokes that make up the final layer. It is exciting to see how much meaning these strokes can bring to the lights and mid-values, and it is easy to assume that more of them will provide more meaning. But part of the impact of the small darks comes from their scarcity. Even one too many makes all the rest feel too obvious. Better to err on the side of too little information than too much.

Opposite:
TOM HOFFMANN, *THE WAY BACK*, 2011
WATERCOLOR ON ARCHES COLD PRESS PAPER
15 × 11 INCHES (38 × 28 CM)

Everywhere your eye goes, the painting is in similar focus, making it difficult to know where to linger. The patches of foliage in the background insist on coming forward. Too many hard edges distract the viewer's attention. It might help to connect some of the darks, reducing the number of shapes.

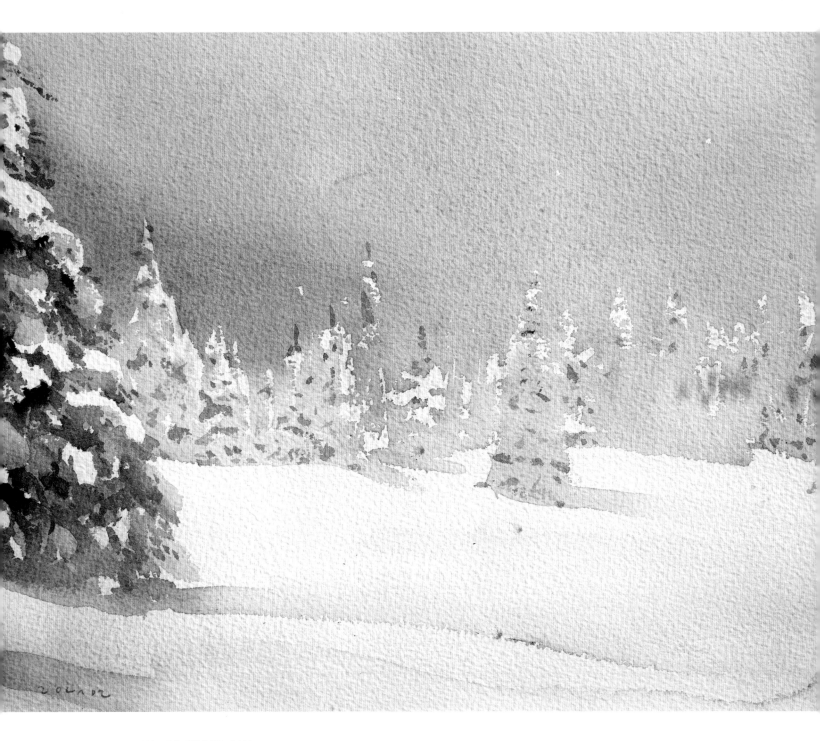

STANISLAW ZOLADZ, *VINTER*, 2009
WATERCOLOR ON PAPER
9⁷/₈ × 15 INCHES (25 × 38 CM)

The layer of darks—just five or six strokes in the foreground tree—
provides all the information needed to describe the atmosphere in this
scene. Even one dark stroke in any of the background trees would have
been a mistake. The artist's restraint is admirable.

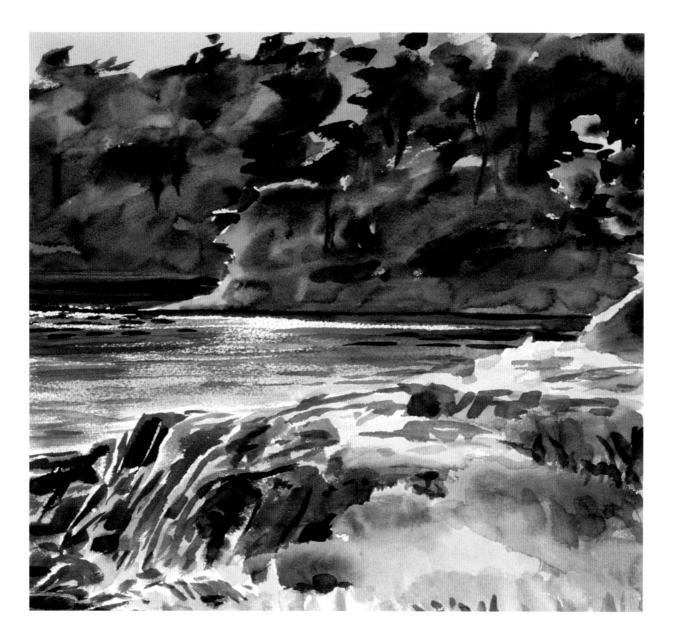

TOM HOFFMANN, *OATMEAL ROCK*, 2007
WATERCOLOR ON ARCHES COLD PRESS PAPER
13 × 14 INCHES (33 × 36 CM)

On a good day I see the moment approaching before it has passed. I literally jump up and stride away from the painting when I see my strokes starting to bring the subject into full realization. I know, at some level, that I will be tempted to keep making those potent strokes beyond the point where they are needed. The foreground rocks in the image above, for example, would have benefited from fewer strokes.

If you can identify a stage of your paintings when you make more strokes than necessary, you know when to turn on the restraint. In my work I become wary as soon as the subject suggests many small strokes. A history of overpainting has led me to wait and look for a simpler way to symbolize the complex subject. Leaving the subject "too simple" rarely leads to regret. In *Pincelada,* on page 74, for example, the single stroke of the mountain provides an engaging contrast to the jumble of individual shapes below.

I knew the foreground rocks were going to be tricky, but rather than do a study or two, I launched right into the painting, saving the rocks for last. When the first few strokes began to define the rocks nicely I got carried away and made *lots* of them.

It is helpful to take an analytical look at paintings you admire to see how many layers are involved. See if you can tell what was done first, then next, and next again. You may be surprised to find that it seldom takes more than four or five layers to reach a very convincing density and light. Many of John Singer Sargent's seemingly detailed images are made up of only three layers. Much of his complex and beautifully fluid water—as seen in the image opposite—is realized with only a first layer of vertical washes crossed by a second of horizontal strokes. There will, of course, be some subjects that refuse to resolve into a simple series of layers. However, as a general approach to simplifying your painting process it is an effective place to start.

TOM HOFFMANN, *PINCELADA*, 2010
WATERCOLOR ON ARCHES HOT PRESS PAPER
15 × 22 INCHES (38 × 56 CM)

The complexity of the foreground in this view from the roof seemed likely to get me bogged down in specifics. I let go of accuracy in favor of an interpretation based on generalization.

JOHN SINGER SARGENT, *WHITE SHIPS*, 1908
WATERCOLOR ON PAPER
$13^{7}/_{8} \times 19^{3}/_{8}$ INCHES (35 × 49 CM)
COLLECTION OF THE BROOKLYN MUSEUM

What appears at first to be dazzling brushwork turns out to be the result
of remarkable awareness. Sargent knew that two simple layers would
be enough to realize the complexity of the water in the harbor. There is
nothing especially difficult about the execution of either the washes or
the strokes. The real accomplishment was his vision.

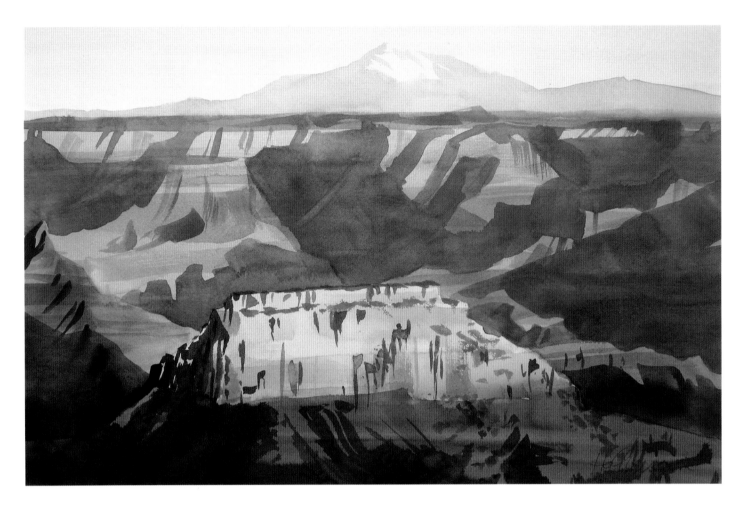

IDENTIFYING INDIVIDUAL LAYERS

TOM HOFFMANN, *SEDIMENTARY*, 2010
WATERCOLOR ON ARCHES COLD PRESS PAPER
15 × 22 INCHES (38 × 56 CM)

To see the first layer as it underlies the later, darker, and more specific ones, it is necessary to look past the darks and mid-values. This is a kind of selective vision that takes practice. Before you begin painting, ask yourself: *What will the individual layers look like?* To rehearse, look at the examples on the following pages and try to see through the darks and mid-values to the first layer that lies beneath.

For instance, with *Sedimentary*, above, the entire middle ground started out as a light orange wash, illustrated opposite. As a second layer, a pattern of slightly darker horizontal orange stripes was applied, then the darker blue shadows were laid on top of those. The butte in the foreground similarly involved three layers that progressed from light to dark.

To avoid getting painted into a corner, watercolor painters need to develop the skill of seeing a couple of layers ahead of themselves. I often feel a sense of despair after one or two layers have been applied. As with the image opposite, at this stage the painting often looks completely hopeless. I want to go out and

Each of the major shapes in this painting has only two or three layers. In the topmost shape, layer 1 was a pale violet rectangle. The purple wash of the mountain was the second layer. That's all there is. Does the snowy part of the mountain look lighter to you? This is partly because it is surrounded by a darker value, and partly because calling it "snow" creates the expectation of whiteness.

get a real job. Do not give up on a picture until you have put in the darkest darks! It may, in fact, turn out to be a failure, but you cannot be sure if those powerful darks are not there yet. By now, I have seen enough paintings raised from the dead to be a believer.

Look at James Michael's inviting scene, *Winter Dunes*, on page 78. If you could peel back each layer of paint, as though they were overlays in a biology textbook, you could re-create the progress of the painting in reverse. To see this progression before the painting was started, the artist had to be able to mentally suspend all of the successively darker layers while he painted the lightest one.

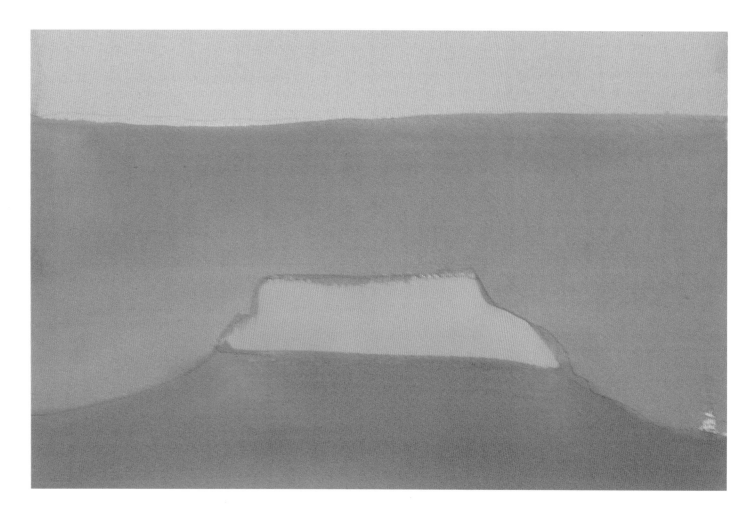

Deliberately ignoring the layers that come later is easier if you have a good sense of what they look like on their own. To see right through the darks, for example, it helps to be able to recognize them as a pattern apart from the lighter forms. Try picturing the darkest darks from the photo on page 78 as a separate image. It helps to squint.

Once you've visualized the darkest darks in the color photo, check the image in your mind's eye against the image on page 79. Without the light and mid-value forms, the darkest layer would look like this. Are there any surprises? If the layers of the original photograph were printed on transparencies, this layer, the darkest darks, could literally be peeled back to reveal the middle values and lights beneath. Instead, when we look at the photo or the actual scene, we do the peeling mentally.

When the major shapes were blocked in with just their lightest overall washes, the canyon scene looked something like this—flat shapes awaiting texture and shadows. At this stage it takes faith to believe that the layers to come will provide the illusion of light and substance and space.

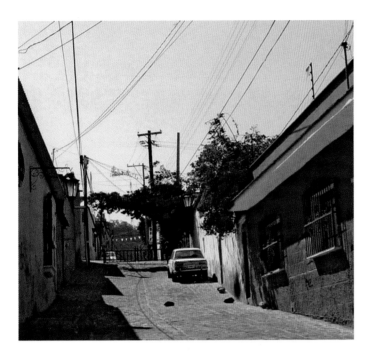

Identify the darkest darks.

Staring at the top of this photograph of Callejón, Oaxaca, the wires would all be part of the darkest layer, along with the vertical poles, the eaves and windows of the buildings on the left, the cast shadows of those buildings, the underside of the purple bougainvillea . . . What else?

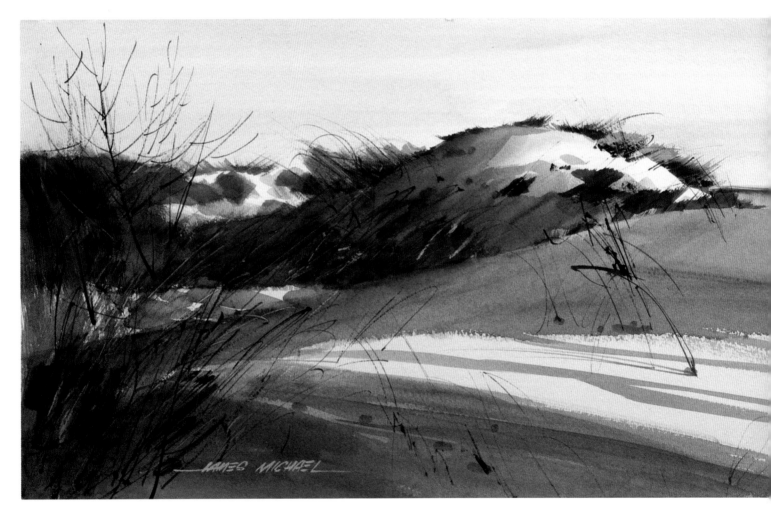

Visualize the darkest darks in isolation.
Exaggerating the contrast of the photograph of Callejón, Oaxaca, isolates the darkest darks. When subtle values are rounded up or down only black and white remain.

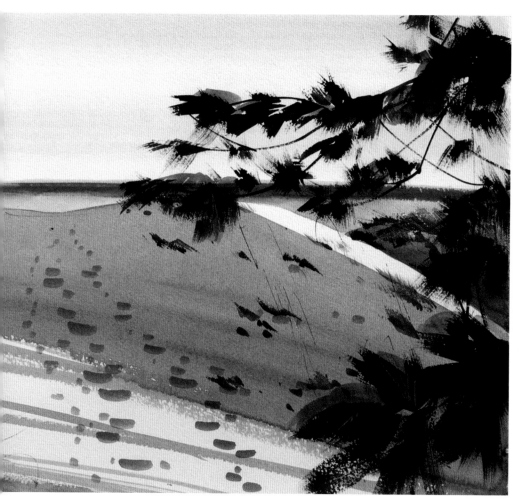

JAMES MICHAEL, *WINTER DUNES*, 2008
WATERCOLOR ON PAPER
22 × 48 INCHES (56 × 122 CM)

Working backward, imagine the scene without the darkest darks (the conifer), then with the medium darks removed (beach grass in shadow), then the dark mid-values (footprints), and finally the lighter mid-values (sunlit grass and cast shadows on snow), until nothing is left but white paper.

Apply the light and mid-values.

I have deliberately painted "outside the lines" to see if it's true that the darks have enough narrative clarity to make sense of this mess. If it works, it means that when I'm laying down the first two layers, I need not be distracted by detail, and all of my attention can be devoted to simply making gorgeous, juicy paint.

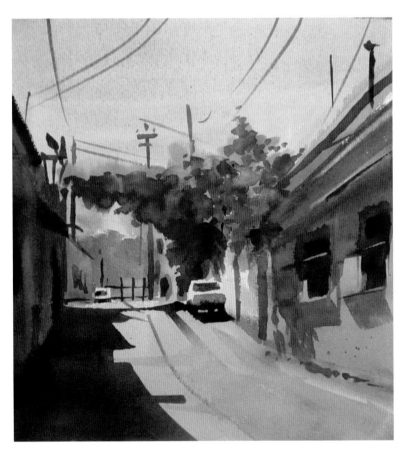

Apply the darks, carefully.

This is a good example of the benefit of asking: *What needs to be true in the finished painting?* Being a little careful with the darks allowed me to be carefree with everything else.

TOM HOFFMANN, *Callejón, Oaxaca,* 2011
WATERCOLOR ON ARCHES COLD PRESS PAPER
11 × 11 INCHES (28 × 28 CM)

EVALUATING THE LAYERS

How much care does each layer require? With a high-contrast image like *Callejón, Oaxaca,* when we see the darks separated from the other values, it is clear that they do most of the work of establishing the illusion of reality. The cast shadows reveal the strong light, while the obvious perspective of the buildings defines a clear feeling of space. Recognizing this early on can be truly liberating. If we can depend on the darks to pull the whole picture together, the lights and mid-values can be applied very casually.

Alas, we cannot always depend on the darkest darks to pull our paintings together. Some images are chosen specifically for the subtlety of the light- and mid-value forms, and the darks cannot be counted on to make the picture cohere. Others seem so complicated we cannot easily discern the role the darks will play. In these cases, it may be necessary to begin taking care earlier in the progression of layers.

Recognizing in advance the point at which shapes need to be defined can be tricky. Get in the habit of assessing the effectiveness of the illusions you seek as the painting develops, layer by layer. Eventually, you will know before the painting begins what role the lights, mid-values, and darks play in creating a feeling of space or light or substance, and this will inform the degree of care you take at each stage. Looking back at the images at left will make this point obvious.

Above:

TOM HOFFMANN, *Homestead*, 2009
WATERCOLOR ON ARCHES COLD PRESS PAPER
12 × 19 INCHES (30 × 48 CM)

In this scene subtle texture and color play a bigger role than in *Callejón, Oaxaca*. The middle values and the lights tell more of the story than the darkest darks. Consequently, more care must be taken in the first layers. Some of the edges between shapes need to be established right away, rather than waiting till the darks go down.

Right:

This detail of *Homestead* shows where roof, tree, and background come together. Notice that there are no bold darks to define the separate shapes. The final form of each had to be established with the very first layer.

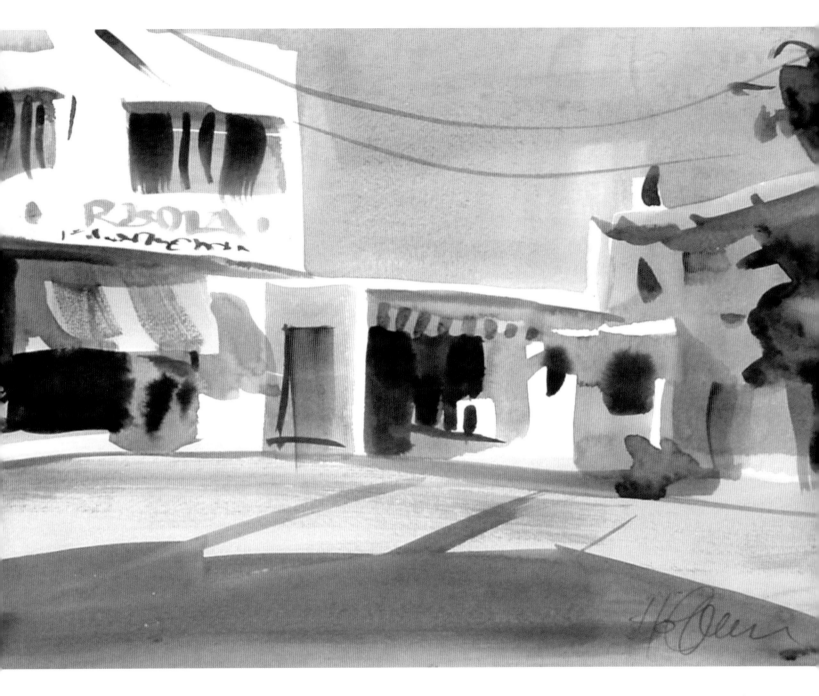

TOM HOFFMANN, *IR DE COMPRAS*, 2008
WATERCOLOR ON ARCHES HOT PRESS PAPER
11 × 15 INCHES (28 × 38 CM)

Most of this sketch was made with two layers. As casual as it is, there is still some sense of light, space, and substance. Can you picture the first layer by itself? At which stage did the illusion of light appear? How about space?

Looking at images and scenes as potential paintings is partly a process of remembering, in terms of form, what has worked before. We each develop a repertoire of successes that informs the choices we make and encourages us to keep expanding our range. For example, enough experience seeing the role the darks play in creating a sense of substance gives us the confidence to take on a new subject. We acquire the faith that what worked in a sunlit street scene in Manhattan will also work in a slot canyon in southern Utah.

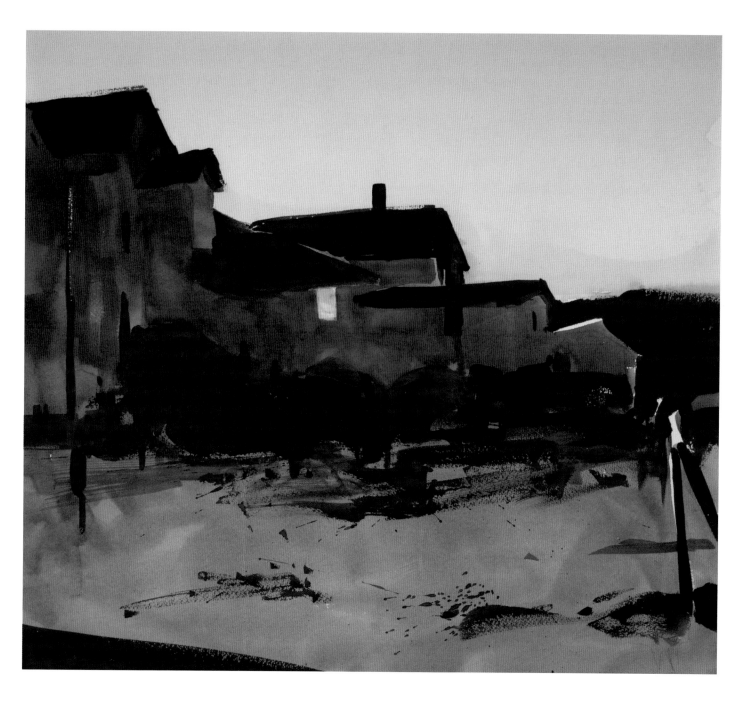

BILL TEITSWORTH, *LAST OF THE LIGHT*, 2010
WATERCOLOR ON ARCHES PAPER
22 × 28 INCHES (56 × 71 CM)

This study is basically a three-value treatment of a particular quality of light, in which each value is its own layer. Which layer provides the space and substance? Which provides the light?

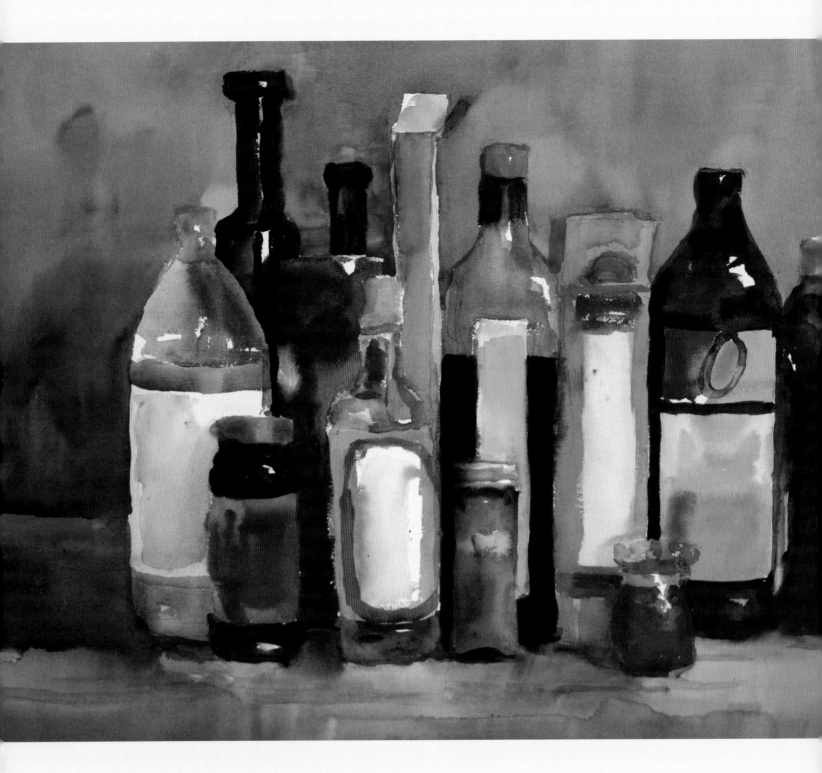

SALLY CATALDO, *UNTITLED STILL LIFE*, 2009
WATERCOLOR ON PAPER
22 × 30 (56 × 76 CM)

The highlights have been reserved, the darks are dark enough, and the
value range is appropriately wide. Attention has been paid to accuracy
of value, leaving the way clear to be relaxed about drawing. The result is
lighthearted, yet perfectly solid.

~ CHAPTER FOUR ~

UNDERSTANDING VALUE

Of all the variables we employ as painters, value is the hardest worker. We can be very loose and casual with our drawing; we can allow the edges of separate shapes to blur and merge; we can be personally expressive, or even downright psychedelic, with color. As long as the relative values are reasonably true, we can still produce a believable sense of light, space, and substance. This is why, at the beginning of the process, it is important to ask: *What role does value play in this picture?*

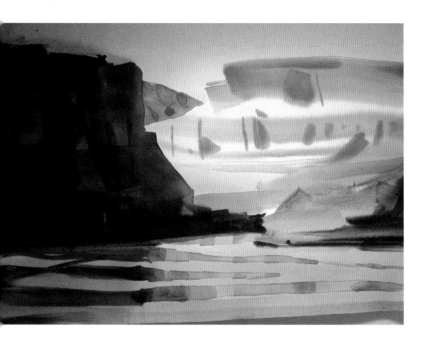

Understanding the role value plays in the scene is always a good place for an artist to start. I'd go further, and say that it is an *essential* first step for most watercolor paintings. In some pictures, value plays a less obvious part in describing the narrative content. This does not necessarily mean that the relative darks and lights do not need to be represented carefully. On the contrary, paying attention to values may be more important in a subtle scene than one with a bold pattern of dark and light.

The transparency of watercolor creates the need for us to make decisions about value at the very beginning of the painting process. Once we commit to a value for a given shape, it is awkward, if not impossible, to make it lighter. To help sort out the relative darkness of each major shape in the scene, there are a number of questions to keep in mind. We will visit these in turn on the pages that follow. As usual, the answers to the questions are often quite obvious. The tricky part is remembering to ask them.

TOM HOFFMANN, MONOCHROME
STUDY FOR *ON THE GREEN*, 2010
WATERCOLOR ON ARCHES HOT PRESS PAPER
11 × 15 INCHES (28 × 38 CM)

As long as the values are correct . . .

TOM HOFFMANN,
ON THE GREEN, 2010
WATERCOLOR ON ARCHES
HOT PRESS PAPER
11 × 15 INCHES (28 × 38 CM)

. . . color can be exaggerated. I wanted to transmit the feeling of powerful energy in Canyonlands National Park by pushing the color to an extreme. Holding on to fairly accurate values allowed me to do so without losing the illusion of light and space.

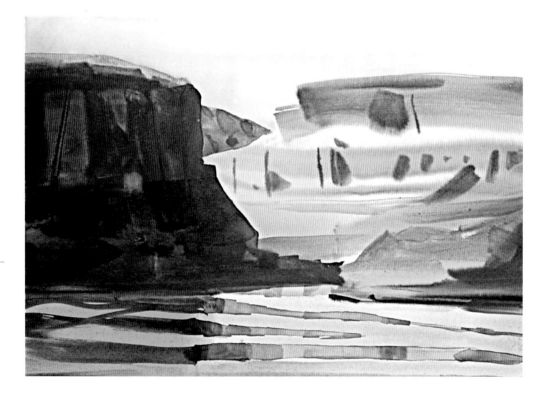

Left:

LARS LERIN, *NOVEMBER*, 1996
WATERCOLOR ON PAPER
27½ × 39⅜ INCHES (70 × 100 CM)

In this painting Lars Lerin established the widest possible range of values by making the sky and dark parts of the building as dark as possible and leaving the doorway pure white. The spotlit section of the wall had to fall somewhere in between. It could have been a little darker or a little lighter, and the painting would still have great power.

Below:

LARS LERIN, *POLAR TOURISTS*, 2007
WATERCOLOR ON PAPER
41⅜ × 59⅞ INCHES (105 × 152 CM)

In this painting, on the other hand, the choices that will support the illusion of white ice and snow exist in a much narrower range. There is very little pure white paper left on the page, but the artist's subtle hand and eye create the feeling that everything on the ground is white.

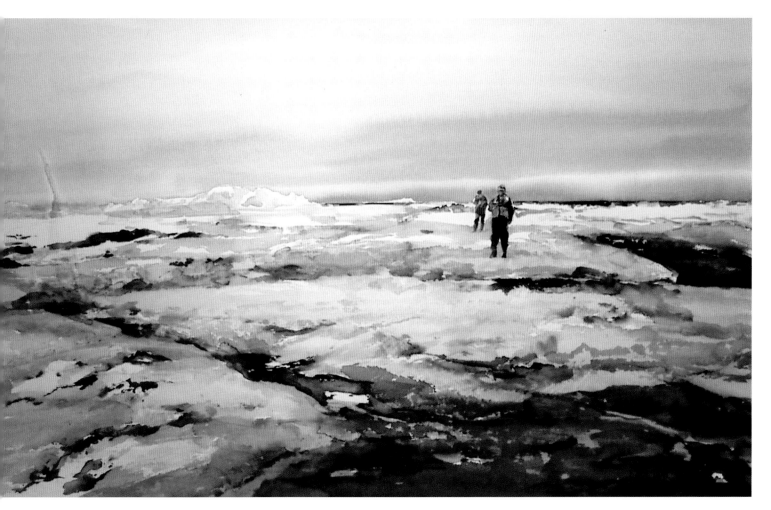

IDENTIFYING THE LIGHTEST PART OF THE PICTURE

My classroom, in Seattle, is lit by overhead fluorescent tubes and a bank of windows along the north side. The walls and ceiling of the room are painted white. If you were making a painting of the room, it would be easy to assume that the walls should be left the white of the paper. White walls/white paper, no problem. But the windows, which often have a cool, bluish cast, are much brighter than the walls, and the warm, yellow fluorescent lights are even lighter than the windows. If you left the walls white, how would you get the windows and lamps to appear lighter? This conundrum is why it is especially important to ask yourself, right from the beginning: *What is the lightest part of the picture?*

The problem in this case lies in the assumption that the walls are white. For watercolor purposes, they are *not* white. If you were actually painting the walls, and not a picture of them, it is true that you would be dipping into a big can of white paint. This is the source of the confusion. Your brain is telling you the walls are white, but your eye knows that they are not the lightest shapes in the picture.

In a watercolor, you cannot get any lighter than the white of the paper. It makes sense to reserve it for the lightest part of the scene, and darken everything else relative to that. If, as is the case in this hypothetical painting, the lightest parts were yellow and blue, you would probably want to apply a faint glaze of color over the white, which would darken it a little. This shifts the value scale for the entire painting. The walls must be made dark enough to make the fluorescent lights seem bright by comparison, but not so dark that they do not seem white, and so on, all the way up the scale to the darkest darks. How dark we make a shape in a watercolor is always a *relative* matter.

What we "know" is firmly rooted in the language of meaning.

Take a close look at the outbuildings in this photograph. Which is darker—the sunlit part of the "gray" barn, or the shadowed part of the "white" building? What we call something can create conflict between the brain and the eye.

Seeing the two surfaces as shapes rather than buildings eliminates any confusion about their relative values. It also helps to squint.

Saying the words "old gray barn" calls forth a host of associations, somewhat different for each of us, but always evocative and persuasive. Our ideas about a subject can profoundly affect what we think we see. In the early stages of making a painting, I like to direct my questions to the abstract qualities of the image, to keep from being misled by meaning. There is plenty of time to check in later to make sure the story is being told, but for now, I want the simple, visual reality. When we are assessing value, it helps to use the language of pure form. It can be very difficult at first to ignore your insistent brain, but after a while it begins to feel like a vacation.

TOM HUGHES, *LOW TIDE, STONINGTON, 2005*
WATERCOLOR ON PAPER
22 × 30 INCHES (56 × 76 CM)

Even though the light on the rocks in the foreground has not been left white, it appears brighter than the "white" boathouse. Proximity to much darker shapes makes the sunlit, upward-facing rock surfaces seem relatively brilliant. What do you think: Is the boathouse pure white paper?

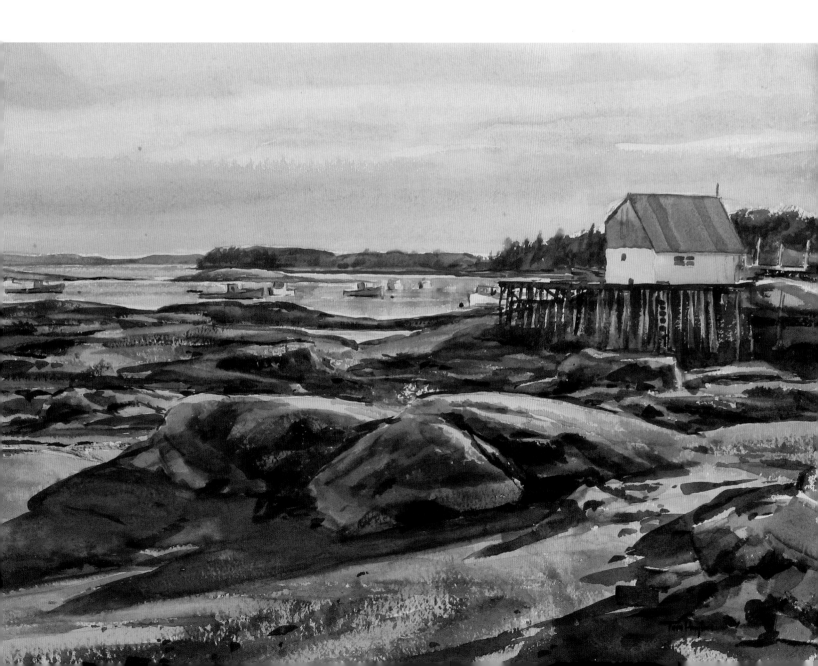

RESERVING THE WHITES

Let's take a moment to talk about the white paper. With a transparent medium, light passes through the paint and bounces off the paper, back to the viewer's eyes. As the source of light in a watercolor, therefore, the paper is very important, but it is not *sacred*. I definitely prefer paintings that allow the paper to remain visible through the paint, but this does not necessarily mean that pure white paper must be reserved. If there is nothing white in the picture, then there does not need to be any white paper.

Students have told me they were taught that "If it doesn't show some white paper, it's not a watercolor." Excuse me, but this is nonsense. Teachers tend to make proclamations, and some people take them as gospel. The words get passed along and rewritten a bit each time. I once overheard a student say, "Tom says that no one should ever take a drawing class." Yikes! I wonder what else has been attributed to me over the years.

I think it's actually a bigger problem to leave too much white than not enough. Even in a scene with large light areas, saving the white paper for where it is really needed can increase the illusion of convincing light.

It is unfortunately quite common to leave a little gap of white paper between shapes, partly as a dam to keep washes from merging, and partly just to produce some kind of sparkle. The result is usually a flattening of the space. Since all the shapes are surrounded by little hard-edged halos, they all have equal prominence. The painting looks like a collage of cut and pasted components, or a mosaic, with white grout lines between the tiles. With so many gratuitous whites, the few that are trying to represent important lights cannot stand out.

In *Craigville Phantom* on page 92, the relatively small whites are no bigger than the "halos" in the orchard scene below, but they are there to fill a pictorial need.

There is no right way to paint, but there is a best way to learn: the way that gives you the most options.

ANONYMOUS (SORT OF), *CHANNEL ROAD ORCHARD MOSAIC STYLE*, 2011
WATERCOLOR ON ARCHES COLD PRESS PAPER
11 × 15 INCHES (28 × 38 CM)

Even though our brains know where the elements of the scene are relative to each other, our eyes are getting a different message. The mosaic quality of the painting creates the sense that each shape is in the same plane as its neighbors. Please tell me you *don't* like this painting.

TOM HOFFMANN, *CHANNEL ROAD ORCHARD*, 2010
WATERCOLOR ON ARCHES COLD PRESS PAPER
11 × 15 INCHES (28 × 38 CM)

Allowing adjacent shapes to touch contributes to the feeling of
space. It seems possible to walk around the trees without bumping
into white lines.

TOM HOFFMANN, *CRAIGVILLE PHANTOM*, 2010
WATERCOLOR ON ARCHES COLD PRESS PAPER
14 × 20 INCHES (36 × 51 CM)

The slivers of white on the right-facing surfaces of the fence do much of
the work of describing the sunlight.

All this discussion hopefully underscores why it is so important that you ask: *Are there whites to reserve?* If you have decided to save some white paper, it remains for you to choose the appropriate technique. Please don't automatically reach for the masking fluid every time you want to save part of the previous layer. That stuff makes a very distinctive kind of highlight—one that can be spotted from across the room. It may be just right for the window reflected on an eggplant, but it would be all wrong for the highlight on a pear.

When it comes to reserving lights, you have several options, and each produces a somewhat different look. Practice and become confident with lifting, scraping, masking, applying wax resist, and, most of all, simply painting around your lights. As your familiarity with the range of possibilities grows, you will be able to decide which one is right for the job, rather than always choosing the same technique by default. You may think masking fluid is easier than painting around the light area, but in fact it takes much longer, interrupts the flow of painting, and creates a calculated look.

Generally, I prefer creating lights by simply leaving them. I can pre-wet the area if I want a soft edge, or leave it dry for a hard edge, but in either case, I put the paint where I want it and leave it alone. For me, the default approach to reserving lights comes down to this: If you don't want paint somewhere, don't put it there.

Right now, someone somewhere is probably saying, "Tom says never use masking fluid." It is true that I don't use it, but you should do whatever works best for your painting. There is no right way to paint, but there is a best way to learn: the way that gives you the most options. So, by all means, mask away, when it is appropriate. Just don't become a junkie.

And one more small rant: Do not paint with a brush in one hand and a paper towel in the other. How confident will your stroke be if you are already thinking about removing it? If you are unsure of the mark you are about to make, you have more awareness work to do. Where's your practice paper? Remember, the goal is to actually *become* a better painter, not to *appear* to be one.

Reserving Non-White Elements

For every new layer you apply, some of the previous layer probably needs to be reserved. Locating these relative lights by drawing with pencil or pale paint makes it easier to apply the new layer with confidence. It is truly amazing how easy it is to paint right over a highlight ten seconds after saying out loud, "I don't want to cover that highlight." It is almost enough to make me go for the masking fluid.

Knowing what needs to be reserved from the previous layer and remembering to do it are skills that come partly from practice and partly from taking responsibility. The benefits of practice take time to be seen, of course, but being in charge produces results immediately.

The language of watercolor requires a way of thinking that eventually becomes second nature. Meanwhile, timing is everything. Remember to ask: *What needs to be reserved?* And make sure to ask it *before* the next layer is applied, as this establishes good habits and eliminates the need for the paper towel and the scrubby.

Identifying the Darkest Part of the Picture

Although the darkest darks usually go on last, it is a good idea to identify them early in the process of getting to know your subject. Make sure to ask yourself: *What is the darkest part of the picture?* Seeing the full value range gives you a basis for comparison when you are learning where on the relative scale each element of the picture should be placed.

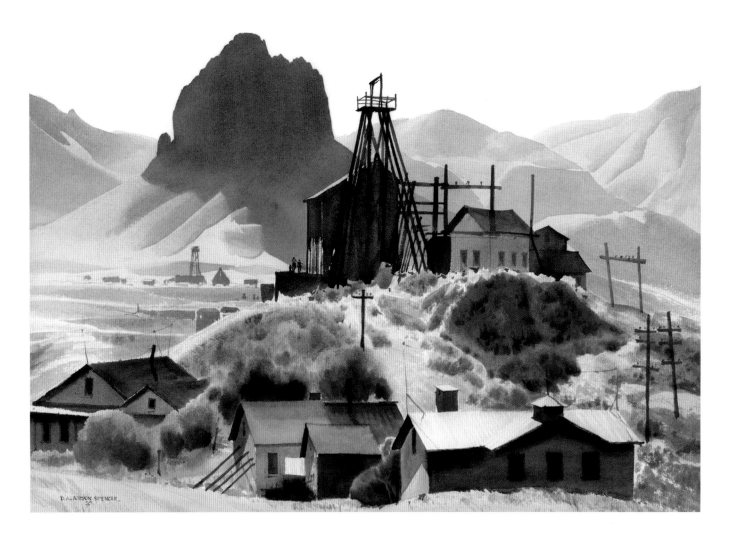

D. ALANSON SPENCER, *OATMAN, ARIZONA,* DATE UNKNOWN
WATERCOLOR ON PAPER
22 × 30 INCHES (56 × 76 CM)

The butte in the background has enormous presence, even though it has been simply stated. Had it been lighter, it would not loom over the valley, but had it been darker, we would not feel the space between it and the mine buildings. Spencer seemed to know that the value of the butte had to be about halfway between the lightest and the darkest parts of the scene. Could it be he just got lucky? The slim white roof of the tallest building suggests otherwise.

In *Oatman, Arizona,* shown above, D. Alanson Spencer makes decisions about the value he assigns to each shape according to its ideal location in the range between the lightest and darkest parts of the image. To take full advantage of the role value plays in establishing a convincing illusion of light and space, it was important for him to identify the lightest light and the darkest dark right at the start.

It is possible to study the value range and dark/light balance without having to first paint the picture. The various forms of sketches and studies discussed in chapter 2 quickly reveal the relationships and the roles of the darks and lights. On page 95 is another exercise that can help increase your sensitivity to value.

At the same time, it provides some insight into how to simplify the infinitely subtle range of value that is often present. By exploring which elements of a complex subject are essential and which are optional, you can discover where you must be attentive and where you can be casual. I use a colored-glass cup, but a shiny metal pot or a burnt-out light bulb would also work well.

Although the three-value study has none of the subtle tones of the real cup, it still looks like glass. This suggests that the many middle-value shapes are not essential to the illusion. When I stare at the cup and move from side to side and up and down, the subtle shapes change size and location dramatically. In any position, however, the cup still looks exactly like a glass cup. How

Evaluate the subject.

The blue glass cup displays a broad range of values—bright highlights, deep dark accents, and a host of subtle middle values. How accurately must these be duplicated?

Create a middle-value study.

Using a single middle value, make a simple silhouette of the cup. Try using a big brush, and *painting* the shape, rather than drawing an outline and coloring it in. Let go of accuracy of drawing—it will help you pay more attention to value. An assessment of the study shows that without a range of values there is no substance to the cup, and it is certainly not yet made of glass.

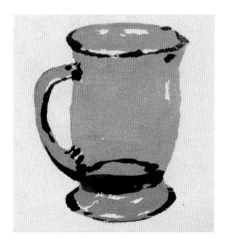

Create a middle-value study, with highlights.

Make another version of the cup, this time reserving the lightest lights. Paint the whole shape a middle value, except for the parts you determine are closer to white. Squinting helps round down to white or up to middle. Saving lights adds noticeable substance to the shape and begins to suggest that it is shiny, if not quite translucent.

Add the darkest darks.

When the new version is dry, add the areas that are closer to black than a middle value. With only three values, the cup now appears to be made of glass. Apparently, the darkest darks and lightest lights are doing the majority of the work.

critical can it be, then, to get those delicate values in just the right places? Moving and looking again, I see that the lights and darks stay in roughly the same spots.

The mid-value shapes seem to be a function of the cup's surroundings, which are subject to change when the point of view

shifts. The lights and darks act more like features of the cup itself. I suspect that the mid-value shapes can be almost arbitrarily located, while the highlights and the darkest darks occur where they do for a reason. When it comes to revealing the nature of the object, one is essential, the other optional.

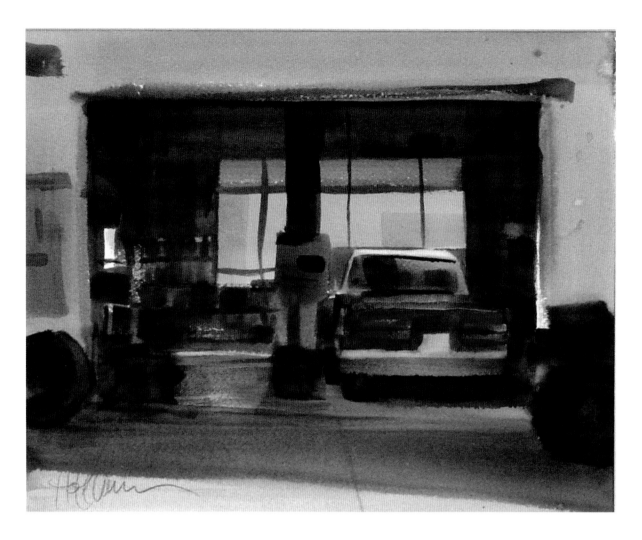

TOM HOFFMANN, *UNCHAINED*, 2009
WATERCOLOR ON ARCHES COLD PRESS PAPER
11 × 15 INCHES (28 × 38 CM)

Looking at the nearby shapes, it is clear that the strip of purple that goes up the sides and across the top of the picture needed to be lighter than the main brown rectangle but darker than the light triangle in the foreground. That range leaves room for refinement. The purple strip could probably have been a little darker or a little lighter and still have been seen as a white wall in shadow.

BRACKETING THE VALUES

How dark is the part I'm about to paint? This is the essential value question, because it invites the artist to consider the *relative* dark or lightness of every element of the picture. And the answer is always the same: *Compared to what?*

I like to look for nearby shapes that establish the value range within which the new shape will work. I want to find something that is darker than what I am about to add and something that is lighter. Basically, I want to know how each element will fit in the overall continuum of values. This will not tell me the precise value

that will do the job best, but it gets me in the ballpark. Then I can usually tell whether I would like it a little lighter or darker.

It can be tricky to remember to think about value when most of your attention is on another variable, especially when the other variable is color. Developing the habit of *bracketing,* or locating each new part of the picture in its place on the range of values, keeps the distractions from causing you to lose track of what you have deemed essential. Do whatever it takes to remember to locate each part of the painting on the range of values. It should be the last thing you think of before your brush touches the paper.

Above:

DON MAREK, *TRUCK STOP*, 2010
WATERCOLOR ON PAPER
21 × 28 INCHES (53 × 71 CM)

While this may appear to be a painting all about intense, saturated color, it is attention to value relationships that quietly makes it possible for the artist to have some fun with color.

Right:

This is the solid foundation upon which Marek's playful interpretation is built. He remembered to ask if the values were correct, even as he turned up the intensity of the colors.

KNOWING HOW DARK YOU CAN GO

When it comes to value, watercolor painters work under a strict budget. We have seen how the white paper represents the limit of lightness in the range of values that are available. There are limits at the other end of the scale that must also be considered. Any color can be made extremely light, of course, but not every color can get dark enough to traverse the full value scale. If you know the limits of the colors you are using, you can adjust your values so that the darkest dark will look dark enough. As you begin to approach the limit, remember to ask: *How dark can I afford to make this?* Cerulean blue, for example, is inherently lighter than ultramarine, which, in turn, will not get as dark as indanthrene blue. This means you may reach the limit of how dark a particular color can get before you have made the darkest darks.

When this happens, you still have options. First, make sure you have enough pigment in your mix. Often a dark is not dark enough simply because it has too much water. When you need a good, rich dark, do not be afraid to mix up some thick paint, especially if you will be applying it to wet paper. You will know when it is too thick if it still looks shiny after it has dried. (This is a job for the practice paper.) If you have made the paint as thick as you dare and it still is not dark enough, you need different colors. Chapter 6 covers the practicalities of color choice more fully, but in general, the transparent colors make deeper darks than the opaques.

Try this experiment: Start with a relatively opaque red, yellow, and blue, such as cadmium red, hansa yellow, and cerulean blue. Mix them together to make the darkest dark you can. Use plenty of pigment in the mix, making a dense, saturated brushful, and paint a stroke on a scrap of paper.

Now use very transparent primaries, like alizarine crimson, quinacridone gold, and pthalo blue, and once again make the darkest dark you can mix. Don't be shy. Try to get as close to "too thick" as you can. Make a stroke of this color next to the first one, and compare.

When your picture requires a broad range of darks, it is wise to consider which pigments you choose very early in the painting process. This is yet another example of the benefits of seeing a couple of layers ahead of yourself. Look, for example, at the photograph opposite. If you make your brown doors dark enough to stand out against the walls, can you still make the openings that much darker? It would be sad to reach the moment, late in the painting process, when you are ready for the openings, and then discover that you can't make them dark enough. Cultivate the habit of exploring the value range your chosen palette can provide *before* committing to those colors.

So far, emphasis has been placed on what to determine *before* you attempt a proper painting of a new subject. There are also skills you can develop that will help you evaluate the paintings when you finish them. These, too, are guided by questions that focus your attention on one thing at a time. In many cases, they are the same questions you would ask before painting, but turned inside out. For example, regarding value, it would be wise to ask "Have I reserved the lights?" instead of "What needs to be reserved?" If you have a place where you can prop up a half-dozen of your paintings and stand back, asking these questions will help you zero in on what is working well and where you need practice.

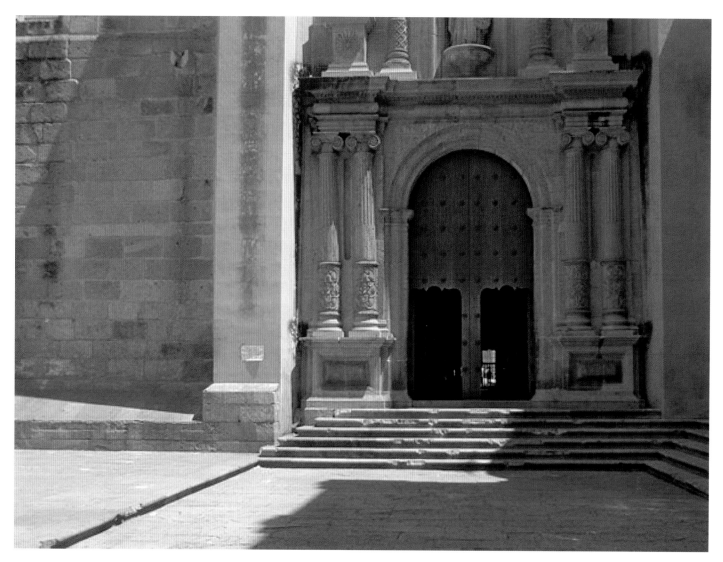

From this photograph of the west end of El Catedral Municipal in Oaxaca, Mexico, it is clear that the large brown doors that fill the archway need to be significantly darker than the stone walls that surround them, but much lighter than the openings at the bottom of the arch. When mixing the color for the doors, it is not enough just to *see* the range it falls in. You also have make it happen.

CRITIQUING THE DARKS

Having observed the progress of many watercolor students over the years, I can make a few informed generalizations about the limits we put on our own range. Most common of all is the tendency to stop short of the deep, rich darks the image may require. This is why it is especially important to ask late in the painting process: *Are the darks dark enough?*

Of course, certain technical concerns can affect how dark the paint can be, but these can usually be solved with a piece of practice paper and a spirit of inquiry. The trickiest issues seem to have more to do with psychology than technique. For example, all watercolor paint dries lighter than it appears when it is wet. This is always true. You knew it the first week you started painting, right? There comes a point after which it is just plain silly to use this as a reason for not getting dark enough darks. You've got practice paper. Do the work, and make sure. *You* are the one who is in charge of your paintings.

As mentioned above, some colors will prevent a mixture from becoming dark enough. Those openings in the doors of El Catedral Municipal on page 99 are seriously dark, but there is still some discernible warmth in the color. Turning up the yellow in your mix would provide warmth, but most true yellows are relatively opaque and limit the depth of the dark. Choosing a strong, transparent warm, like quinacridone gold, will provide the necessary heat without lowering the value of the dark.

Neither of these technical realities is too difficult to overcome, but something more challenging sometimes stands in the way. A large part of the potential range of values is not being used because we are afraid of getting *too* dark. Considering how many watercolors suffer from being too *light*, that's what we really should be wary of. I have seen many times more paintings where the darks are too light rather than too dark.

Whenever I discover a self-imposed limitation, I want to cross that border right away. As a teacher, it is my job to nudge students out of their comfort zones. Go explore the territory you have been avoiding. If you see that your work consistently stops short of getting dark enough, make a few paintings where the darks are deliberately *too dark*. Once you have seen what "too dark" really looks like, you can take a half step back, knowing that you now have access to the full range of values. I like the metaphor of the race car driver who has taken the turn too fast. He is the one who knows exactly how fast he can safely go. (Okay, he *did* flip his car, but all we have to worry about is a piece of paper.)

TOM HOFFMANN, *NOVEMBER SNOW LOPEZ ISLAND* (IN PROCESS), 2010
WATERCOLOR ON ARCHES COLD
PRESS PAPER
11 × 15 INCHES (28 × 38 CM)

Are the darks dark enough? It was a misty day, but this looks more like fog. Watercolors often suffer from not taking advantage of the full value range. Let's see what it looks like with darker darks . . .

TOM HOFFMANN, *NOVEMBER SNOW, LOPEZ ISLAND*, 2010
WATERCOLOR ON ARCHES COLD PRESS PAPER
11 × 15 INCHES (28 × 38 CM)

That's more like it. Darker darks in the foreground generate much more space in the painting.

Knowing When to Depart from "Accuracy"

As the interpreter of the image, you are the one who decides what the value relationships need to be. What you see is just the starting place. As such, it can be manipulated as much as you see fit. Liberties are yours to take, so make sure to ask yourself: *When should I depart from accuracy?*

Working from a photo, such as the one of MacArdle Bay, shown below, can make the job of fine-tuning variables much easier than painting from life, because with a photo you already have shapes on a page. However, using photographs can also present some challenges. For instance, this scene of McArdle Bay is one I have enjoyed for twenty years, and I am predisposed to see it as flawless. Once it becomes a painting, however, the purely pictorial reality of the image is revealed. It either works as a painting, or it does not. If something feels "not quite right," we need to detach from our prejudices and take stock. Let's examine the photo carefully. What about that skinny strip of tree trunk squeezed against the left side, for example? Is that doing any good at all? And look at the thinnest tree on the right side of the scene. It just happens to end exactly even with the top of the headland. And that big zigzag branch lines up with the same ridgetop. The illusion of depth would be better served if I had crouched down just a bit to take the picture, but I am not a photographer.

Like most of us, when I snap a picture I rely on the wealth of information even a bad photo contains to provide a convincing sense of light and space. It doesn't have to be a great image to be believable. A painting, however, contains only what we put into it. Even though I took the photo, I need to be skeptical of its formal qualities. Considering the arrangement of the dark and light shapes is part of our job as painters; accurately duplicating a photo of the scene is not.

In fact, when painting from life, the scene itself may need to be altered to make a good painting. It can be difficult to give yourself permission to rearrange the natural world. I often see what I should have done only after the painting is finished, and even then only when enough time has elapsed that I no longer remember the reality.

It is tempting to try to explain away problems by saying, "It really looked like that." But the question is not whether a painting looks just like the scene. We need to ask if it works.

Questioning visual reality marks the beginning of personal expression. The earlier in the process we ask the key question— *When should I depart from accuracy?*—the less paper we use. Variable by variable, we benefit from considering how changing the value, color, wetness, and composition will serve our purposes.

Photos rarely depict the true experience of being at the scene, especially in a high-contrast image. If the emphasis is on the subtlety of the lights, like the photo of Mercado Benito Juarez, Oaxaca, shown on page 104, the darks often come out as a solid black shape. While we may accept that in a photo, in a painting it simply would not work. If you were actually present at the scene, there would be plenty of subtle information visible within that big dark shape. In the painting, it will often be necessary to at least suggest the complexity, rather than painting half the picture dead black.

The three major shapes in the background—sky, headland, and water—are nicely varied in value, but they are nearly all the same size. Considering who is in charge, would you change their proportions? More sky or less? What about the distribution of dark verticals in the foreground?

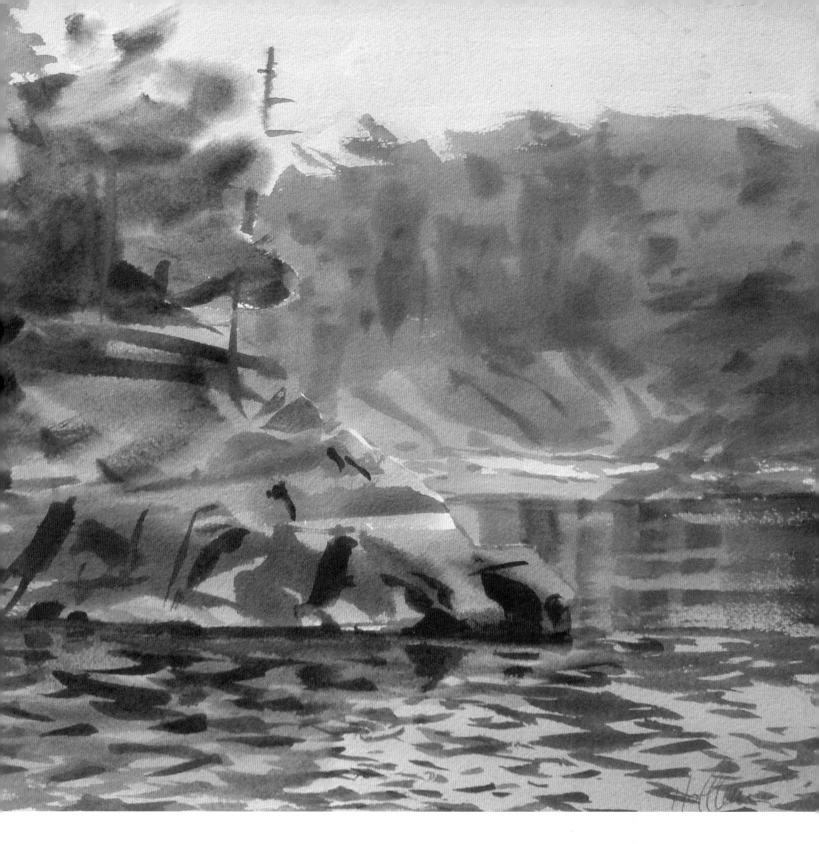

TOM HOFFMANN, *PERCH, 2010*
WATERCOLOR ON ARCHES COLD PRESS PAPER
15 × 15 INCHES (38 × 38 CM)

I have painted this scene more times than any other spot on the planet (there it is, again, on page 109), so I know I want to separate the foreground landmass from the background. On this day, the darks in the distance looked just as dark as those in the foreground, and the driftwood logs on the beach appeared lighter than anything up close. To make the space believable, I lied.

Taking its exposure reading from the light opening in the center, the camera does not show much detail in the foreground darks. As a photo, the image of Mercado Benito Jaurez, Oaxaca, is moody and intriguing, but as a painting those big, empty darks would be too large a percentage of the picture to devote to a lot of nothing.

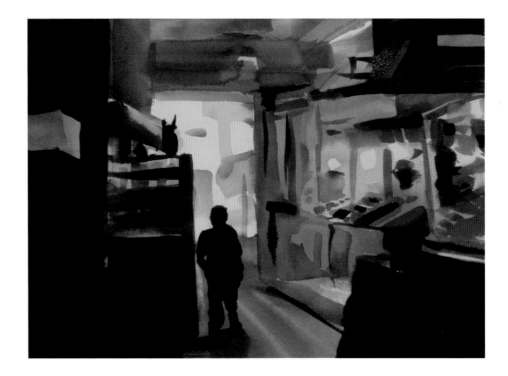

In this version of *Mercado Benito Juarez, Oaxaca,* the empty darks are isolated from the rest of the scene, having nothing in common with the lights and middle values.

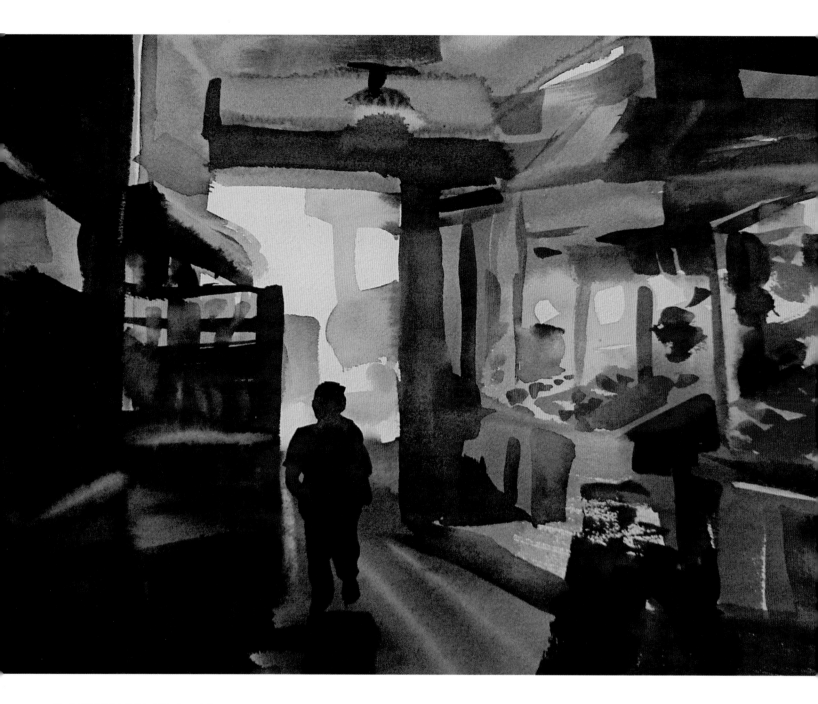

TOM HOFFMANN, *MERCADO BENITO JUAREZ, OAXACA*, 2011
WATERCOLOR ON ARCHES COLD PRESS PAPER
11 × 15 INCHES (28 × 38 CM)

A suggestion of information, even if you can't tell what it is, makes the darks feel like an integral part of the scene.

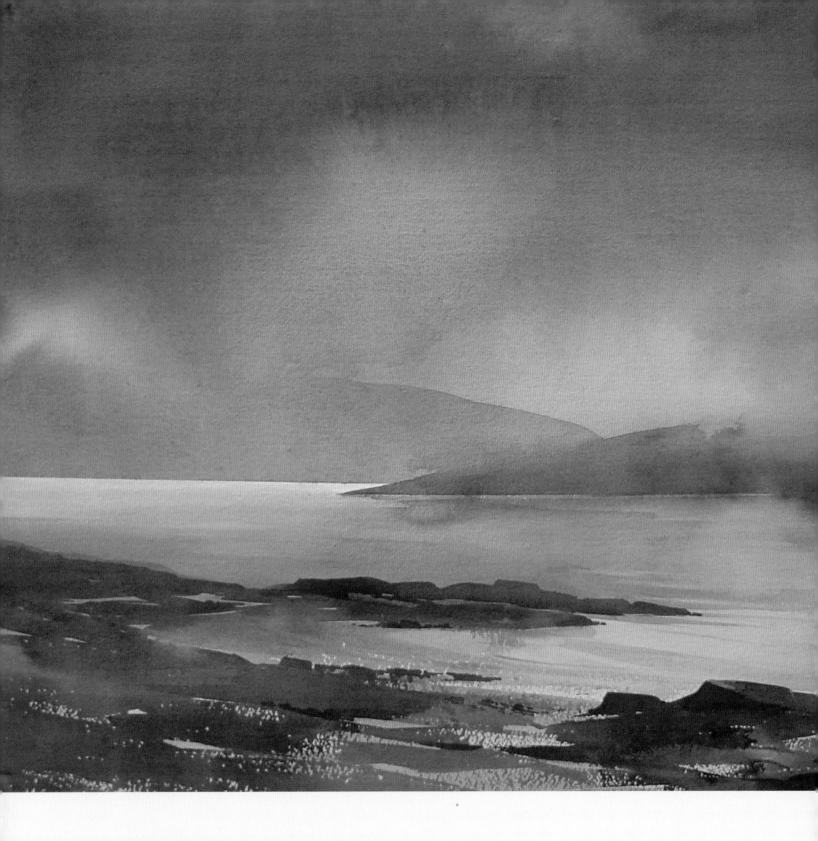

PIET LAP, *SOUND OF SLEAT, SCOTLAND,* 2010
WATERCOLOR ON ARCHES PAPER
22½ × 30 INCHES (57 × 76 CM)

In the sky area of this painting, the artist was able to let the wetness of the paper and gravity do what they would with the paint. He knew that whatever happened would be "perfect enough." When he needed to maintain tighter control of the flow, such as where the most distant hill changes from a hard to a soft edge, he made thoughtful choices about where to wet the paper and where to leave it dry.

~ CHAPTER FIVE ~

SHARING CONTROL OF WETNESS

When watercolors go wrong it is usually for one of two reasons: overworking an area or losing control of wetness. In many cases the former comes about as a result of the latter. The role of the water in watercolor is a slippery subject. Keeping track requires a degree of mindfulness that may at first seem alien to the looseness many painters anticipate from the medium. Ultimately, though, you will discover that a thoughtful approach is what sets you free.

A useful first step toward understanding and controlling wetness is to take responsibility for it. I often hear students explain mistakes by saying, "the brush got too wet" or "the paper got too dry," as if that happened by itself. As long as you continue to blame the paper or the brush, the same mistakes will keep happening. Fate plays no part in the painting process. It is all up to you.

When wet paint meets wet paper it is impossible to tell *exactly* what will happen. The good news is that we don't need precise information. It is enough—in fact, it is best—just to know *approximately* how the paint will behave. Leaving some room for the fluidity of the paint to assert itself is how the characteristic look of spontaneity enters a watercolor. Too much control is just as likely to ruin a painting as too little. Finding a graceful balance requires staying aware of the factors that affect the movement of the paint.

WORKING WITH HARD AND SOFT EDGES

Sometimes the subject matter of what you are about to paint will tell you whether the edges of the form should be hard or soft, but there are no rules about this. Clouds often appear to have soft edges, for example, but you can paint perfectly acceptable clouds with only hard edges. You can search long and hard in most of Edward Hopper's watercolors and never see a soft-edged cloud.

As you paint, ask yourself: *What kind of edge does this form need?* Most often, the focal point of the picture determines how wet the paper and the brush need to be in any given area. Hard edges are assertive and tend to describe distinct forms, while soft edges merge with the field on which they have been applied. For instance, in *Familiar Rock*, opposite, we are encouraged to see the trees on the foreground headland as individual forms, while on the hillside in the background we are meant to see the forest as a whole.

Soft edges tend to describe a subject in *general* terms, while hard edges are usually more *specific*. Consider the role that the particular area you are about to paint is meant to play in the big picture before deciding whether your paper should be wet or dry. Ask yourself: *How much attention do I want the viewer to pay here?*

TOM HOFFMANN,
FAMILIAR ROCK, 2009
WATERCOLOR ON ARCHES COLD
PRESS PAPER
12 × 14 (30 × 36 CM)

The hard edges of the nearer trees are necessary to keep them separate from the more distant hillside. If the painting were made with only hard-edged shapes or all soft edges, the pictorial space would be ambiguous. Choices have been made that deliberately focus the viewer's attention, much as you would focus the lens of a camera.

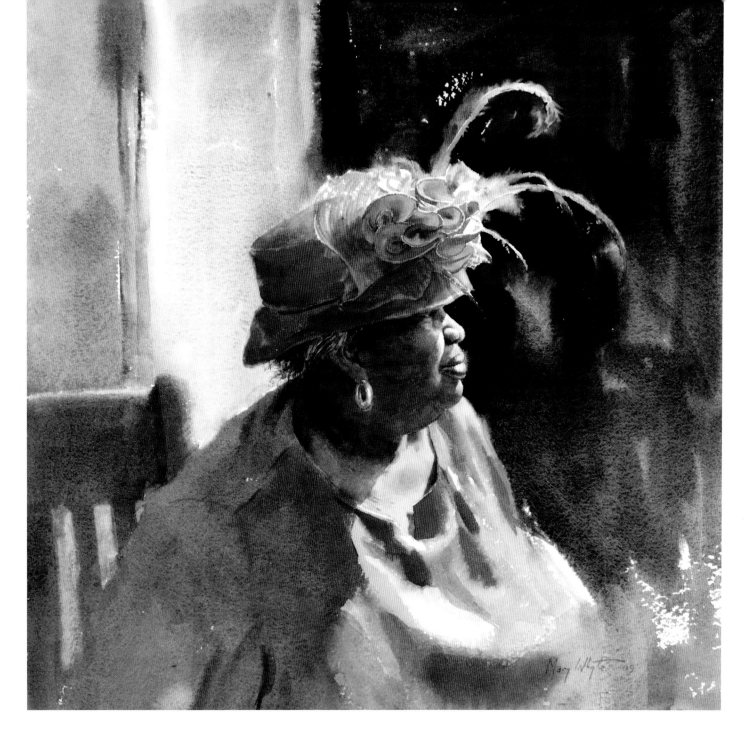

Above:

MARY WHYTE, *RED*, 2011
WATERCOLOR ON PAPER
18½ × 18½ INCHES (47 × 47 CM)

Limiting the hard edges to the face and the hat keeps the viewer's eye from being distracted elsewhere. The job of the background, for example, is simply to set off the figure. Once that is accomplished, nothing more needs to be added.

Opposite:

TOM HOFFMANN, *BABY GRAND BALER*, 2009
WATERCOLOR ON ARCHES COLD PRESS PAPER
11 × 15 INCHES (28 × 38 CM)

Here, the baler is clearly the star of the show. The stacked hay bales play a supporting role, and they would compete for center stage if they were more specific. They are made up of many brushstrokes, but because these are mostly soft-edged marks, it is possible to take in the overall shape as one form without being distracted by too much information.

It is often appropriate to *imply* complexity in a subject rather than to *specify* it. Too much specific information leads to a confusing picture, where the viewer's eye is pulled in several directions at once. If your pictures tend to lack clarity and cohesiveness, consider holding off on the hard edges until you know where you really want them. As a preliminary study, try blocking in the lights and the middle values all wet-on-wet. By the time you're ready for the darks, you will probably have a good basis for deciding where you want to focus attention. See how the picture "reads" if you only make hard edges in that center of interest.

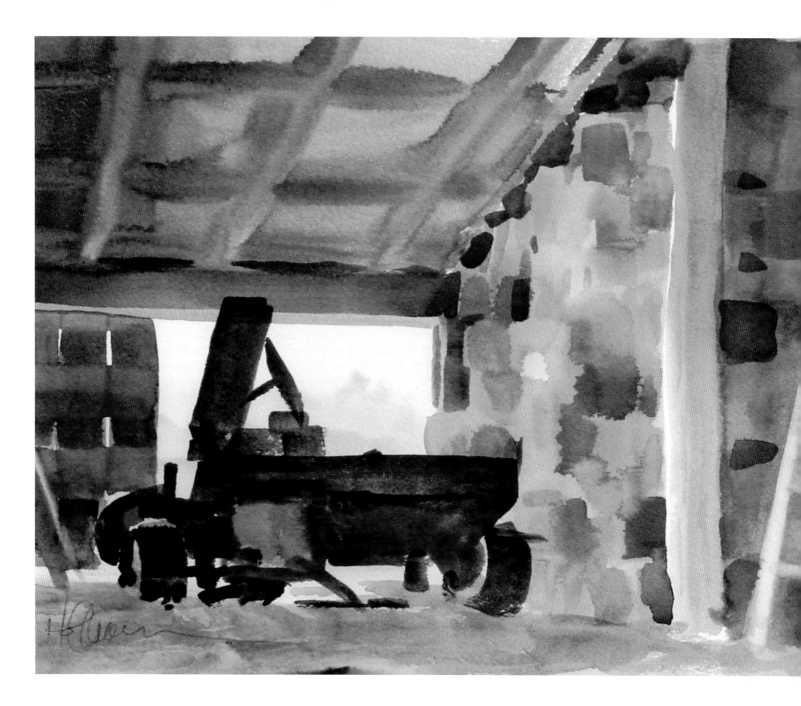

SUZE WOOLF, *SEKIU 3212*, 2010
WATERCOLOR ON GESSO
25 × 19 INCHES (64 × 48 CM)

Knowing what will happen *within an acceptable range* allows the artist to give some of the control back to the paint and paper. In her telephone pole paintings, Suze Woolf juxtaposes carefree and careful brushwork to marvelous advantage. She knew she could let the colors flow together at will on the pole and still achieve an appropriate background.

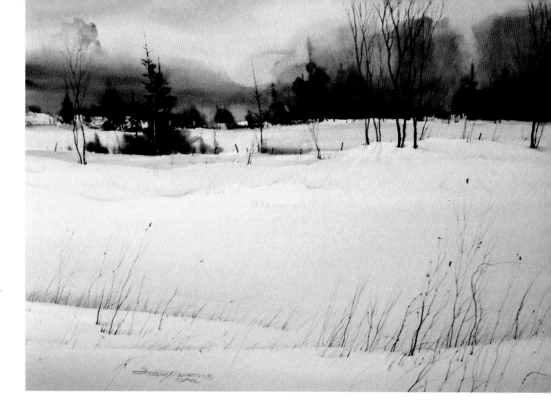

STERLING EDWARDS
A PIEDMONT SNOW SCENE, 2008
WATERCOLOR ON PAPER
22 × 30 INCHES (56 × 76 CM)

In this winter scene, both exciting and serene, Sterling Edwards makes excellent use of the infinite variety of soft edges watercolor can provide. If your subject calls for soft strokes, like these dark, distant conifers, but you don't want the paint to spread too much, the brush must be drier than the paper.

Planning the Wetness of the Paper

Dry paper always results in a hard edge. There is not much variation from one hard edge to the next. You can make a rough stroke on dry paper that reveals the texture of the surface, but it is still a hard edge.

Soft edges, on the other hand, have infinite variety. Once you have chosen to create soft-edged forms, it remains to decide *how* soft. The relative wetness of the paper and the brush determine how a stroke will spread. Don't forget who's in charge here. It is a good idea to visualize the result you want and try it out on a piece of practice paper. Always use the same kind of paper that you use for the proper painting, so that the results will be the same. I use the backs of failed paintings, of which I seem to have an endless supply. Ask yourself: *How wet does the paper need to be?* When you think you know the answer, experiment with different degrees of wetness on the paper. Learn to judge the wetness by the look of the paper. Holding the sheet at eye level between you and the source of light reveals the sheen.

Many watercolor painters assume that you must wait for the paper to be wet to *exactly* the right degree before applying secondary strokes that need soft edges. In fact, controlling the edge quality of those strokes has as much to do with the dryness of the brush as with how wet the paper is.

To practice, try this exercise, in which the wash on the paper is constant but the wetness of the brush varies. First, make a large, shiny wash (not dripping wet) of a pale color. Then load a brush with a contrasting color, using lots of paint and very little water, and make a stroke into the initial wash. Next, add a little more water and make another stroke. Keep adding water and making test strokes until you lose control of the edge altogether. Work quickly, so the paper does not dry. When the brush becomes wetter than the paper you will see the second color displacing the first, resulting in a bloom.

A variation on this exercise keeps the wetness of the brush constant and varies the wetness of the paper: Make three washes—one just damp, one quite shiny, and one dripping wet—each about 6 × 6 inches (15 × 15 cm) in size. Then load the brush with plenty of pigment and very little water. Work quickly, so your washes stay wet. Observe how the brushstrokes look on the palette. You should briefly be able to see the tracks of individual bristles before the stroke flows back together. The idea is for the brush to be drier than any of the washes. Make a short stroke in the center of the first wash. Reload the brush with more paint but no more water, and make a similar stroke in the second wash. Do the same for the third. Were the results what you expected?

Leaving some room for the fluidity of the paint to assert itself is how the characteristic look of spontaneity enters a watercolor. Too much control is just as likely to ruin a painting as too little.

The antidote for most wetness control issues is staying aware of how wet your brush is compared to the paper. Most watercolor painters dip their brush into the water bucket far more often than necessary. This is a sure way to lose track of the relative wetness of brush and paper.

When you are putting color into a wet surface, the initial wash can be thought of as your entire water supply. Any strokes added while it's still wet don't need more water from the bucket. Instead, just get some more paint on your brush, which is still a little bit wet, and add it to the wash. When you are applying color to a wet surface, the paint can be *much* thicker than what you would use on dry paper.

Sometimes all the care, practice, and conscious thought you can muster is still not enough to dispel uncertainty about whether the brush or the paper is wetter. When painting a large, complicated sky, for example, it is not always easy to be sure how wet every part of your paper is. A hard edge in the wrong place could be fatal. Pay attention to that sense of doubt. Think of it as a red flag, so that you will remember not to make that next uncertain stroke in the most conspicuous spot. Look for a place where you can make a tiny mark that won't be obvious later, and watch how the paint behaves. If you still can't be sure what will happen when the brush touches the paper, *pay attention!* Let your eye follow the stroke closely, so that you can stop as soon as you see something wrong. The idea is to catch it before you make a whole bunch of hard-edged strokes. If the conditions are not right, you should be able to notice it a quarter of an inch into the first stroke. Hopefully, this is a small enough sin that you won't feel the need to correct it. With watercolor, the cure is usually more harmful than the ailment.

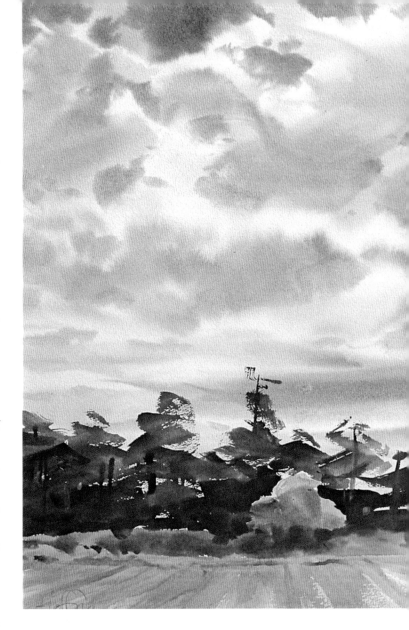

Above:

TOM HOFFMANN, *HIGH SUMMER*, 2008
WATERCOLOR ON ARCHES COLD PRESS PAPER
22 × 15 (56 × 38 CM)

As the sky approaches the horizon, the blue changes from ultramarine to cobalt, and from cobalt to cerulean. About halfway down it became clear that the paper was getting too dry. I had to wait for it to dry completely, so I could rewet it and continue. To keep from jumping the gun, I turned around and kept busy painting another view.

Opposite:

FRANK LALUMIA, *WHITE SANDS*, 1998
WATERCOLOR ON PAPER
21½ × 14½ (55 × 37 CM)

The yucca plant stands out against the sky even though it has no hard edges. The paint stays put, softening just a bit. The artist could have made these strokes by controlling either the wetness of the paper or the dryness of the brush, or both.

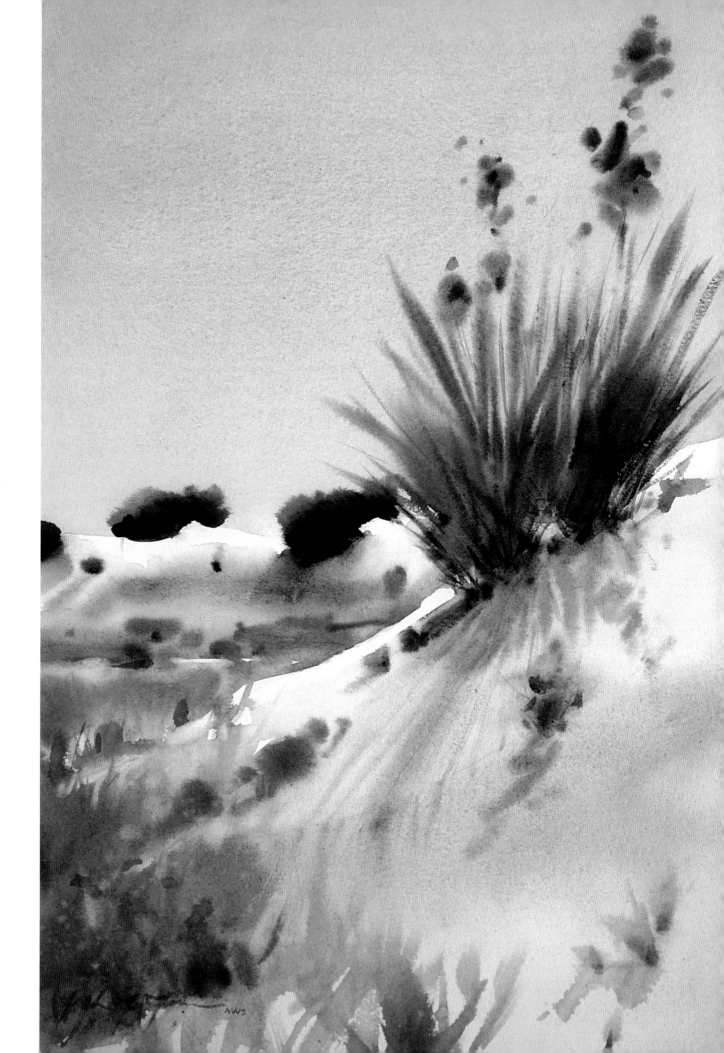

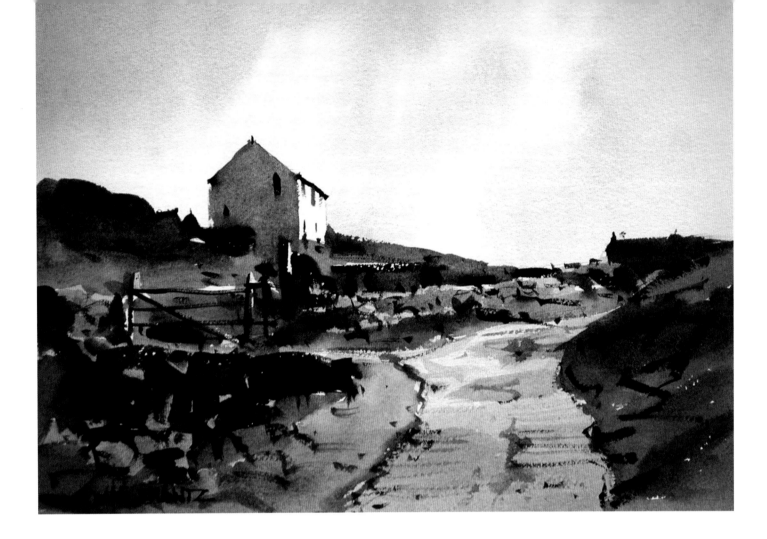

LESLIE FRONTZ, *LAND'S END FARM*, 2005
WATERCOLOR ON PAPER
8½ × 11½ INCHES (22 × 29 CM)

Most of the big shapes in this scene have hard edges that separate them from each other. The road,
for example, is separate from the grass on either side, and the hill beside the house is crisply profiled
against the sky. Within the hill shape, however, all the forms are soft. Why did the artist choose to make
that subject matter vague? Touching a relatively dry brush to paper made wet by an overall wash,
suggests the rocks and bushes without overstating them.

PROVIDING ENOUGH TIME FOR EACH TASK

How wet you make the paper determines how long it will stay
wet. When you lay down a wash you are "setting the timer" for
wet-on-wet opportunities, so ask yourself: *How much time do I
need to complete this task?* If you plan to make a complex series of
soft-edged forms within a wash, such as the rise beside the house
in *Land's End Farm*, shown above, it will be smart to give your-
self more than enough time to mix all the colors, select all the
brushes, and apply all the paint while the initial wash is still wet.

Remember that when you apply the initial wash you don't
have to exhaust your brush by covering the maximum amount of
territory before you reload it. If you want the wash to stay wet for
a while, dip into your reservoir of paint frequently, so that each
movement of the brush is depositing wet, juicy paint. This way,
you won't find yourself saying, "The paper got too dry."

Think of the initial wash as your water supply for all the soft-
edged work to come, then stay out of the bucket. In the sequence
on pages 117–119, you can see that as the successive layers
become more color-saturated, the brush gets drier, but the edges
that appear on the paper are still soft. My intention with this
demonstration was to keep all the edges soft until the painting
revealed the need for hard edges.

Apply a warm base color.

To provide enough time for several layers of wet-on-wet work, I make sure to wet the paper thoroughly. Then I add a warm base color for the clouds, suggesting the late afternoon hour.

Add cool color to the first-layer strokes.

I then begin to describe the shadows on the clouds by introducing some cool color. I do not add water to the brush, but the paper remains wet enough to provide soft edges.

Darken the shadows.

I add more color to the brush, but not more water. A layer of darker strokes makes the cloud shapes more three-dimensional. At this point all edges should still be soft, but work must proceed quickly to put in more soft layers.

Add a final layer of shadow.
Enhancing the shadow gives the clouds density.
Up to this point, the initial wetting of the paper and
brush has provided all the water for four layers. I
decide to introduce the blue later, so the clouds
can be painted freely at this stage.

Wash your brush!
For the first time since starting this exercise, I wash
my brush before introducing the blue. This allows
the color to be intense. I pay close attention to the
first blue stroke I make to be sure the brush is not
wetter than the paper.

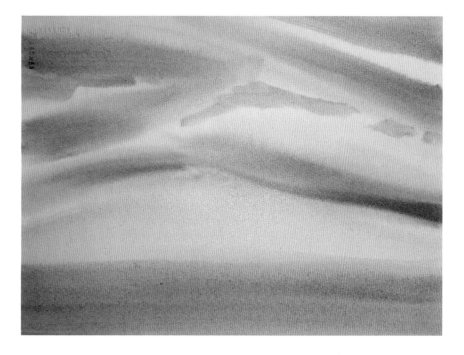

Check the wetness of the paper.
At this point the edges of the paper had begun to
dry, so I let it dry all the way, and rewet the lower
third to ensure soft edges for the landforms. Then I
apply the first layer for the ground—a simple rect-
angle of late summer grass.

Try some soft-edged shapes on the ground.
I introduce a distant hill and a few soft-edged firs to provide a definite feeling of space. Notice, however, that the diagonal forms of the clouds still dominate the composition.

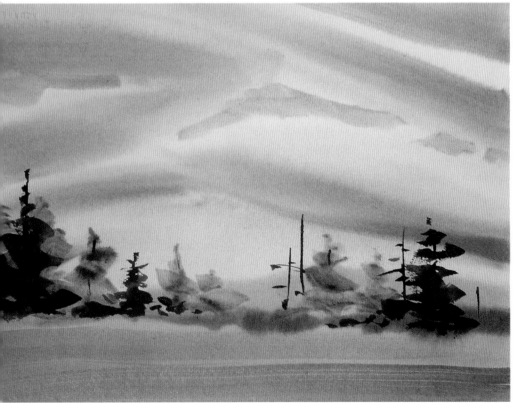

Redirect attention to the foreground.
To offset the strong diagonals, I incorporate some hard edges in the foreground. Now the bold pattern of the clouds can enliven the scene without taking over completely.

TOM HOFFMANN
CLOUD DEMONSTRATION, 2011
WATERCOLOR ON ARCHES COLD PRESS PAPER
15 × 22 INCHES (38 × 56 CM)

It is liberating to know that you are largely in control of drying time. Atmospheric conditions vary widely from day to day, and the paper you use can have profound effects on drying, but a little practice will reveal whatever adjustments need to be made. As with every aspect of watercolor, thinking one or two layers ahead is the key to taking the panic out of the process. Stay calm. Even if the paper dries before you are finished with your soft-edged work, you can probably rewet it later. This is discussed in greater detail on page 126.

GAUGING HOW MUCH PAINT YOU NEED

How much paint does the job require? When you mix up the puddle of paint you will use, be sure to make more than enough to do the job, so you won't have to stop in the middle to make more. Ask yourself this critical question, then use the biggest brush with which you can comfortably do the job. That brush is the unit of measure for determining the right quantity of paint. When you know your brushes well you will have a sense of how much paper one loaded brush can cover. Ask yourself how many brushfuls the task calls for, and then mix up that many, plus an extra one.

If you want to extend the quantity of paint by adding more water, don't forget that you also need to add more pigment. Conversely, when you discover that the paint on your brush is too dark, you will naturally add only water until it is light enough. Remember, though, that your brush will now be fully loaded with the paler paint. You must still decide how much of that paint you want to carry to the paper. If you try to use a full brush for a small stroke, you will end up depositing an unruly blob. Shake the brush, or wipe it on the edge of your bucket. This is the step that, when forgotten, leads to the feeling that "the brush got too wet."

TOM HOFFMANN, *SOMBRAS FUERTES*, 2008
WATERCOLOR ON ARCHES HOT PRESS PAPER
16 × 18 INCHES (41 × 46 CM)

In this painting on hot press paper, I did not make enough paint for the large shadow on the street. The puddle ran out halfway across, and although I added the rest within 30 seconds, it still led to a patchy-looking result. Even so, I would rather leave it "wrong" than try to correct the mistake.

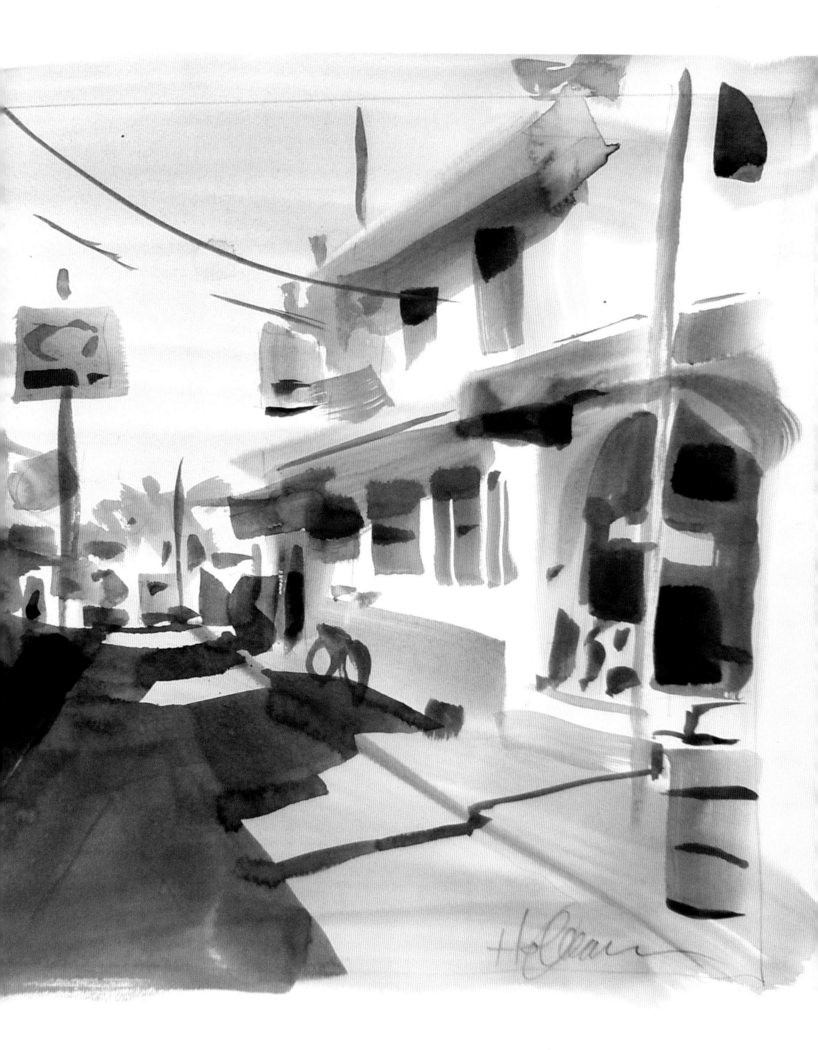

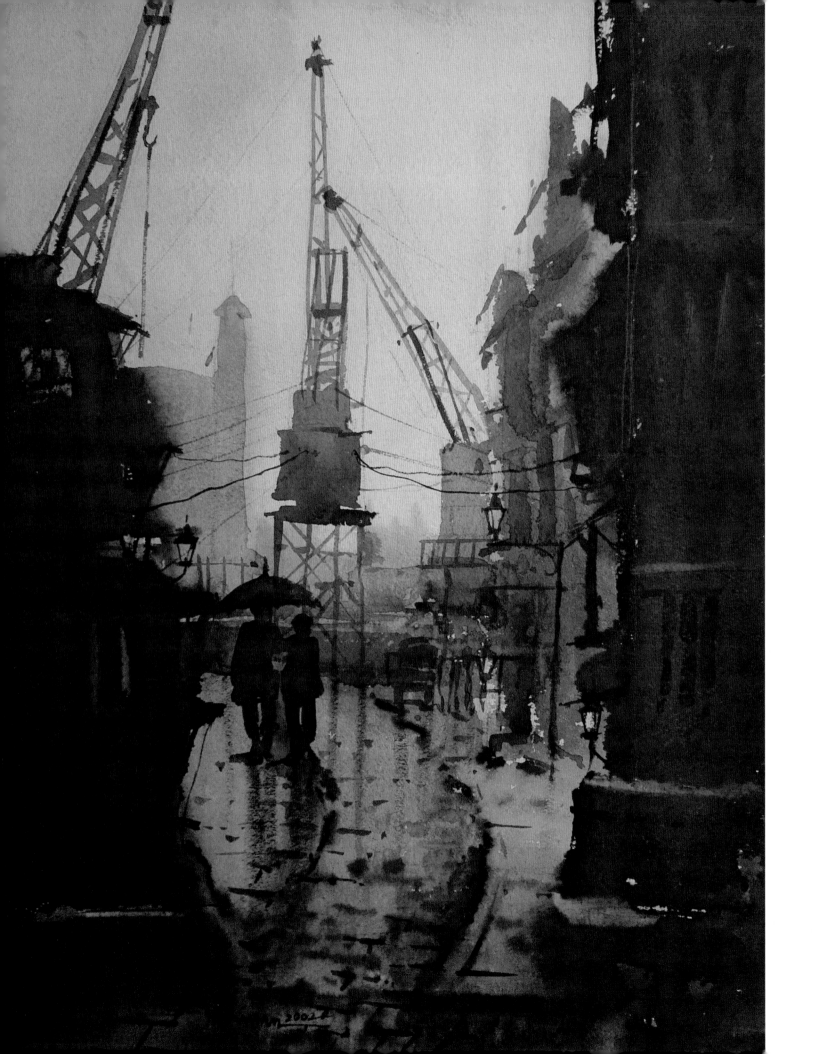

Gauging the Wetness of the Brush

How wet is the brush compared to the paper? Always knowing the answer to this question will prevent the majority of wetness problems. If you are not sure of the relative wetness of the brush and the paper, you would be wise to figure it out before making another stroke. Cultivating a sensitivity to any uncertainty about this relationship will keep you out of all kinds of trouble.

Try the following experiment before you read on. Make a 6 × 6–inch (15 × 15–cm) semigloss wash of any color on a piece of paper. Your brush will still be somewhat wet. *Do not wash your brush,* but add some pigment of a new color to it. (I know, I am asking you to touch the paint on your palette with a dirty brush! See page 125 for more about this.) On a dry area of the palette, notice how the paint behaves. It should be less fluid than the initial wash. Now make a stroke of the new color in the middle of the wash. Observe how it spreads.

Next, make another 6 × 6–inch (15 × 15–cm) semigloss wash, just like the first one, on a second piece of paper. This time, wash your brush and *load* it with the second color. Try to make your brush *wetter* than the paper. Make the same kind of stroke in the middle of the wash, and watch what happens.

In the first case, the brush was not wetter than the wash, because no water was added to it. The stroke of new color stayed where you put it, with some softening of the edges. In the second case, the brush was wetter than the wash. The liquid flowed from the brush, pushed aside the suspended pigment of the initial wash like flotsam in the path of a flood, and dropped it at the edges when the spreading stroke reached equilibrium. Voilà—a bloom.

The soft-edged stroke from the first half of the experiment is the kind of mark that is appropriate for countless situations. The bloom, on the other hand, is usually a big mistake.

JIAUR RAHMAN, *SILENT LOVE, 2002*
WATERCOLOR ON PAPER
30 × 22 INCHES (76 × 56 CM)

Being conscious of the relative wetness of brush and paper allows the artist to use a variety of edges to establish an effective illusion of light, space, substance, and mood. In a twist on the usual approach to depicting depth, Rahman gives the dark foreground shapes soft edges, while the pale background forms are hard-edged.

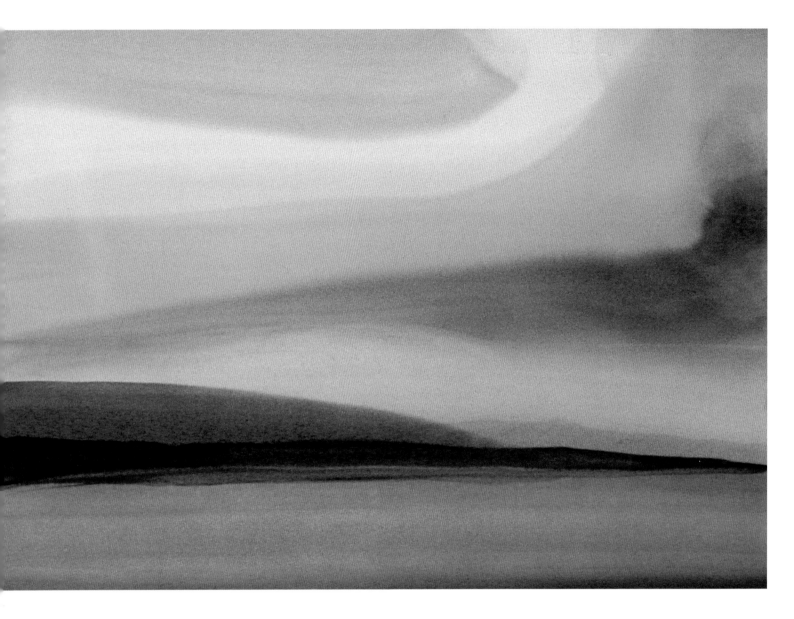

Above:

TOM HOFFMANN, *New Year*, 2010
WATERCOLOR ON ARCHES HOT PRESS PAPER
22 × 30 INCHES (56 × 76 CM)

This simplified landscape was done entirely while the surface was wet. The three colors in the cloud were laid down gold first, then light gray, and finally dark gray. In the process, the brush was never dipped into the water bucket. The gold was used as part of the light gray mix, which, in turn, was used as part of the dark gray.

Opposite:

TOM HOFFMANN, *NEEDLES*, 2010
WATERCOLOR ON ARCHES HOT PRESS PAPER
30 × 22 INCHES (76 × 56 CM)

Just in case you've never seen a bloom before, there's one in the green foothill. In a painting that is about the fluidity of the paint as much as it is about the scene being depicted, that telltale edge is not unwelcome and certainly less obtrusive than "correcting" it would be. But even if you can sometimes accept blooms, it is still a good idea to know how *not* to make them.

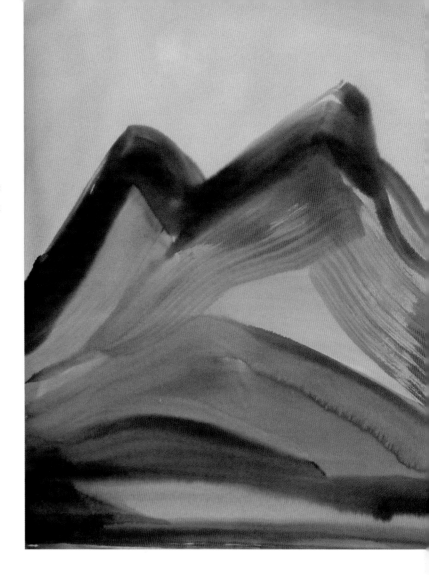

Any time you plan to touch a wet brush to wet paper, your job is to stay aware of the relative wetness of the two. Considering the tendency brushes have to keep trying to get too wet, what can you do? There are actually only two places your brush can sneak into extra water: the water bucket and the puddles on your palette. If you stay out of those two spots and work reasonably quickly, your brush will not be wetter than the paper, and you will not cause blooms. Period.

"But, how do I wash my brush if I can't dip into the water bucket?" you ask.

Consider not washing it.

To many watercolorists this is a cardinal sin. It certainly goes against what your kindergarten teacher told you. But remember: Every time you dip into the water bucket you lose track of how wet the brush is compared to the paper. Alarms should go off. Maybe it's not necessary as often as you think. Whatever objections you have to *not* washing your brush, I contend that for wet-on-wet work you gain far more than you lose.

Most of the initial load of paint you put on the brush was used to make the wash, so there really isn't much left, anyway. Whenever you apply paint to an already painted surface you are effectively mixing colors, since the transparency of watercolor allows the first layer to show through the second. How bad can it be, then, for a little of the first color to still be on the brush when you add the second? If you are proceeding from light to dark, as is usually the case, the issue of combining colors on the brush becomes even less troublesome.

If you are still shaking your head, you may be concerned about polluting your colors on the palette. I usually work from hardened lumps of paint, which can be easily cleaned with a wet brush on the rare occasion when I need a color in its pure form. Most of the time, a little leftover color from the last transgression doesn't worry me. If I have fresh paint in my palette and a "dirty" brush, I take care to pick up the new color from the edge of the blob, avoiding introducing orange into the middle of my cerulean.

Having made my case, I should add that there are times when I can't help losing track of how wet the brush is. If I change brushes, of course, I am automatically in uncertain territory. Even if I keep using the same brush, as I did for *New Year*, shown opposite, there are some times when I have no choice but to wash

it. When I paint clouds and sky, for example, I like to do the blue last, after all the cloud shadows are in place. This means that when I am ready for a nice, clean cobalt or cerulean, my brush is still charged with a fairly dark neutral from the shadows, which would be deadly to the blue. So, I wash the brush.

I usually want the blue to merge with the gray shadows along the bottom edge of the clouds. These are theoretically still damp, so if the brush is even a tiny bit too wet, a bloom will occur, spoiling the illusion of vast space. I shake or wipe the excess water from the brush, then try a stroke on clean paper to get a look at the sheen. If I think it's dry enough, I add the blue and try it on the palette. I'm ready. Maybe. Of course, by now so much time has passed that the paper is almost certainly drier than the brush. With red flags waving, I make a small stroke in an inconspicuous place . . . *Ah,* but there is another way. Read on.

REWETTING AN AREA

Rewetting is an essential tool for taking the anxiety out of the watercolor process. Once a painted area is *completely* dry, you can go over it with a wet brush without disturbing the paint at all. There are exceptions, as we will see, and some skills to practice, but for the moment let's just rejoice in this wonderful news. It means nothing less than that you can add another layer and control its edges whenever you want.

So make sure to ask yourself, early and often: *Can I rewet this area?* Remembering to ask this one question will save you from getting panicky about fast-drying paint.

Here is a rewetting exercise that makes good use of an old, failed picture: First, dig through the archives for a "dead" painting that you know is completely dry. Load a large brush with clear water, and make a wash right on top of a relatively simple and pale part of the painting. Be efficient in the application of the water, taking care not to move your brush back and forth too much in any one spot. Next, add some pigment to your brush, and make some strokes in the wet area. Note how the strokes you added look like they were made while the original first layer was fresh.

To explore the limits of the technique: Wet another section of the old painting, this time going back and forth in the same spot until the original paint begins to lift and move. Then, find a heavily pigmented section of the painting, such as the darkest dark, and try rewetting there. Is it making a muddy mess? I'll discuss the limits of this technique in a minute, but first, let's review why it works when it does.

Once a stroke or wash of watercolor paint is thoroughly dry, the pigment particles are coated with a combination of the gum arabic binder that is part of the paint and some of the gelatin that is the sizing on the surface of good paper. This double coating also acts as a glue to stick the pigment to the paper. When you brush over it, the water sits on top of the original paint without disturbing it. New paint laid into that water acts very much like paint applied to fresh paper.

In the exercise above, you probably observed that the darkest areas of the painting released their pigment and looked muddy much sooner than paler sections. There is a limit to the capacity of the binder and sizing to hold on to the pigment. It is possible to have so much color in an area that it is unwise to try to rewet it. If the dry paint looks shiny, it is best to leave it alone. (Whether the paint should ever have gotten that thick in the first place is material for another argument between the purists and the progressives.)

If the first layer is not completely dry, rewetting can be disastrous. The pigment will be disturbed, resulting in the ultimate watercolor catastrophe: *mud.*

With these few exceptions, you can rewet a painting just as if you were working on blank paper. How much water you apply depends on how long you want it to stay wet, and how far you want your new layer to spread. Practice until you feel confident.

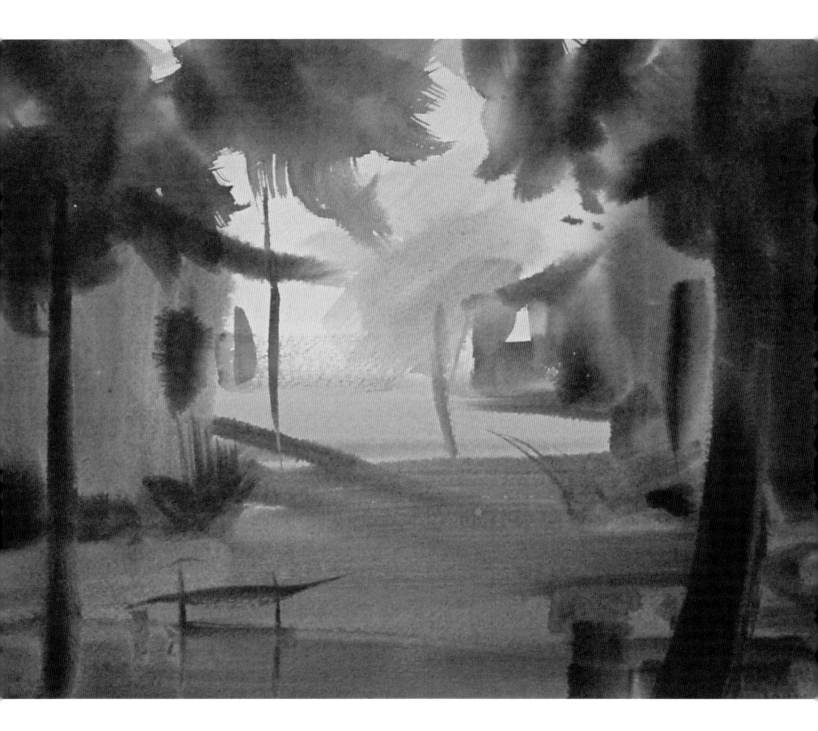

TOM HOFFMANN, *ACCESO, 2009*
WATERCOLOR ON ARCHES HOT PRESS PAPER
11 × 15 INCHES (28 × 38 CM)

The whole ground plane in this scene was painted with an initial wash of light yellow oxide, like the sunlit area in the background. After the wash had dried, it was rewet with clear water, and the soft-edged foreground shadows were added.

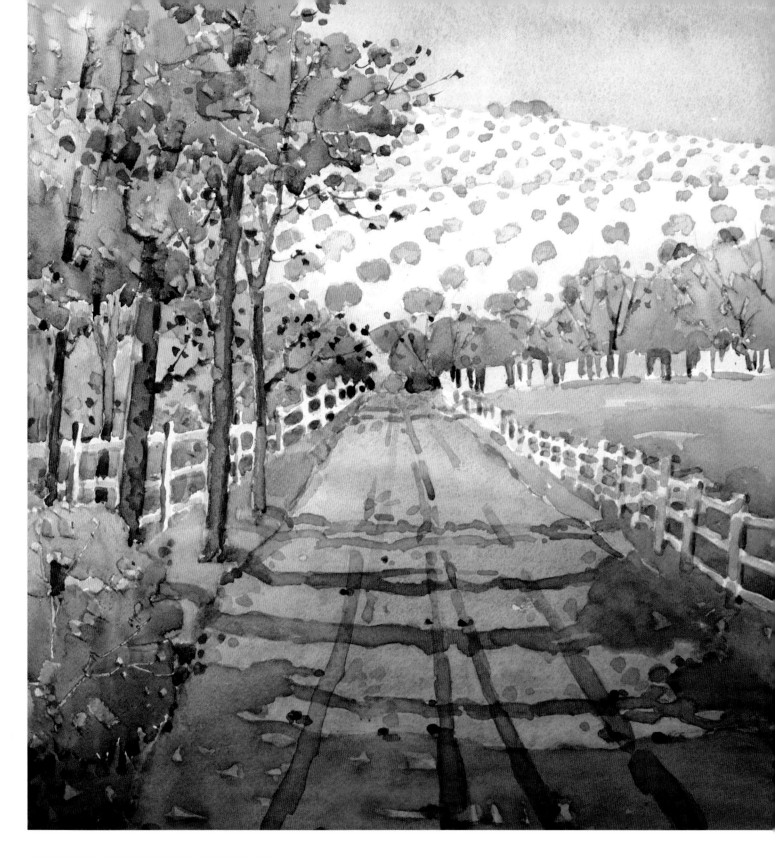

JOYCE HICKS, *THIS WAY TO THE VINEYARD*, 2010
WATERCOLOR ON PAPER
18 × 24 INCHES (46 × 61 CM)

Although almost every shape in this painting is hard-edged, there is no confusion about where the various elements are in space. The artist relies on composition and subtle value transitions to create the illusion of depth and to direct the viewer's attention.

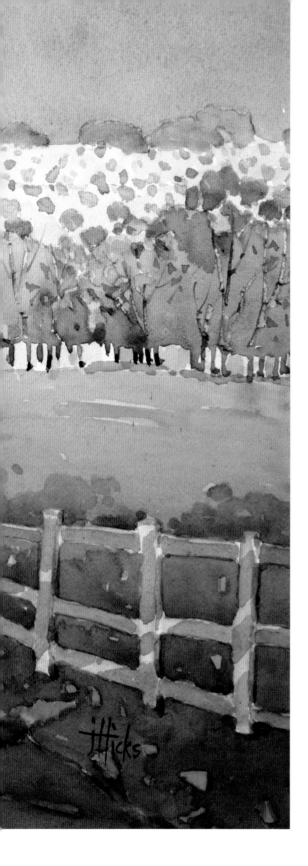

KNOWING WHEN TO DEPART FROM "ACCURACY"

When your gaze travels over a scene, your focus shifts to accommodate differences in depth and light. The feature you are studying at any given moment is in sharp focus—full of rich detail and a wide range of values. It is easy to fall into trying to paint that part, and *every* part, with all the information your eyes perceive. For many realist painters this is how we are wired. We want to do justice to every aspect of the scene. It all deserves to be lovingly painted, so we give it our best attention. But a painting in which every element has equal presence can be quite boring. It has not been interpreted so much as embalmed.

When should I depart from accuracy? Part of the artist's job is to communicate to the viewer a unique perception of the order within the image. It is up to us to decide what should be in focus, what needs to be included, and what can be left out.

Try this visual exercise: Go to a window and focus your vision on an object in the foreground. Take note of a few details on that object. Now shift your focus to something behind the foreground object, and look for detail there. Keep your focus sharp upon the second object, and observe the first one peripherally. What happened to the details you could see before? If you shift your focus back and forth between the two objects, the details in the out-of-focus object are lost. The object is still there, but only vaguely present.

To translate this kind of selective vision into watercolor, it is necessary to decide where you want the viewer's attention to be focused. Asking a question we learned earlier—*What role does the part I'm about to paint play in the big picture?*—will help you remember what needs to be in focus. Now you also need to ask: *Is this best seen as general information or specific? Forest or trees?*

Controlling wetness is a great way to make these choices literally. Hard edges are in focus; soft edges are not. The painting at the left and the following three paintings represent very different decisions about the role of edge quality in determining how the image is focused. In each case, the artist has deliberately departed from literal accuracy in pursuit of an accurate interpretation of the experience of being in that place.

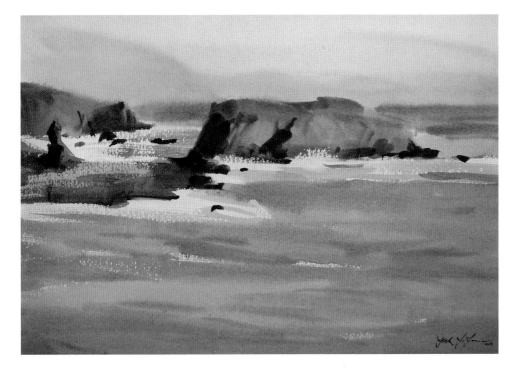

FRANK LALUMIA, *WHERE THE RUSSIAN RIVER MEETS THE SEA*, 1999
WATERCOLOR ON PAPER
14½ × 22½ INCHES (37 × 57 CM)

Hard edges are sparingly used in this swiftly painted seascape. The artist allows the horizon, where sea meets sky, to blur. Even the edges of some of the rocks are soft against the sky. Notice, though, that where waves break against rock the edges are consistently hard.

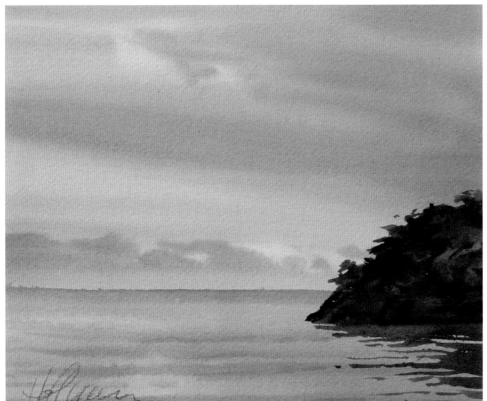

TOM HOFFMANN, *I HEAR THEM*, 2008
WATERCOLOR ON ARCHES HOT PRESS PAPER
10 × 12 INCHES (25 × 30 CM)

In reality, the mountains across the strait, though pale, were quite distinct. I chose to soften them to increase the feeling of space.

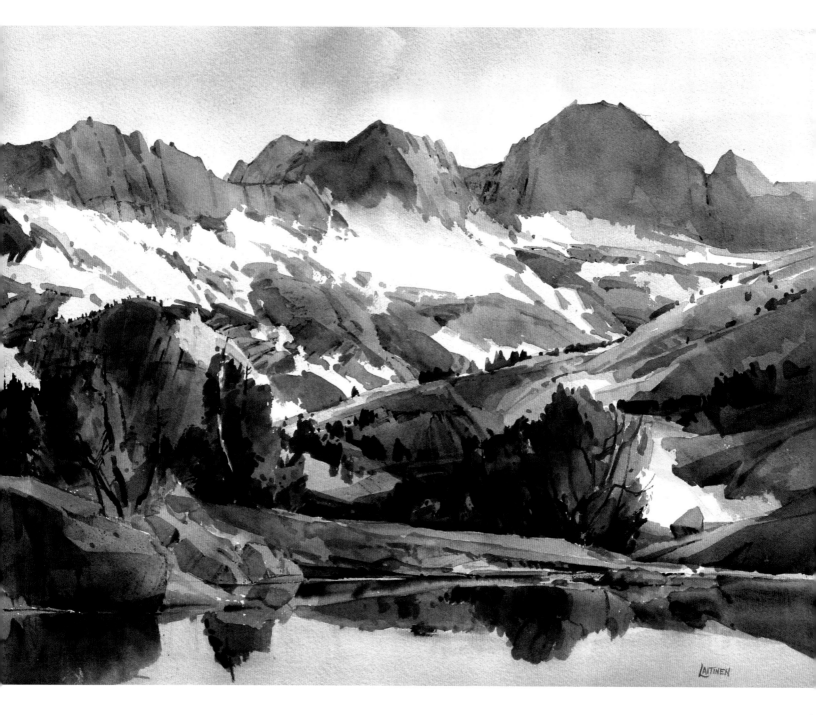

DALE LAITINEN, *CONNESS GLACIER*, 2009
WATERCOLOR ON PAPER
29 × 41 INCHES (74 × 104 CM)

As with Joyce Hicks's painting on page 128, the shapes here are separated by hard edges, but within most of those shapes the artist varies the color with soft transitions. Here the value range is widest where our eye is meant to linger.

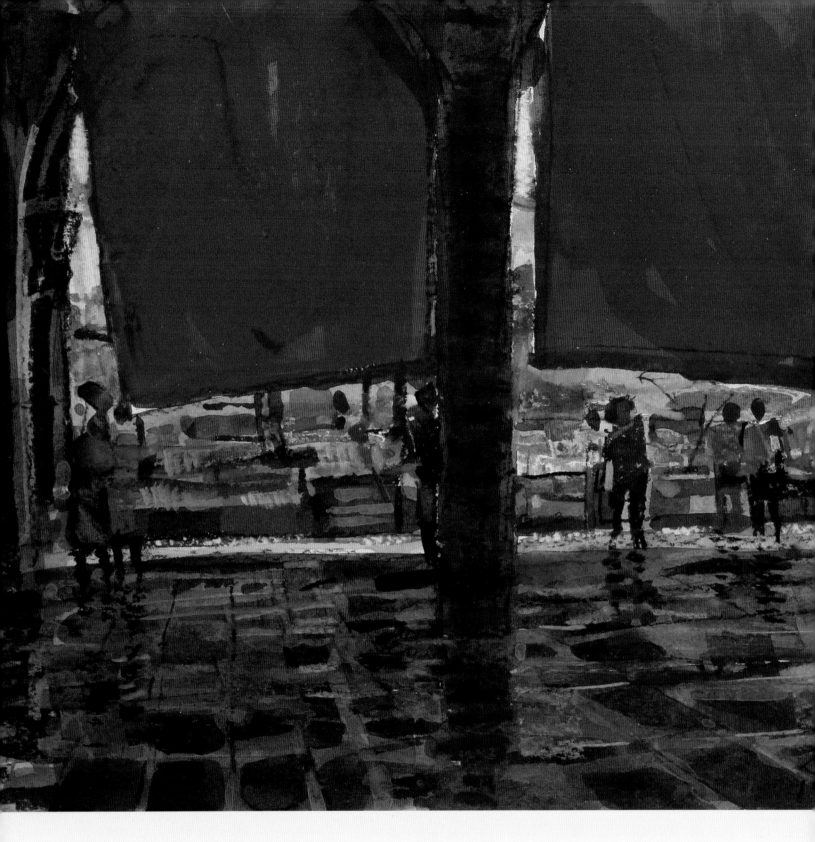

GEORGE DEVLIN, *FRUIT MARKET, VENICE*, 2007
WATERCOLOR ON PAPER
9 × 12 INCHES (23 × 30 CM)

In a picture so clearly dominated by a single color, it would be fair to say that Devlin's purpose was simply to celebrate red. But notice the care he has taken to use color to separate indoors from out, and the distribution of intense cool colors that serve as a counterpoint to the red. Degrees of saturation among the reddish neutrals subtly reveal the reflectivity of the stone floor.

GETTING THE MOST OUT OF COLOR

Color is the most subjective and the most seductive of painting variables. How individuals make color choices is a mysterious combination of perception, associations, and intuition. It would be difficult to fully describe the process to someone else, especially since we cannot be quite sure we even see colors in the same way. It can also be hard to understand another painter's palette. I certainly wonder what moves someone to make foliage pthalo green, for example.

Luckily, it is not my job to tell people what colors they should choose. (Not that they would listen, anyway.) Color choice is deeply rooted in personality, which is as it should be. You don't need someone else to tell you how to feel about colors. It can help, though, to be reminded to consider the impact your choices have. As with every other watercolor variable, my main concern is that you make your choices deliberately.

Serving Your Main Goals with Color

Color profoundly affects the mood of a painting. Being aware of the impact your choices have on the finished product is essential. If you have articulated your thoughts and feelings about what attracts you to the image you want to paint, you can consider colors accordingly. Ask yourself: *What color choices serve my main purpose?* In some cases, the effect of colors on the mood of a picture is quite obvious. Imagine one of Picasso's Blue Period paintings, for example, done in bright red. Other effects are much more subtle. In those cases it will be especially useful to answer questions, detailed below, that will help focus your attention.

Make your color choices consciously, not by default. Color is mood. Such a powerful tool should not be wasted. How do *you* decide which colors you will use? Do you look at the scene and reach for the colors that will give you the most accurate match? Do you stick to your favorites and bend over backwards to find places for them? Do you limit the range of colors and intensity to insure an overall harmony? Do you like to make each shape in the painting multicolored? And the big question: Do you make your choices consciously, or out of habit?

> Make your color choices consciously, not by default. Color is mood. Such a powerful tool should not be wasted.

The questions that lead to informed color decisions, therefore, are quite general. They deal with issues such as number (*How many colors do I need?*), temperature (*Does this part of the painting require warm or cool colors?*), and dominance (*How should I begin to mix this color?*), rather than specific preferences. I will not suggest the ideal component colors for your neutral shadow, for example, but I will encourage you to ask whether you have used them elsewhere in the painting, and if you want them to remain visible as ingredients in the mixture.

FRANK LALUMIA, *MAUI*, 2004
WATERCOLOR ON PAPER
30 × 22 INCHES (76 × 56 CM)

It is easy to sense the artist's pleasure in a subject that involves such rich, saturated color. No need to hold back—it's Hawaii!

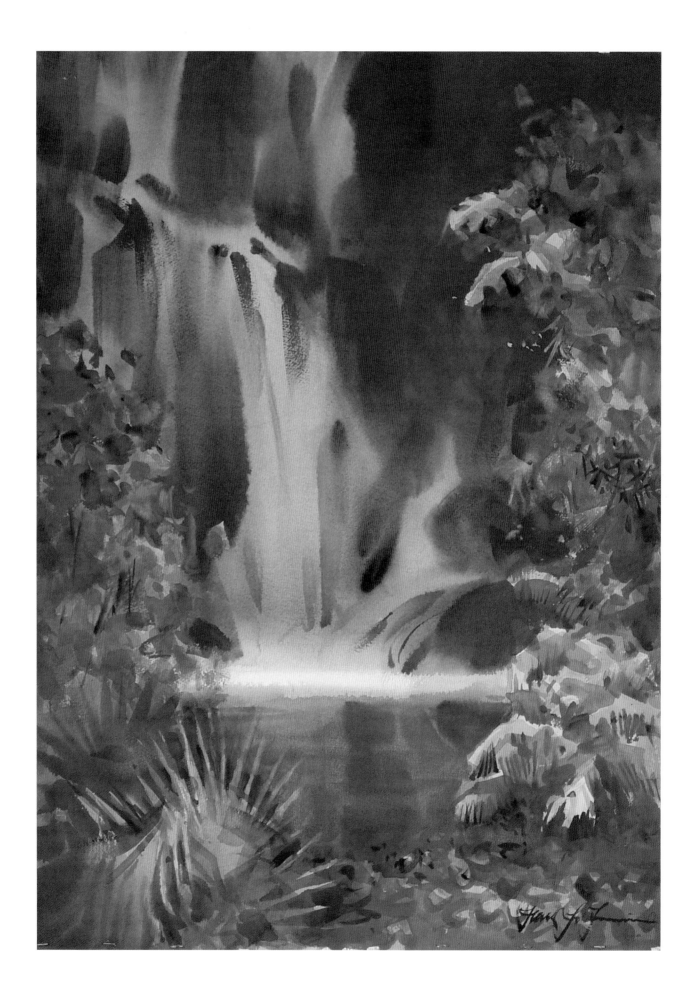

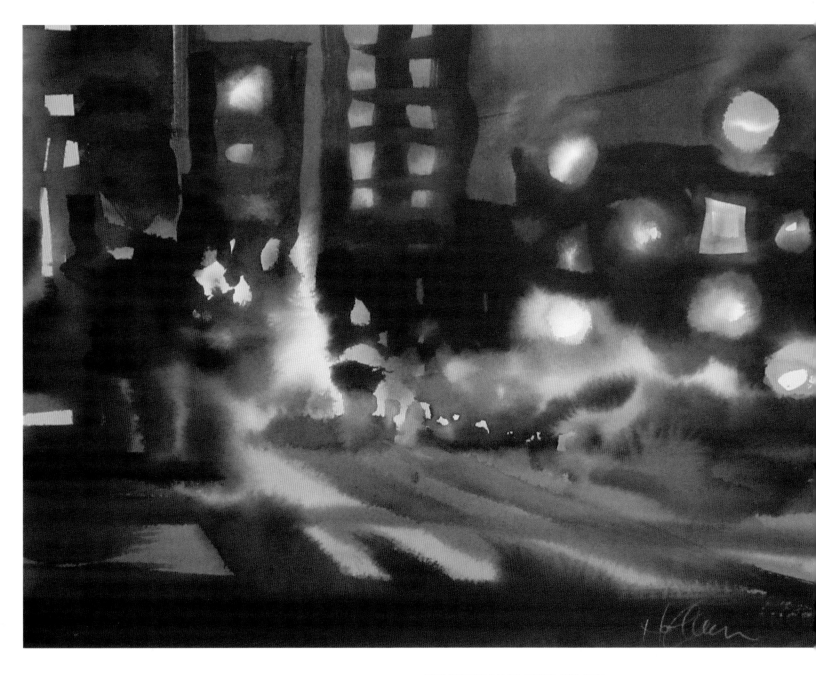

TOM HOFFMANN, *OUT LATE*, 2011
WATERCOLOR ON ARCHES HOT PRESS PAPER
11 × 15 INCHES (28 × 38 CM)

This interpretation of a midnight walk is more about mood than specific information. Shapes wobble and dissolve, but the distribution of colors remains stable—warm on the bottom, cool on top. This arrangement reflects the feeling of being out late, where the street level is still active but up above the city is asleep.

Looking objectively at your paintings will reveal what your habits are regarding color. Start by standing back from a dozen paintings, more or less, to see if there are any noticeable tendencies. Are you generous or conservative in the number of colors you use? Do you make deliberate decisions about how colors are distributed on the page? Are you thinking about color temperature and relative intensity? Are your darkest darks all the same color? And most important of all: Do you always make the same color choices, no matter how your purpose changes?

Begin your assessment by identifying the feelings you were after in several paintings. Do the color choices you made support your intention? How might you have enhanced the emotion? Would using more colors, or fewer, strengthen the feeling you sought?

Too many factors are at work to hope to catalog the effects of every color on the emotional content of a picture. It is hard enough to remember which ones stain. Rather than compiling a list of rules (never use green in the sky, placing a red object near the center stabilizes the image, pink with green sells paintings, and so forth), I recommend developing a solid instinct, based on the experience that comes from focused awareness. This can be an uncertain activity at first. It involves letting go of your support system of experts and rules. But it is deeply satisfying to discover that you can ride without the training wheels.

Experience comes from outside ourselves and accumulates inside, but understanding always comes from within. Instead of asking the authorities your question, first try asking yourself. For example, if you are after a feeling of serenity in your painting, should you introduce a new color for this next passage, or refer back to one you have already established? Or, when you are trying to mix a good gray and it keeps coming out brown, what color should you add? You have a lifetime of color experience. If you ask the questions, you will know the answers.

TOM HOFFMANN, *THE FORMER WORLD*, 2010
WATERCOLOR ON ARCHES HOT PRESS PAPER
13 × 16 INCHES (33 × 41 CM)

Once this image began to take shape I saw it as land just coming into being. I wanted the raw quality of separate elements: earth, air, fire, and water. Intense colors seemed right, with warm and cool colliding and just beginning to merge.

The computer allows me to see how the painting would have looked If I had used a more integrated palette. By turning up the sepia everywhere, the warm and cool are brought closer together. The color change replaces the feeling of newness with a sense of equilibrium and resolution.

EVALUATING YOUR PALETTE

How many colors do I need? When we ask this question we walk a fine line between fact and opinion. I have definite preferences when it comes to the number of different colors a painting can carry, but I hesitate to come between you and your taste. When it comes to color, even after forty years of watercolor practice I am only qualified to tell you what *I* like.

Having said this, I will risk adding that I rarely feel that a painting suffers from using too few colors, but I often think there are too many. When you assess your color choices to see if they are appropriate to your purpose, take a good look at how many colors you include. To me it seems unlikely that the number of colors you choose would have *no* effect on the mood of a painting, so if you always use lots of different colors regardless of the feeling you intend, consider putting some limits on your palette.

A traditional limited palette is composed of a red, a yellow, and a blue. With the three primaries, you theoretically have the potential to mix a full spectrum. Paint is not the same as light, though, and even the purest primary paints will not combine to make perfect secondary and tertiary colors. The spectrum that results from the particular primary colors you select will be limited by the combinations those primaries can make. Sargent, for example, often used ultramarine for his blue, burnt sienna for his red, and yellow ocher for his yellow. The green that results from a mixture of ultramarine and yellow ocher is more of an olive than an emerald, since both parent colors contain a bit of red. Similarly, the best violet we can make from ultramarine and burnt sienna is a bluish brown. Artists have always capitalized on this limitation, using the restricted range of three component colors as a source of harmony in their paintings. If we can adjust our expectations and imagine that we are describing a world where these mixtures are the true green and violet, an overall feeling of cohesiveness will come from every color being related to all the others.

A limited palette is an effective way to achieve an overall unity on the page, but it frequently sets a minor key mood. A diverse palette makes a cheerful, lively surface, but it can leave the viewer no place to rest. Be sure to assess the effect the range of colors you have chosen has on the feeling of the piece.

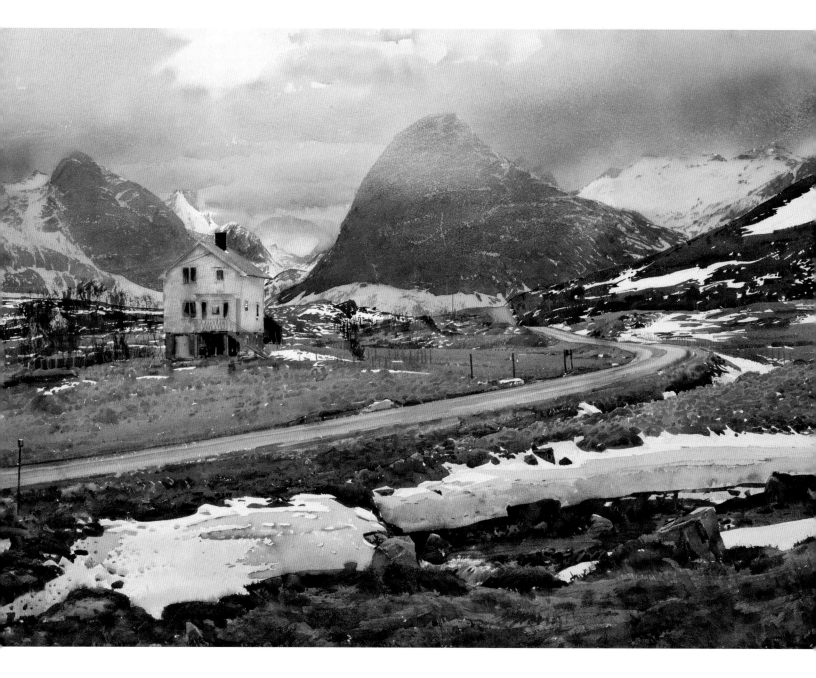

STANISLAW ZOLADZ, *LOFOTEN*, 2008
WATERCOLOR ON PAPER
29⅞ × 41⅜ INCHES (76 × 105 CM)

In a painting that depicts vast space and several landforms, the artist
has made masterful use of a limited palette, employing it to unify the
image and make the illusion of space convincing. Shifting the dominance
of warm ocher to cool blue emphasizes the division between foreground
and background, and keeps the mountains feeling distant.

The two Michael Reardon paintings shown here have several qualities in common. Both use hard-edged shapes and accuracy of value to depict a convincing sense of light. The mood of each is quite different, though. One is remote, dignified, and austere, while the other is accessible, boisterous, and playful. This change in mood is partly due to the viewpoint—the palace looks fully half a day's journey away, whereas we could walk right up to those dragons—but most of the differences come from the palette.

It looks as if one could make all of the subtle colors in *Leh Palace* by mixing a single red, yellow, and blue. The sunlit areas use only the red and yellow, the shadows mostly blue. *Wat Phra Sing,* on the other hand, involves saturated colors, and plenty of them. Even the "white" figures are actually multicolored. One speaks of restraint, the other of exuberance. Both succeed beautifully.

Left:
MICHAEL REARDON, *LEH PALACE*, 2010
WATERCOLOR ON PAPER
22 × 11 INCHES (56 × 28 CM)

A limited palette suits the austerity of the subject. Even in their purest form, the red, yellow, and blue are diluted.

Opposite:
MICHAEL REARDON, *WAT PHRA SING*, 2000
WATERCOLOR ON PAPER
7 × 5 INCHES (18 × 13 CM)

A broad palette of saturated color enhances the delight of coming across these happy creatures.

Meadow Gate

MIXING YOUR COLORS

Years back, a couple of students returned from a workshop with a sort of Rolodex of color samples they had spent the week compiling. Little pieces of watercolor paper were held together on loose-leaf rings, with a color swatch on one side, and the recipe on the other. The idea was to carry it along on plein air excursions, as an aid to color mixing. If you wanted to paint that cactus over there, for example, you would flip through the pages on the ring until you found the closest green, and simply follow the recipe.

To me, this approach is exactly backwards. The recipe book seems designed to make sure you never become confident of your own instincts. Maybe, after using it for a long time, you will actually memorize the recipes and know what to mix just by looking at the subject, but surely there must be a faster route to increased color awareness.

Once again, taking responsibility for your decisions is the first step. Develop confidence in your instincts. Choosing and mixing colors is a lot like cooking. Some people rely on recipes and never vary them. Others feel free to substitute ingredients, or even improvise completely. As with cooking, color mixing is built upon a foundation of a few principles. Understanding them gives you the freedom to try something unexpected that still works beautifully.

When you see a color you like in another artist's painting, it is natural to ask, "How did you make that color?" But what you really need to know is the answer to "How did you know what to do to make that color?" The following exercises offer an approach to the task of providing your own answers to the question: *How should I begin to mix this color?*

Everything begins with the primaries. Start with a red, a yellow, and a blue that seem to be relatively pure. The blue, for example, would not appear to have much red or much yellow in it. (Cobalt would work. Pthalo would also be fine. Ultramarine has a little too much red, and therefore will not make a pure green.) The red should be neither too orange nor too purple, and the yellow should be neither too green (like aureolin) nor too orange (like new gamboge). The more pure the colors are, the more versatile they will be as mixers. You can test them for intensity by combining them to make secondary colors. The purple, orange, and green that result should be clean versions of those colors.

Look around for an object that is a single complex color—something like an eggplant, or a paper bag, that will require at least a little of all three primaries to match. Mix your primaries together to make the color. When you are satisfied that your mix is as good a match as you can make, put a stroke of it on a piece of paper.

Now choose a different set of primaries and match the same object. Try more sets of primaries and more objects. Make your sample strokes beside each other for comparison.

If one group of primaries will not make a perfect match, get as close as you can and compare your mixed color to the object. Would the color you made serve as a reasonable interpretation of the object? My experience is that it almost always would. If you had chosen to match the back of your hand, for example, a mix of just about any red, yellow, and blue would make a believable flesh tone. It might not be perfect, but it would be perfect enough. How often, really, does a color have to be an exact match?

There are many ways to mix a color. When I'm on an excursion and have only a limited quantity of paints with me , I may run out of some of my favorite colors. Cobalt blue is often the first to go, then quinacridone gold, green gold, carbazole violet, ultramarine, and so on, until I'm left with pthalo blue, hansa yellow, some kind of brown, and whatever the red is that replaced the red I had before that. I may miss my favorites, but as long as I've got some version of the primary colors, I can keep painting.

This "close enough" approach to color mixing gives you a solid place to stand—a place from which you can find a path to where you need to be. It boils down to asking: *What do I add to what I've got to get what I want?* To know where to go first, I look for the dominant color, as discussed on the following pages.

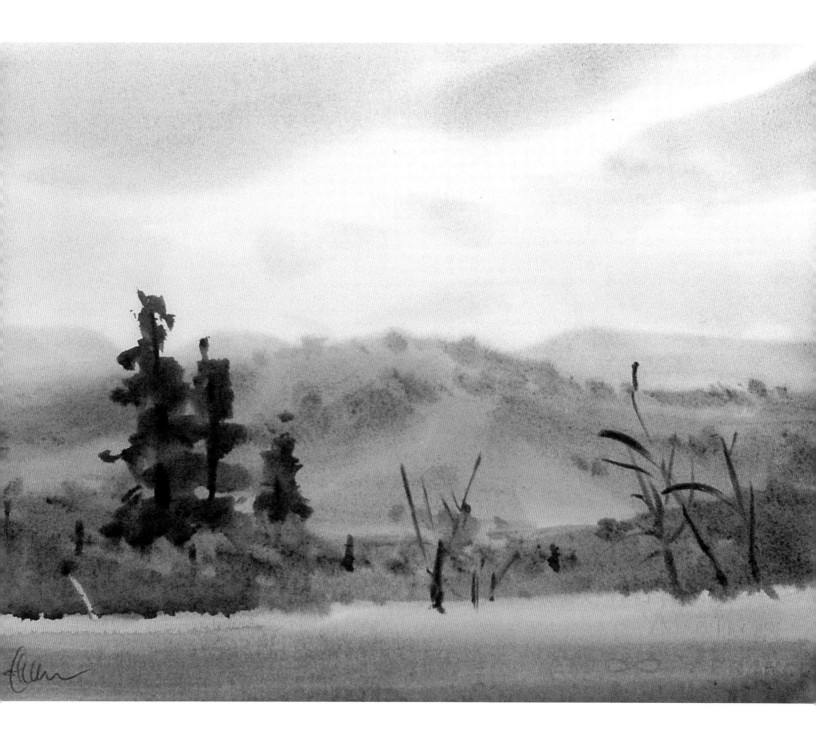

TOM HOFFMANN, *RANCHO ALTO, 2010*
WATERCOLOR ON ARCHES HOT PRESS PAPER
11 × 15 INCHES (28 × 38 CM)

Pthalo blue, new gamboge, and some kind of red I couldn't identify are
not the colors I would normally have chosen for this scene, but they
worked just fine when I had run out of everything else.

IDENTIFYING THE DOMINANT COLOR

Mixing a complex color can be tricky. To narrow down the possibilities, imagine that there are only six color names: red, yellow, blue, green, orange, and violet. When confronted with a color that is difficult, ask yourself: *What is the dominant color?* And then allow yourself to answer with just one of those six choices.

In the scene from a shrub steppe of Eastern Washington, right, the characteristic color of the spring grasses is vibrant but complex. To mix the color, where would you begin? Some people might choose orange. Some would pick red. Others might see green. In any case, this color is not easily reduced to a single hue. Whatever you identify as the dominant color, it is clear that it is just a starting place. A single color might not do justice to the richness of the subject, but to get started, all we need is one.

Once the dominant color is present, what else is needed is easier to gauge. If the main color is too blue, it needs either red or yellow, or some of each. A color that is too red would need blue or yellow, and one that is too yellow would need red or blue. That is the whole story. To test your instincts, take another look at the shrub steppe photo. If you had already mixed a color for the foreground grasses, what would you reach for to change it to the color of the sunlit hills in the background?

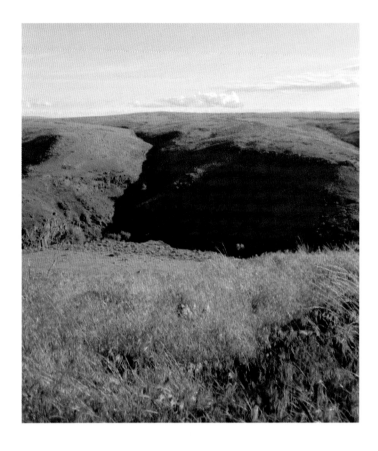

Evaluate the subject.
To identify the color in the spring grasses in this photograph, try squinting. This helps minimize the texture.

Look closely to identify the dominant color.
There seem to be several colors present here. Try to choose just one as a place to begin.

Make a version of the color you choose.

Let's say you identified orange, as shown here, but when asked the question "What is the dominant color?" you really wanted answer with "orangey-green." If so, you've already moved to the next step.

Add a second color.

Consider what you want to add to move closer to the complexity of the grasses. I chose green. I like the way these two colors, orange and green, can be separate and still work together. But the hue is still missing something. I see more red in the photo detail.

Add a third color, if necessary.

Adding the red without mixing it in completely allows the three component colors to assert themselves the way the different-colored grasses do.

Now try the same process for the shadow color in this picture of the hills in the Yakima Canyon, at right. It may help to isolate the shadow. The colors often seem more apparent out of context. Take care, though, to make sure the value stays close. With the context gone, relative dark and light are difficult to compare.

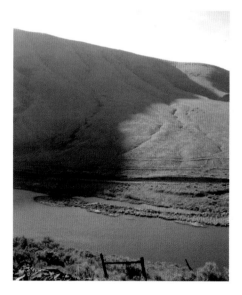

Evaluate the subject.
Again, to identify the shadow color in this photograph, try squinting.

Isolate the area you want to identify.

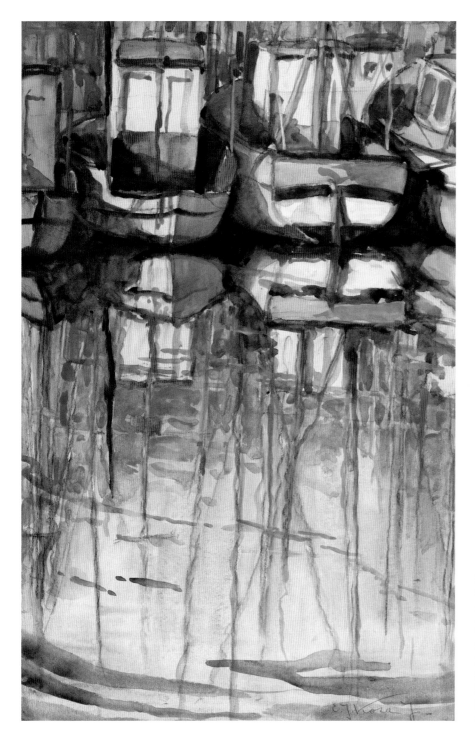

EMIL KOSA JR., *BOAT HAVEN*, 1932
WATERCOLOR ON PAPER
17 × 11 INCHES (43 × 28 CM)

To me, this is, above all, a painting of sunlight.
With a palette limited to no more than four colors,
Kosa has created an interplay of intense warms
and cools that vibrate with light. By surrounding
the reserved whites with strong blue and yellow
passages, the artist efficiently establishes a feeling
of the full spectrum of sunlight.

EVALUATING THE EFFECTS OF COLOR TEMPERATURE

Selecting a relative temperature is the most general way we categorize colors. A color can be identified as warm or cool even before we give a name to its hue. Most watercolor artists arrange their palettes with warm on one side and cool on the other. This is not just for convenience. Thinking of color in terms of warm

and cool is an excellent way to stay aware of the role color plays in realizing your intentions. How the color temperature balance of a painting is arranged can have a profound impact on the viewer's experience. This is why it is so important to ask yourself: *Does this part of the painting require warm or cool colors?* The following paintings make deliberate use of warm/cool relationships to enhance the artist's purpose.

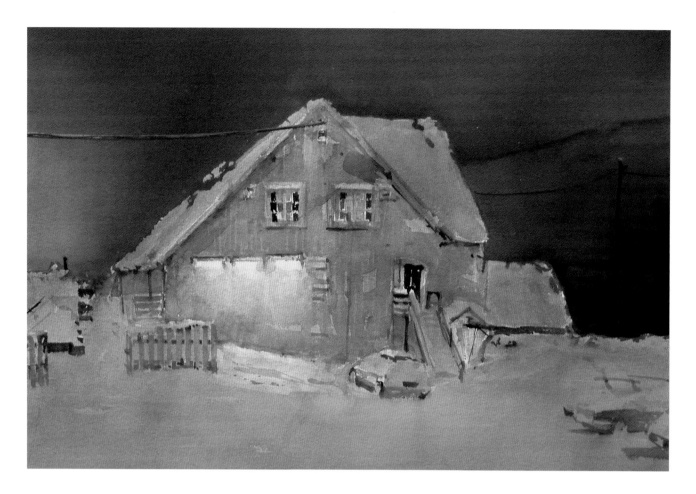

TORGEIR SCHJØLBERG, *LYS I MØRKE*, 2004
WATERCOLOR ON PAPER
27½ × 35½ INCHES (70 × 90 CM)

In Kosa's *Boat Haven* opposite, the warm and cool were roughly equal in area. Here, however, Schjølberg wants the cool to dominate the scene. The result is a palpable chill that leaves us eager to get indoors, where all the warmth is concentrated. This is precisely where form and content overlap.

Imagine the scene with the color temperatures inverted, as in this digitally altered version of the image. The mood changes dramatically. Now I'm not so sure I want to go inside, after all.

Above:

TOM HOFFMANN, *LOS TAMALES MEJORES*, 2010
WATERCOLOR ON ARCHES COLD PRESS PAPER
10 × 10 INCHES (25 × 25 CM)

The warms represent the largest area of this Oaxaca street scene, but their main role is just to provide a frame for the cool center of action. This is the opposite of the arrangement in Schjølberg's *Lys I Mørke*, on page 147, but the result is the same. Color temperature dominance works to focus attention.

Opposite:

LESLIE FRONTZ, *IN PORT*, 2003
WATERCOLOR ON PAPER
11½ × 8½ (29 × 22 CM)

Relative to each other, the sky in this painting is cool and the ground is warm. Notice how the artist has located the warmest features against the cool background, and the coolest against the warm background. Less-intense cools, like the shadows along the ground, reach into the warm area, and less-intense warms, like the crane booms, reach into the cool. These juxtapositions help to stitch the composition together, at the same time that they enliven the surface of the page.

L. FROITZ

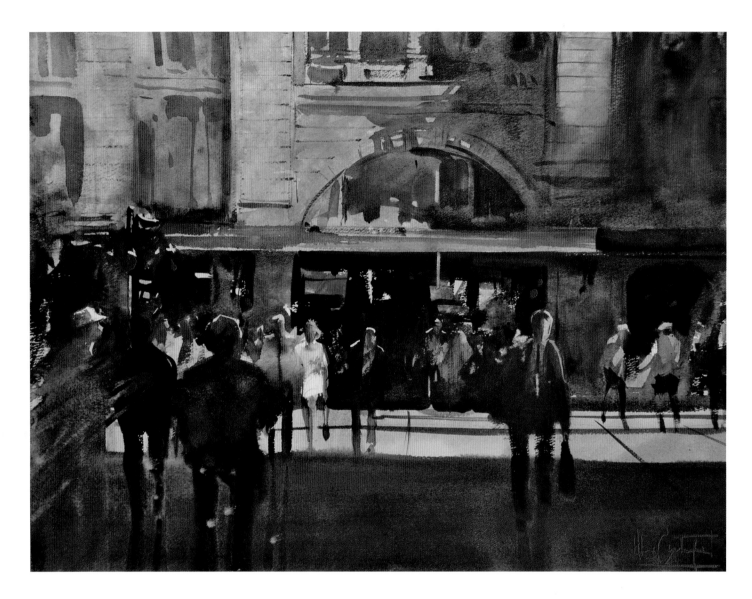

ALVARO CASTAGNET, *FLINDERS STATION, MELBOURNE*, 2008
WATERCOLOR ON PAPER
14 × 22 INCHES (36 × 56 CM)

The division between warm and cool is more pronounced in this busy
scene than it is in Frontz's *In Port*, on page 149, but Castagnet has
taken care to insert a few cools within the warm zone, and vice versa.
What do you think motivated his decision?

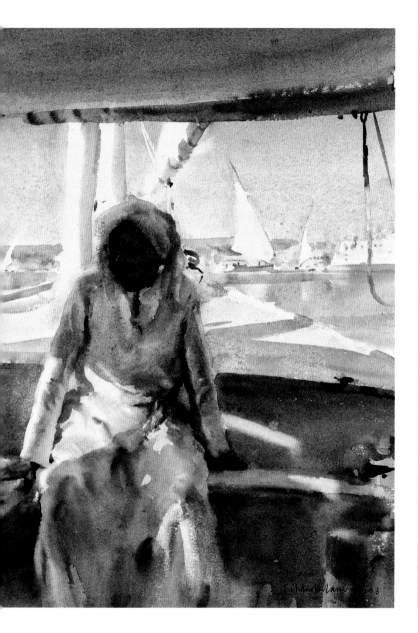

TREVOR CHAMBERLAIN, *FELUCCA JOURNEY, EGYPT, 1993*
WATERCOLOR ON PAPER
14 × 10 INCHES (35 × 25 CM)

Looking at this painting beside a black and white version reveals the role the warm and cool placement plays in creating a convincing illusion of light and space. Pay attention to whether the shape you are observing has a noticeable color temperature.

Although the values are correct, the monochrome image tells us nothing about reflected light. Chamberlain's observation of color temperature changes is responsible for the feeling of being in the same space as the white-robed figure and the vastness of the open air beyond.

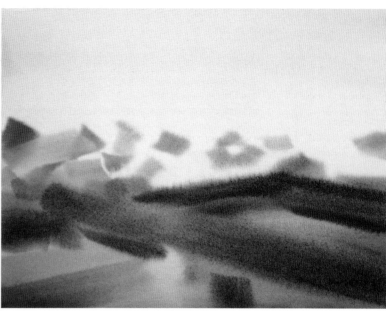

Evaluate the subject.

This image is just right for a warm/cool analysis. With the exception of the yellow in the sky and the green tree, everything could be made with an orange and a blue.

Select your two colors and paint the purest warm and cool lights.

I chose pyrrole orange for the warm and ultramarine for the cool. I wanted to locate the purest warms and cools right at the beginning, so I would have them as a basis for comparison. The tiny lights on the hillside looked to me like intense versions of the colors, so I made a loose pattern of strokes in both colors.

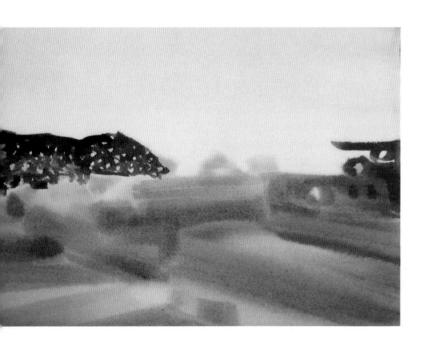

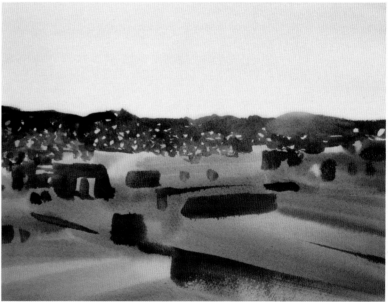

Add the next darker cools.

The dark of the hillside is almost pure blue. It is cooler than the sky, but warmer than the lower right rooftop.

Add the next darker warms.

The hillside warms up a little as it moves to the right. Now the warm darks begin, with their temperature cooling somewhat as they step back in space.

Here's an exercise for exploring the concepts we've touched on regarding warm/cool relationships: First, limit your palette to just two colors—one distinctly warm (yellow ocher, gold, rich green gold, cadmium red light, pyrrole orange, quinacridone burnt orange, and so forth), and the other distinctly cool (any blue, violet, perylene green, hunter green, pthalo green, and so forth). Then, make a version of a picture in which for every element you decide how warm or cool it should be. The purest form of the warm color would be reserved for the warmest part of the scene, and the purest form of the cool would only be used for the coolest part. Everything else would involve mixtures of the warm and cool colors. (The second-warmest shape, for example, would have a little bit of the cool mixed in.)

To get started, look at the image you've chosen to see if there is any content that you automatically think of as either cool or warm. The sky on a clear day, for example, would obviously be cool, as would the ocean. A bare light bulb or fire, on the other hand, would be warm. You might ask: *What would be the warmest part of this scene?* Then you have something to compare everything else to. If you decided, for example, that a brick wall in sunlight was going to be very warm, then the shadow on the wall would be somewhat cooler. The shadow on a clump of foliage would be even cooler, since the foliage in sunlight is cooler than the brick in sunlight. It's all relative, just like value. When you are deciding where on the temperature scale to place a particular subject, try looking for something a little cooler and something a little warmer than the part you are about to paint. It helps to locate each new bit between two parts to which you are already committed.

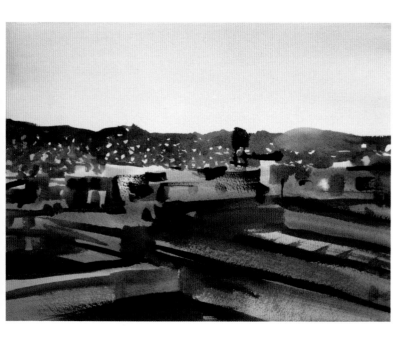

Add the more neutral darks.
The darkest neutrals add to the illusion of substance. Only the clouds remain to be added.

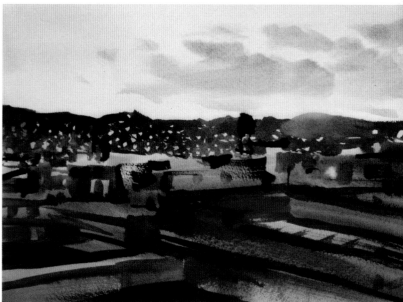

Add the finishing touches.
The clouds are mostly cool, with soft, warm edges.

TOM HOFFMANN, *OAXACA ROOFTOPS*, 2011
WATERCOLOR ON ARCHES COLD PRESS PAPER
11 × 15 INCHES (28 × 38 CM)

KNOWING WHEN TO DEPART FROM "ACCURACY"

On a sunny day, I enjoy the challenge of trying to match the color of the sky. It is rarely just one convenient blue, like pure ultramarine or cerulean. Sometimes it takes as many as four colors to come up with something that looks just right. As entertaining as this can be, from the point of view of what the painting needs it is not really necessary. As long as I don't make the sky too dark, there are any number of blues that will work just fine.

When it comes to creating an effective illusion of light and space, reading the values well is a much more useful skill than color matching. For the sake of the coherence of the page, it is more important for the colors you choose to *work together* than be accurate. What works in the real world or in a photograph does not necessarily work in a painting. While in front of your subject, ask yourself: *When should I depart from accuracy?* Colors often need adjustment before they serve your purposes. As we have seen, limiting or expanding your palette can put emphasis where you want it in a painting. A good example is the notorious "wall of green" that landscape painters so often face. Where I live, in the Northwestern United States, most of the wilderness is covered in conifers. Great swaths of many scenes are uninterrupted green, which could be tiresome for both painter and viewer. I always manage to see some variations in that tapestry of green, and I am happy to exaggerate wherever a little extra color is needed. In the image opposite, Kate Barber takes off from a black and white source, turning up the hints of color she discerns.

Adjustments can also go in the other direction. In *Snow on a Queens Bridge*, page 156, Jonathan Janson subdues the differences in color to emphasize the effects of the storm.

KATE BARBER, *NOSE TO NOSE*, 2010
WATERCOLOR ON PAPER
22 × 30 INCHES (56 × 76 CM)

Something tells me the subject was a black and white dog, *not* a maroon and blue dog. The artist could see that there was plenty of room for interpretation. Her dog manages to be fanciful and perfectly believable at the same time.

Limiting the palette, as we have seen, can go far toward creating a sense of harmony. Combined with an awareness of the role of color temperature, using just a few colors may help resolve a difficult composition. Choosing to emphasize the colors that contribute to a particular mood, as I have done in *Entrance to the Underworld*, opposite, is an example of deliberately departing from accuracy.

Opposite:

TOM HOFFMANN, *ENTRANCE TO THE UNDERWORLD*, 2007
WATERCOLOR ON SAUNDERS COLD PRESS PAPER
22 × 15 INCHES (56 × 38 CM)

The world beneath the viaduct is certainly not all blue, but it feels like it is. This cool-dominant, limited palette creates a contemplative mood and gives coherence to a complex composition.

Below:

JONATHAN JANSON, *SNOW ON A QUEENS BRIDGE*, 2005
WATERCOLOR ON PAPER
10⅝ × 14½ INCHES (27 × 37 CM)

The artist has softened edges and neutralized colors until the snowstorm has at least as much presence as the bridge in this painting. The feeling is accurate, while the appearance is probably not.

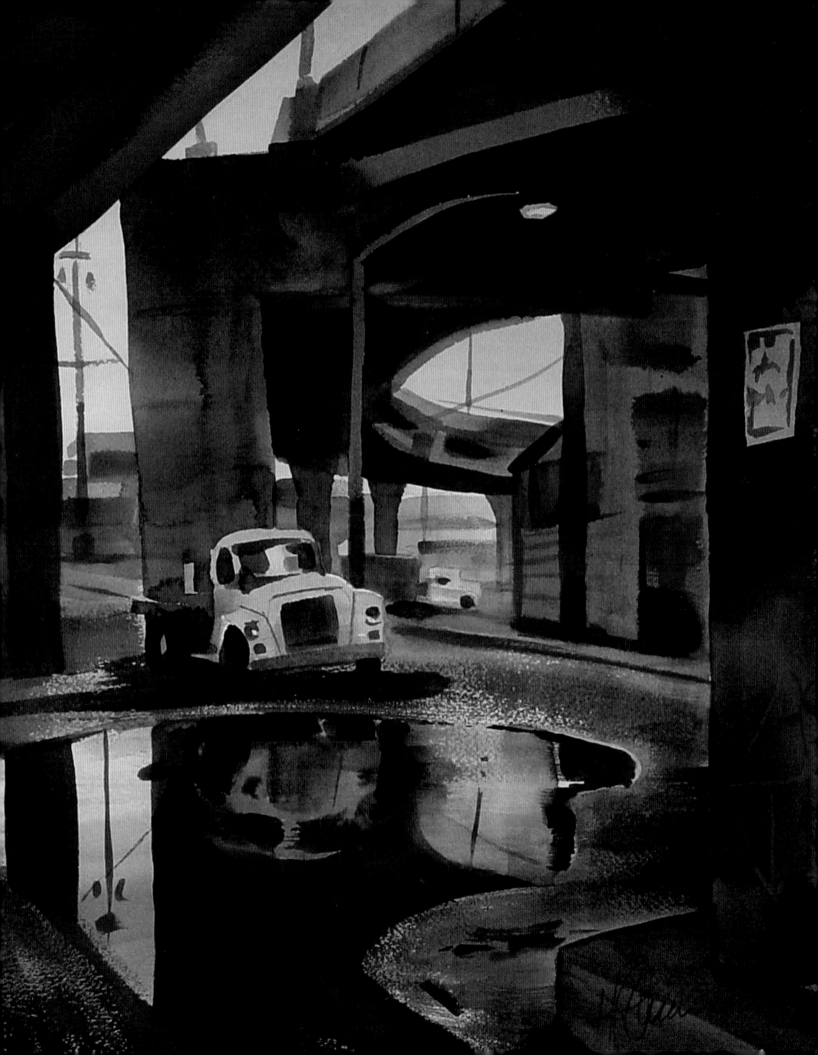

While it is true that less can be more, sometimes *more* is more. In the image above, Bernie Beckman adheres to standard landscape colors in the trees and sky at the top of the painting, and then makes a bold leap from the cliff edge into a wide-open palette for the rocks.

Above:

BERNIE BECKMAN, *MONSON SLATE QUARRY*, 2006
WATERCOLOR ON PAPER
30 × 44 INCHES (76 × 112 CM)

This is an expanded, rather than a limited, palette. The bold color is not accurate, but it seems perfectly suited to the spirited brushwork.

Opposite:

TREVOR CHAMBERLAIN, *EVENING, HERTFORD BASIN*, 1993
WATERCOLOR ON PAPER
7 × 10 INCHES (18 × 25 CM)

Trevor Chamberlain takes care to give even his deepest darks a color identity. As a result, they are an integral part of the image.

Enlivening Your Darks

Don't forget to ask yourself: *What color are the darks?* Questioning reality is especially important when working from photographs. As we have seen, real does not necessarily mean correct. During our discussion about value in chapter 4, we saw how darks in photos often swallow up information. They also tend to look perfectly black. In a painting where everything else has a noticeable color identity, making the darks all black leaves them stranded. Without the benefit of the cohesive force of the overall palette, the darkest darks only connect to each other. They can form a separate pattern that floats above the page like a flock of raucous crows. In the Oaxacan Rooftops image, page 153, the darks that have a definite color temperature are fully integrated into the picture, while the few that are a completely neutral black look as if they are perched there temporarily.

Developing awareness of the role color plays in enlivening your darks is not just a means to an end. It is also much more fun than always using black. Many of us became painters out of love of mixing colors. Why pass up an opportunity to invent your own darks?

Choosing Colors for Your Neutrals

Taking care to integrate your neutral colors into the overall palette will add layers of depth and meaning to your work. In general, we think of neutral colors as those that have no definite identity. They are neither here nor there: not red, not yellow, not blue. We might define neutrals as the grays and browns we make when we mix all three primaries together. Thinking of landscape subjects, this calls to mind rocks, tree trunks, and branches; sand, clouds, and shadows also often qualify. But, in fact, most of the visual world is actually composed of neutrals. Grays and browns have all three primaries in *nearly equal proportions*, but the majority of the rest of the colors in the landscape involve at least a little red, yellow, *and* blue.

Imagine a grassy field in late spring. Green is surely the dominant color, but if you use a pure spectrum green, made of only blue and yellow, it will look artificial, like cheap plastic turf. You will probably want to add a little red to get it to look like it comes from this planet. The green will still dominate, but "neutralizing" the color a bit by adding its complement creates an earthier hue.

What color are the neutrals? When a gray or brown is called for in a painting, consider giving it a noticeable color identity or temperature. Since neutrals like gray and brown are made up of all three primaries, it would be easy to let one of the component colors dominate just a bit. Alternatively, you could let all three remain visible by not mixing them too thoroughly. The resulting colors are clearly neutral, but the viewer is invited to do some of the work of mixing the components.

Choosing colors that are already present in the painting for your neutrals keeps them integrated in the scene. They should look like part of the same world you have been describing all along. Instead of automatically reaching for Payne's gray and burnt umber, try using the red, yellow, and blue that are already at work on the page. The two quite different paintings on pages 162-163 both benefit from the coherence that comes from mixing the neutrals from the more intense colors that are used elsewhere on the page.

Above:

In this detail of *Socks* it is clear that, nominally, these are white socks, but the warm and cool component colors remain clearly visible. Likewise, the "gray" background reveals how it was mixed.

Opposite:

MARY WHYTE, *SOCKS*, 2010
WATERCOLOR ON PAPER
13⅜ × 14¾ (34 × 37 CM)

The rich, dark background in this portrait appears very casual, but care has been taken to vary the color temperature. The darks are never merely dark neutrals.

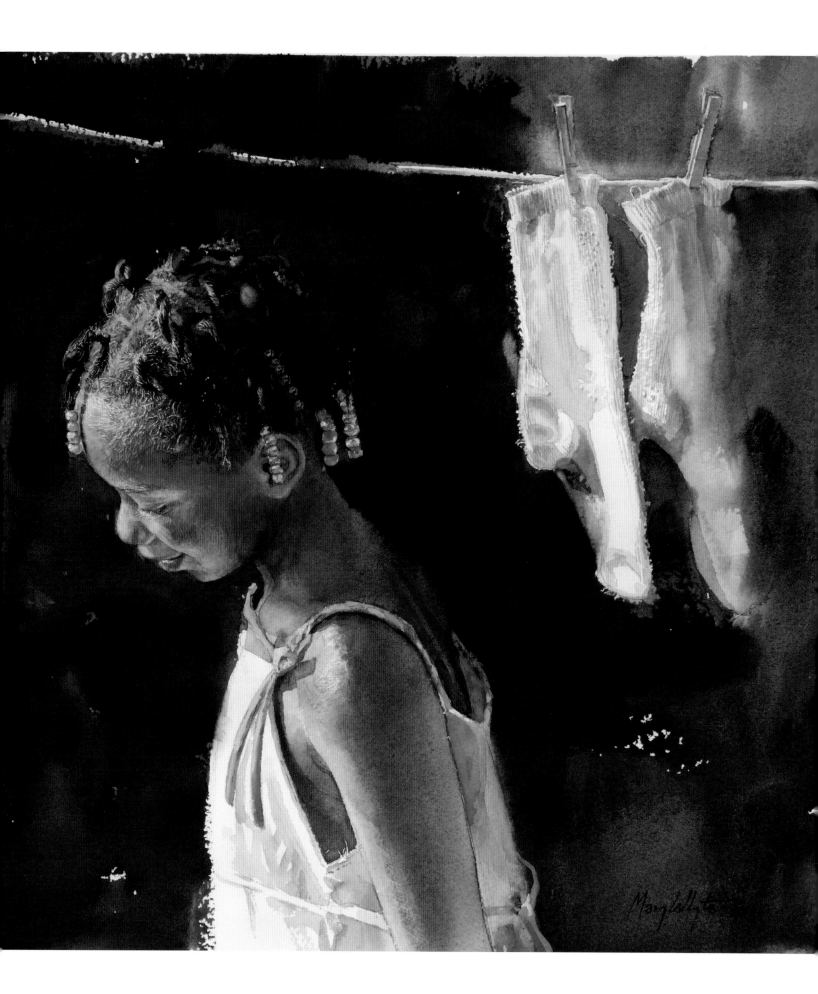

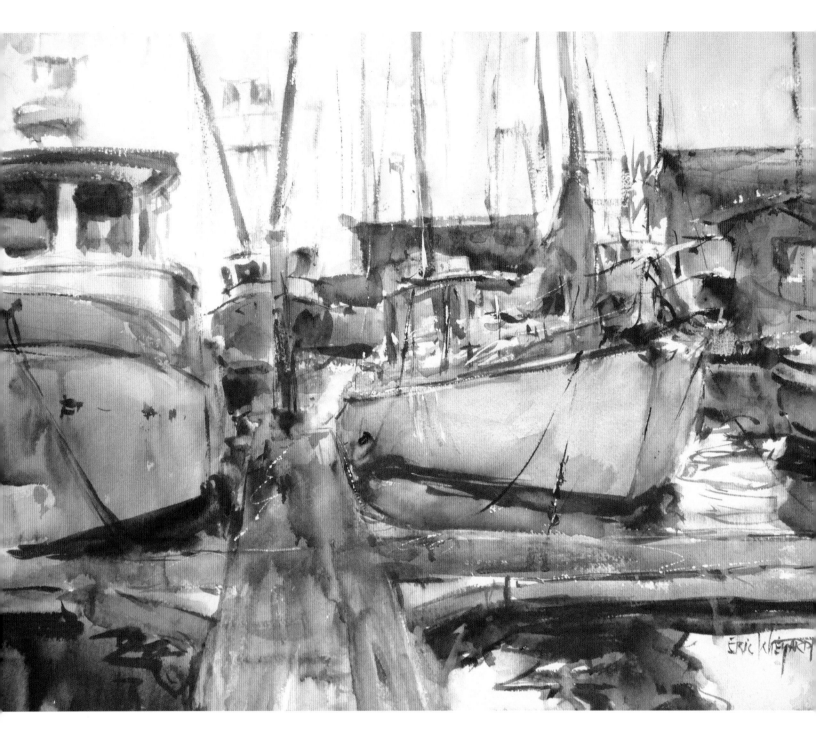

ERIC WIEGARDT, *ILWACO SAILBOAT*, 2009
WATERCOLOR ON PAPER
18 × 24 INCHES (46 × 61 CM)

Here the artist leaves the components of his neutrals visible on the
page, rather than mixing them into simple gray or brown. When we see
those same colors elsewhere in the painting, they resonate with our
expectations.

ISKRA JOHNSON, STUDY FOR *FROM ONE TREE*, 2003
WATERCOLOR ON PAPER
5 × 6 INCHES (13 × 15 CM)

The potent pinks are surprising as the color of leaves, and they might seem unlikely out of context. But the artist has used the intense component colors as the basis for all her mixes, and the result is completely believable.

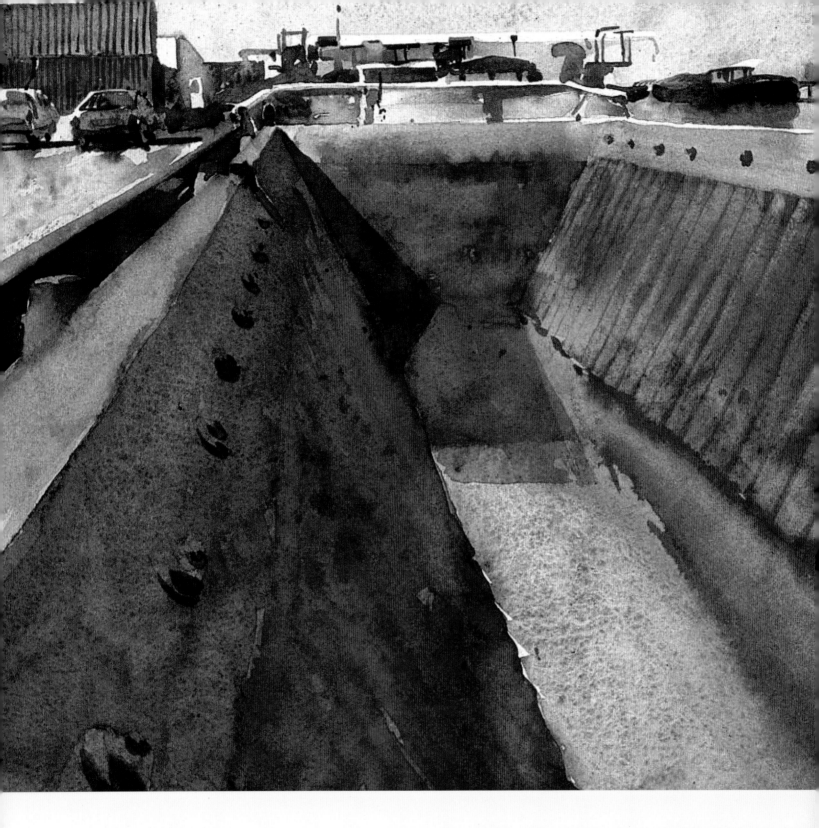

MARC FOLLY, *CHANTIER*, 2001
WATERCOLOR ON PAPER
9½ × 12¼ INCHES (24 × 31 CM)

Composition plays the major role in describing space in this industrial landscape. Marc Folly makes optimum use of dramatic linear perspective to locate the various elements relative to one another. The converging diagonals make us feel almost physically drawn into the trough, which takes up the entire distance from foreground to back. All the other features of the scene are squeezed into a shallow strip of territory at the far end, which goes even further to emphasize the cavernous foreground.

DEVELOPING AN INSTINCT FOR COMPOSITION

We all know that mastering the technical aspects of value, wetness, and color requires a great deal of hands-on experience. Developing an instinct for composition also takes practice, but of another sort. Composition is all about awareness. Arranging shapes on the page so that your main purpose is served is not a matter of manual dexterity. It is entirely a function of *understanding* the medium.

In chapter 1 we looked at the composition of the major shapes as a first step in creating a believable feeling of space in your paintings. Decisions you make regarding where the elements of your picture will be located also determine which of the other variables will need to be brought into play. Once the shapes are given their relative positions, choices can be made about how to make them appear separated on the page. In this way, composition informs decisions about technique (value, wetness, and color).

When composing *Gasworks*, below, for example, it was clear to me from the start that the arrangement of shapes would not be sufficient to describe the distance between the foreground and background. Recognizing that issue in advance and planning a solution were matters of awareness, rather than technique. Once I made a plan, I was able to shift the process from one set of skills (awareness) to the other (technique). Having done this, I could mix colors, adjust values, and apply strokes with a clear purpose.

TOM HOFFMANN, *GASWORKS*, 2010
WATERCOLOR ON ARCHES COLD PRESS PAPER
9 × 13 INCHES (23 × 33 CM)

There is meant to be considerable space between the rusty gasworks structures and the skyline in this scene, but both elements rest on the same horizontal line, which could compromise the feeling of depth. Since placement alone was not going to create the desired illusion, relative value, color, and complexity were adjusted to contribute to the sense of space.

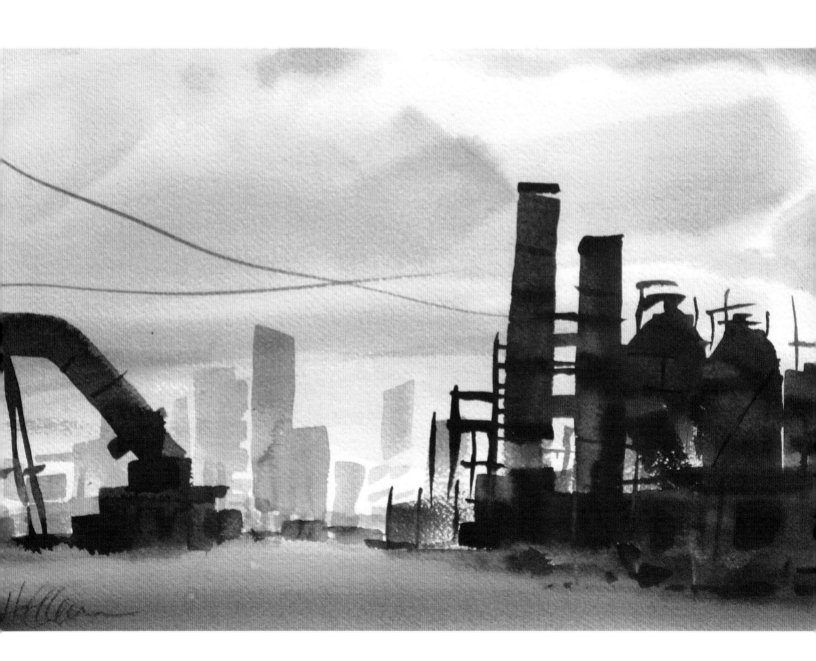

For many painters, making adjustments to the composition is more difficult when working from life than from a photograph. It is easier to see a photo, already translated into a two-dimensional page, as a collection of shapes. Moving them around a bit does not seem so outrageous.

In the photograph below the composition gets confusing on the left side, where several boats overlap. The aluminum boat in the foreground feels attached to the blue boat. If you squint or close one eye, you may notice that the light horizontal band on the foreground boat happens to line up exactly with a similar stripe on the blue one. This juxtaposition confuses the eye, making the two boats feel connected. Once the confusion is identified, potential solutions become apparent: Move the aluminum boat lower or higher on the page until the stripes no longer converge, change the color or value of one of the stripes so they are noticeably separate, remove the foreground boat altogether, and so forth. Standing before the actual scene, it may not occur to you that changes like these are even possible, let alone helpful. The scene attracted your attention, after all. It must be good the way it is.

What works in the real world or in a photo may not work in a painting. Learning to notice what might cause uncertainty is a process of moving back and forth between form and content. The translation from reality to illusion does not always flow without interruption. Unless you are some kind of natural watercolor wizard, you should get used to the idea that making a good painting usually takes more than one try.

Compared to the choices we make as we move a brush across the paper, compositional decisions are made mostly in relatively calm moments. Before any paint touches the paper, or when an early version is being assessed, we can take our time considering alternatives. Still, it can be difficult to see your own work objectively even when you don't have a brush in your hand. The questions presented throughout this chapter are intended to heighten your objectivity, helping you focus your awareness on conscious choices that can enhance your intentions.

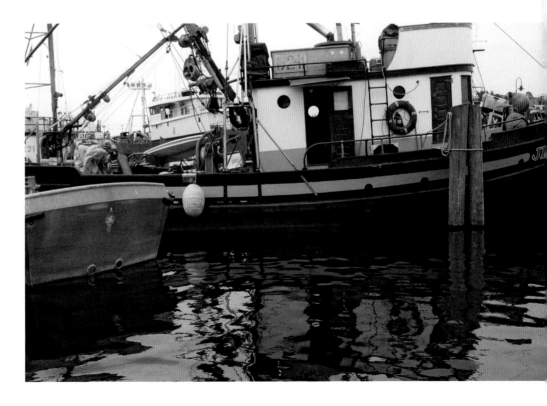

Much of what improves a composition is quite subtle and can easily be overlooked. The convergence of light stripes, for example, that runs through the center of this image is just the kind of problem I might not see until I had made at least one version of the picture. This is another reason to begin with a simple study or sketch, saving both time and paper.

SKETCHING YOUR SUBJECT

How much drawing does the picture need? Drawing can be the painter's primary tool in the early stages of studying and sketching a new subject. I wholeheartedly believe in creating at least one thumbnail sketch of a new subject—particularly to work out compositional issues. However, when the good paper comes out and the proper painting begins, I like to keep the pencil work to a minimum. "Drawing" and "composition" have become almost interchangeable terms in my watercolor practice. I see the role drawing plays mostly as arranging the components of the picture. Once that job is done, I want to stop making lines and start painting shapes.

A drawing done as a work of art in its own right can involve mark making that would be inappropriate in a transparent watercolor. Shading, for example, would cover the paper with so much graphite it would not receive the paint gracefully. Of course, there are many wonderful combination watercolor/pencil pieces, but, in general, we expect to see mostly paint on paper in a watercolor. The line work that precedes the painting is meant to make it easier to apply the paint with confidence, but too much preliminary drawing ends up constraining the brushwork, making it feel necessary to stay inside the lines.

As a general rule, I use a pencil or very pale paint to locate the major shapes. These are the relatively few shapes that need to be separated from each other for the illusion of space to be realized. It is not necessary to describe the objects at this stage of the process. We only need to know *where* they are, not *what* they are. Making sure the viewer can tell what he is looking at comes late in the painting process, usually after a couple of layers of paint have been applied.

> Making sure the viewer can tell what he is looking at comes late in the painting process, usually after a couple of layers of paint have been applied.

For the most part, the less drawing I do on the watercolor paper, the freer I am to invent as I go, and the more likely I am to stop when the painting tells me to. I am not recommending doing no drawing at all, though. I do this sometimes, and it can get me into trouble. If I am overconfident and skip the thumbnail sketch, or don't lay out the page at all, I often end up with a composition that doesn't work, as happened with *Houseboat Backyard,* opposite. Most of the trouble comes from the dark cluster of pilings in the center of the composition. The dark rectangle on the right side of the cluster happens to line up with the rectangular buildings that are supposed to be way across the water. And the light and antenna on top could easily be mistaken for the Space Needle. Chances are I would have noticed these issues if I had taken a few minutes to make a sketch. Considering that a painting succeeds or fails at the level of the basic shapes, a little preliminary drawing can't hurt.

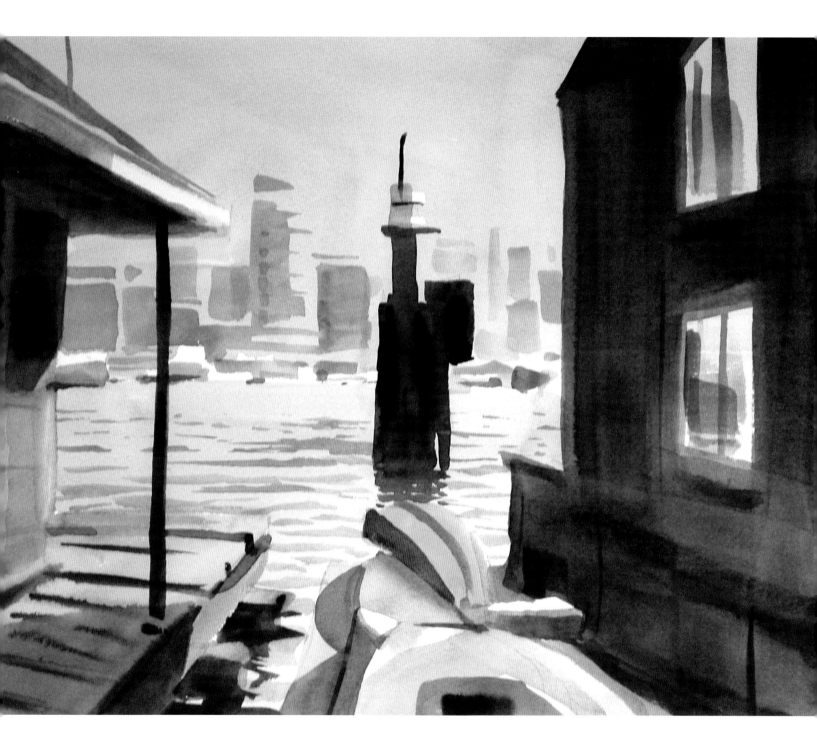

TOM HOFFMANN, *HOUSEBOAT BACKYARD*, 2010
WATERCOLOR ON ARCHES COLD PRESS PAPER
10 × 14 INCHES (25 × 36 CM)

The illusion of space in this scene from one of Seattle's houseboat communities is undermined by
the placement of the cluster of pilings. It appears to be perched directly on top of the orange kayak.
In addition, its shapes are similar to the buildings in the distant skyline. If I had created a thumbnail
sketch, I probably would have realized that I needed to keep
the two elements more separate.

TRANSLATING FORM INTO CONTENT

As painters, we are accustomed to looking at an image or a scene in terms of pure form. We squint or close one eye to see the relative value of shapes or the distribution of color. We learn how to pay attention to what is happening on the picture plane completely apart from what it means. Any illusion we succeed in creating, whether it is space, or light, or mood, is just that: an illusion. When all is said and done, all we really have is paint on paper. We make the washes and strokes that we believe will call forth the story we hope to tell, but it is the viewer who ultimately supplies the meaning.

This translation of form into content is very often done subconsciously. To the untrained eye, content appears to be coming directly from the painting, and all the credit for a convincing story is given to the artist, but the viewer must be ready to meet us halfway, or nothing is communicated. The individual viewer may not be aware that he is interpreting form, but the role is still gratifying. And, just like reading a poem or listening to music, it takes talent. At least, it *can*, if the artist has faith in his audience.

Try as we might—and some try very hard—we cannot control exactly what every individual will read into our paintings. Even the most carefully rendered duplicate of a photograph leaves the door open for a viewer to interpret the image according to his own associations. This, of course, is a good thing. If we could manipulate every viewer's response completely, we would be propagandists rather than artists.

For the realist painter, creating an effective illusion of space in a painting is especially important. Although everything is actually happening on a flat piece of paper, the individual shapes that make up the scene must appear to be in different planes. We ask ourselves: *Is the message clear?* We usually want the viewer to know where the elements of the scene are relative to each other, so we take care to establish foreground, middle, and background planes, like the flats in a stage set. The wonderful irony is that the primary tool for creating the illusion of three-dimensional depth is how we arrange the shapes on the two-dimensional picture plane.

KATE BARBER
THE PRICE OF GAS, 2005
WATERCOLOR ON PAPER
15 × 20 INCHES (38 × 51 CM)

Although this scene is crowded with shapes, the foreground, middle ground, and background are clearly separated. Care has been taken to overlap forms and show where they meet the ground plane, making it possible for the viewer to make sense of the space.

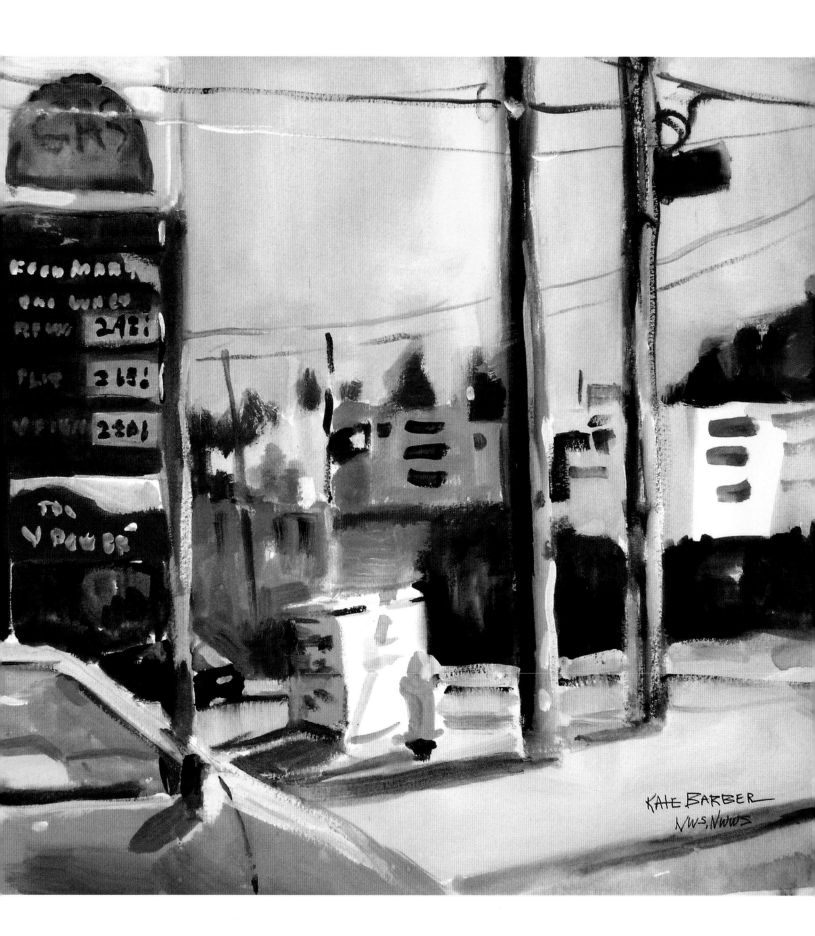

KATE BARBER
NWS, NWWS

Sketch the subject.

Notice how the horizon lines up with the eave of the cabin, and the profiles of the mountains meet the corners of the roof. The tops of the trees also just happen to touch the outline of the hills, and the cloud, which mimics the shape of the mountain, teeters on the highest peak. All of these alignment choices undermine the illusion of depth.

Look for awkward alignments.

This configuration of lines comes from the previous drawing. Do you see it? Out of context, it appears completely abstract. The lines radiate from a central point, seeming to be in a single plane. At the same time, they are attempting to describe shapes that are separated by considerable space (cabin front, roof, hill, mountain, and sky). What we see (the visual reality of lines on paper) works against what we know (the illusion of depth).

Adjust your sketch.

Shifting the alignment of shapes a little clears up the ambiguity. Making the overlap of shapes obvious ensures that the mind and the eye get the same message.

When we look at a painting we receive information by means of both what we *see* and what we *know*. Whether consciously or not, every viewer is seeing both form and content. If the artist has intended to create a convincing sense of space in the picture, it is important for the viewer's eye and mind to get the same message. It is the painter's job to make sure that the parallel aspects of form and content are working together.

In the top sketch opposite, the major shapes have been arranged in a relationship that seems to make sense, according to what we know. In terms of what we see, however, the message is not clear. Our brains know that the cabin is in front of the mountains, and that the cloud is beyond the peak, but our eyes are being given a different message. Form and content are at odds, making the experience of looking at the image uncertain.

There is no harm in making it easy for the viewer to read the space in your painting. If you are not sure whether the illusion is complete, try looking at the painting in a mirror. The objectivity you gain by reversing the composition should make the answer obvious.

CARL SCHMALZ, *BACKYARD LAUNDRY*, 2007
WATERCOLOR ON PAPER
15 × 21½ INCHES (38 × 55 CM)

A little overlap goes a long way. In a composition with so many rectangular shapes (roofs, walls, fence posts, chair, and laundry) there was the risk of making a two-dimensional collage. With subtle overlapping of shapes, Carl Schmalz made sure we could easily see where each shape is in space.

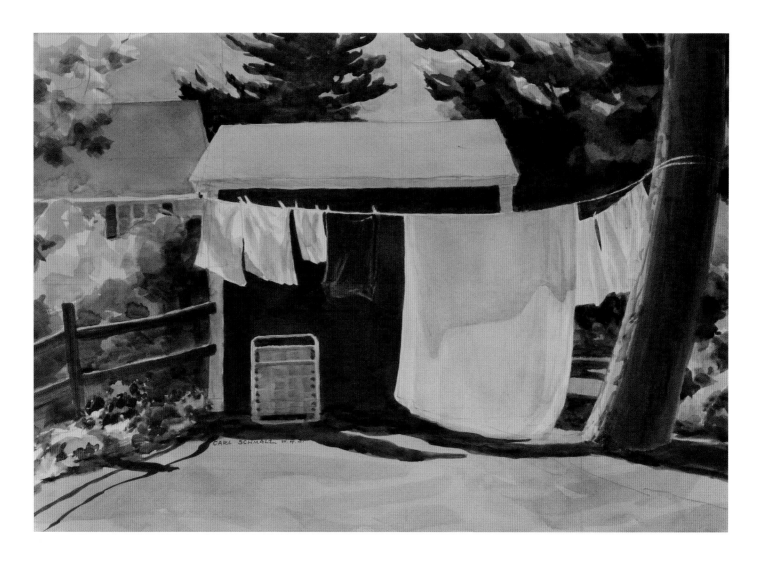

The diagonal edges of the dominant foreground shape (the dark rooftop) are almost exactly parallel to diagonals in the middle distance (the hill on the left and the roofline on the right). This coincidental relationship is so insistent it seems deliberate, making it hard to ignore and flattening the space.

As shapes, the high wall (left) and the tree just beyond are almost perfect mirror images, which encourages us to see them as linked rather than separated in space. In addition, both line up with the ridgeline in the distance. A more obvious overlap would enhance the feeling of distance.

KNOWING WHEN TO DEPART FROM "ACCURACY"

Since so much of the illusion of space in a painting comes from the placement of the major shapes, it is important to question how they appear in the scene. How they relate to each other in terms of scale and alignment is up to you. They can, and often should, be moved. What you see, as always, is just a starting point. When you are evaluating your subject, make sure to ask: *When should I depart from accuracy?* This is especially important when working from photographs. Most of us are amateur photographers, at best, and we tend to compose our pictures by putting the main subject right in the middle of the frame. Even those who think of the scene as a potential painting often forget to see how the shapes line up. As a result, the illusion of space is compromised.

When you look at the two photographs at left, try either squinting or closing one eye. This will help reveal how the shapes relate to the picture plane. For instance, in the first image, does the overhang appear to be closer or farther away than the garden?

With the second image, squinting reveals that the patch of roofs in the middle ground has so much in common visually and is so precisely aligned with the low wall in the foreground that the former appears to be stacked on the latter. The shapes align so neatly and are so similar in color and value that they appear to be on the same plane. How might these two elements be shifted to enhance the feeling of space?

There are almost always enough subtle clues in an actual scene, and usually in a photo, to tell us where the various components are in relation to each other. By the time that information has been transferred into washes and strokes on a page, however, at least some of the subtlety is gone. Seeing in advance what must be changed or emphasized in a scene takes time and practice. It is always easier to see what you should have done after you've gone astray. This is yet another reason to start work on a new image with a simple study, such as the one opposite, rather than a full-blown painting.

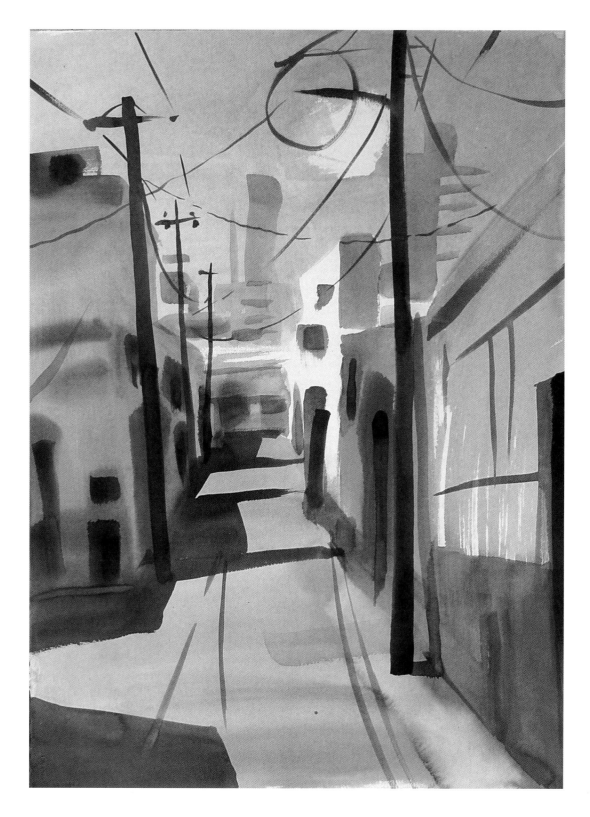

TOM HOFFMANN, *BLACK/WHITE ALLEY*, 2008
WATERCOLOR ON ARCHES COLD PRESS PAPER
12 × 9 INCHES (30 × 23 CM)

A quick monochrome value study reveals changes that will help make the space and light more convincing. The location in space of the buildings at the far end of the alley is muddled, and something is not right about the phone pole on the left. The shadow in the lower left corner does not lie down flat on the ground. What would you do to solve these problems?

CREATING THE ILLUSION OF SPACE

Overlapping shapes is an effective way to tell the viewer that two forms are separated in space, but it is not always sufficient. Checking to see if the feeling of depth you want has been adequately established is an ongoing process—one that may need to continue well beyond the composition stage of the painting. This is when you need to ask yourself: *Which variables will work best to separate the shapes?*

Each of the main variables we have discussed can be manipulated to add to the illusion of space. Adjusting value, wetness, and color—alone, or in combination—will enhance the feeling established by a strong composition. How many variables, and which ones the task requires, depends on the individual situation.

The list of variables is short. Once a problem is identified, it does not take long to consider which ones are not doing all they can. Potential solutions can be tried out quickly, in a thumbnail sketch. You may even see a solution just by posing the question mentally. Recognizing which variables to put to work takes some practice, though. To begin, consider the choices other artists have made.

Most of the examples that follow show how variables can be used to *separate* shapes. It is worth noting, however, that shapes can also be *combined* by manipulating variables. For instance, take a careful look at *Falmouth Dry Dock,* on page 178. Where the hull is in shadow, Chamberlain chose to allow the ship to merge with the space inside the dry dock by minimizing the differences in color, edge quality, and value.

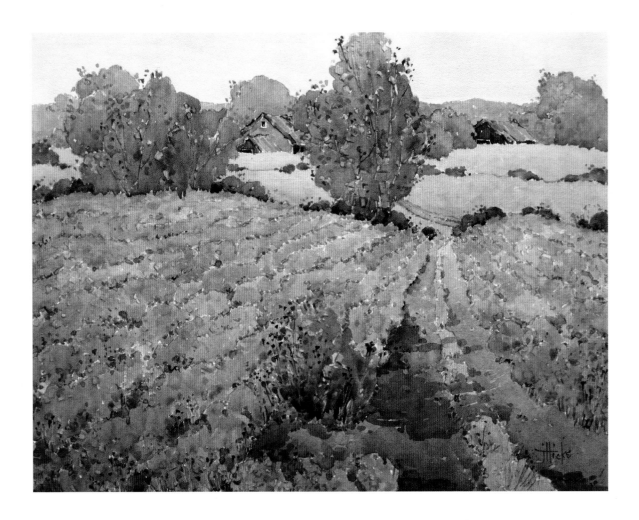

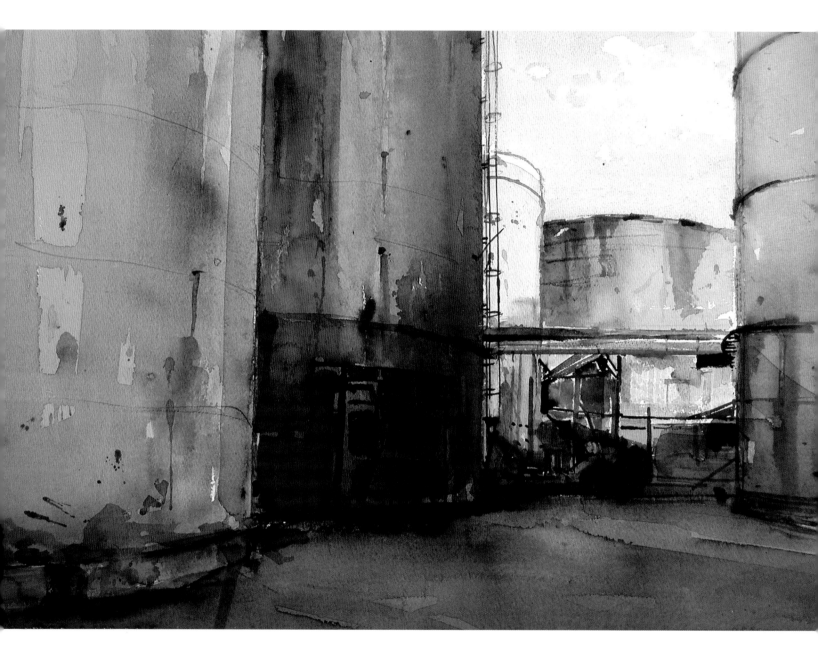

Opposite:

JOYCE HICKS, *PENNSYLVANIA IDYLL*, 2011
WATERCOLOR ON PAPER
18 × 24 (46 × 61 CM)

Working with a limited palette, Joyce Hicks still makes the most of color as a compositional tool. At every major transition, from foreground all the way back to the sky, there is a noticeable change in hue. This, combined with the overlap of shapes, makes the feeling of space unmistakable.

Above:

TORGEIR SCHJØLBERG, *KULTURLANDSKAP*, 2004
WATERCOLOR ON PAPER
19¾ × 27⅝ INCHES (50 × 70 CM)

This bold image, with only seven shapes, is more like a still life than a landscape. Look at the places where the shapes meet. Which variables are working to separate them? While drawing alone would go a long way toward making the spatial relationship of the shapes obvious, color and value enhance the illusion.

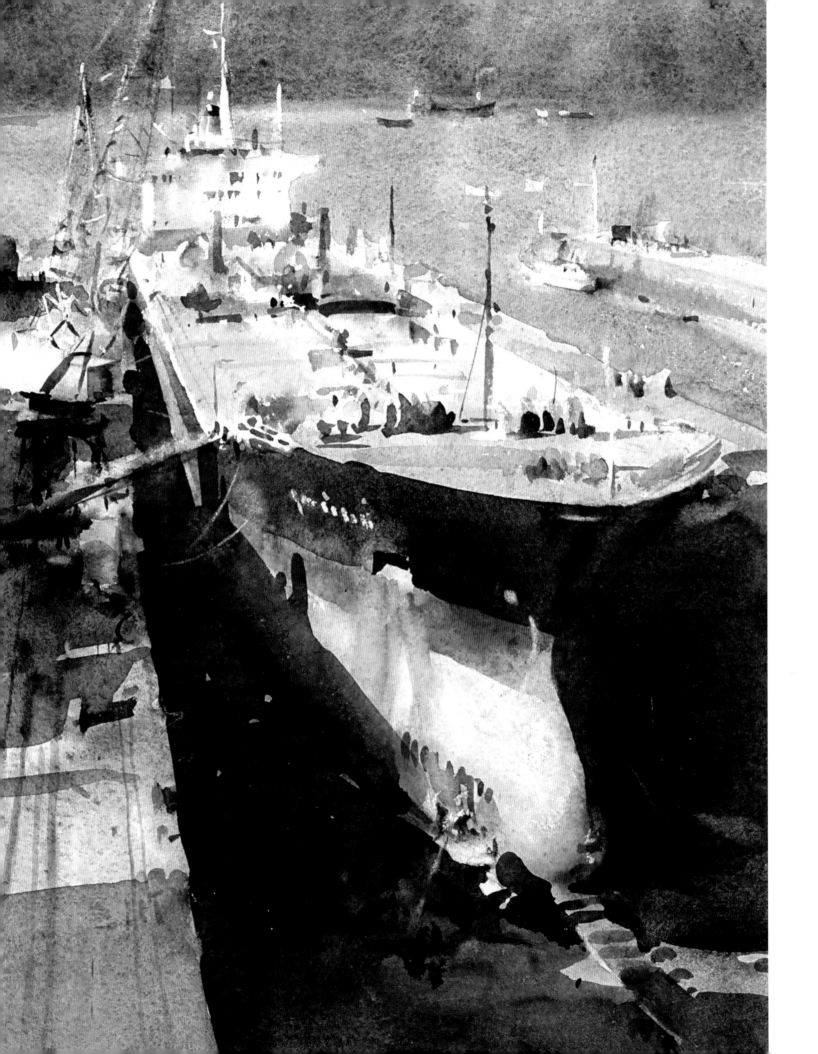

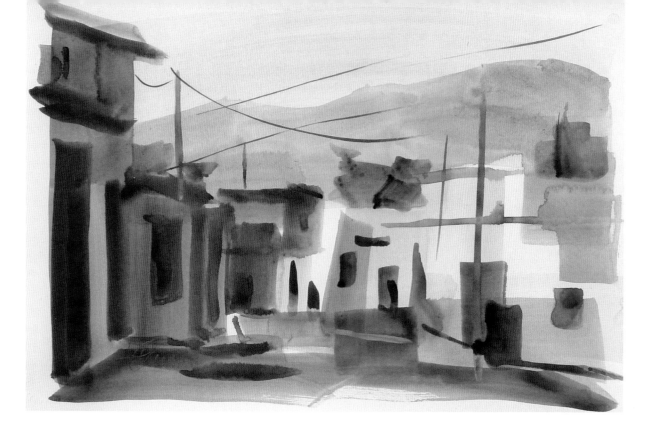

Above:

TOM HOFFMANN, *ETLA, OAXACA*, 2009
WATERCOLOR ON VISTA HERMOSA PAPER
15 × 22 INCHES (38 × 56 CM)

Space is deliberately made ambiguous in this composition. The planes of the buildings have come unhinged, creating the feeling that they are being shuffled, like cards. There is still a sunny side and a shady side of the street, which anchors the scene somewhat, and the stability of the mountain in the background helps contain the chaos.

Opposite:

TREVOR CHAMBERLAIN, *FALMOUTH DRY DOCK*, 1992
WATERCOLOR ON PAPER
13 × 9½ INCHES (33 × 24 CM)

Following the outline of the deck of the tanker, it is clear that the artist is using more than one variable to separate the ship from its surroundings. There is a noticeable color difference between the warm deck and the cool water, but they are quite close in value. Maestro Chamberlain kept a crisp edge between the two to ensure that the ship maintained its imposing substance.

BEING MINDFUL OF ABSTRACTION

Not every painting relies on a believable illusion of space for its success. Before you start painting be sure to ask: *What role does composition play in this picture?* You may decide—as I did with *Etla, Oaxaca*, above—to compose the elements so that space is not represented in a traditional manner. Composition serves the order and balance of the page at the level of pure form first, and then as a tool for creating an illusion of space.

At the same time that we are working toward an illusion of reality, we are also arranging strokes and washes on the picture plane. Even when the viewer's attention is focused on the illusion, at some level he is observing the brushwork as an abstract pattern. It seems like a good idea, therefore, to stay aware of the appeal our marks have apart from whatever they are meant to describe.

In many cases, the effectiveness of the illusion depends on decisions we make regarding how the strokes are distributed. With *Seaweed 1* (opposite), for example, a kind of circular irony is at work. We experience the illusion of brushstrokes on paper becoming seaweed. If we were actually standing on the beach, however, we might describe the seaweed as being arrayed on the sand "like brushstrokes on a piece of paper."

As we approach the line between realism and abstraction, more of our attention is consciously devoted to the paint as paint. Without the distraction of an illusion, it becomes increasingly important to make sure that the fluid nature of the medium is not compromised. Keeping the composition simple and purposeful can free up the viewer's attention to be devoted more to what the paint is doing.

BETSY CURRIE, *GRASSES WITH SKY*, 2005
GOUACHE ON PAPER
4¼ × 6¾ INCHES (11 × 17 CM)

The grass seems to have simply "grown" on the page, but conscious decisions were made to ensure this feeling of natural order. The stalks that curve to the left balance those that curve to the right, and the yellow and green strokes are alternated to suggest space. While all the strokes are actually on the same plane, it feels like the grass is several feet thick. How do you think the image would change if no sky were visible?

CYNTHIA HIBBARD, *SEAWEED 1*, 2011
WATERCOLOR ON PAPER
16 × 12 INCHES (41 × 30 CM)

This distribution of shapes seems as if it happened by itself—a result of the movement of the waves. But, seen as a composition, it is clear that the artist has taken care to create both a casual array of forms and a balanced page.

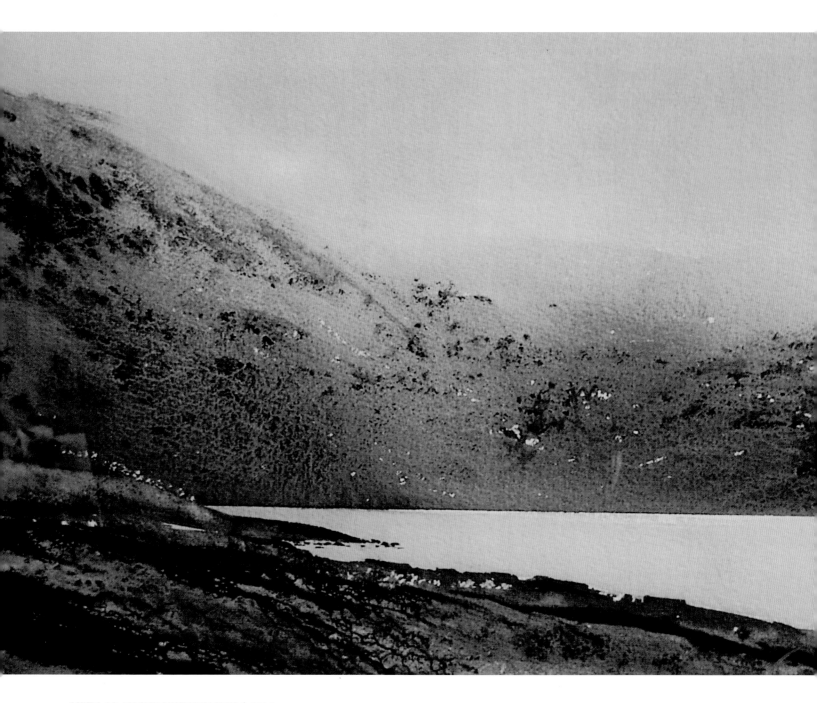

PIET LAP, *NORTH UIST HEBRIDES 5*, 2010
WATERCOLOR ON PAPER
15¾ × 21¾ INCHES (40 × 55 CM)

The artist invites us to enjoy the flow and granulation of the paint at least as much as we pay attention to the story it tells. The placement of the relatively few shapes immediately describes what we need to know about content, leaving us free to savor the medium.

Establishing Balance

Balance in a composition is a tricky concept. It hinges on questions both subjective and universal. On one hand, every artist has his own sense of what makes a painting "hold still." Having more weight on one side may feel awkward to some, but provide a desirable feeling of tension for others. At the same time, it is clear that we all share some fundamental sense of what makes a composition click into place. In class, with a group of a dozen painters assessing the same painting, I often ask that critical question: *Is the painting balanced?* It is remarkable how frequently everyone agrees about where the image needs a little something more. Should you trust your own instincts, then, or stick to the classic standards? Below are a handful of suggestions, starting with rule number one.

DISOBEY THE RULES

As students of painting, we all encounter rules along the way, many pertaining to composition: "Always have the subject touch the edge of the paper in three places," "Never have a vertical in the center of the page," "Always place buildings with an edge forward," "Never run a hard edge all the way from one side of the page to the other," and so on. These are all good advice, as long as you replace the "never" and "always" with "consider." The teachers who made the rules were really saying, "This is something that often serves me well. Keep it in mind." By all means, gather as many effective suggestions as you can. Just don't become bound by them.

How you decide what your painting needs will be a combination of what has worked in the past and what the immediate situation suggests. In the relatively calm moments of translating the subject into paint, such as when you are deciding where to place the horizon, you can weigh the alternatives in terms of the feeling you want the painting to embody. If you have learned that raising the horizon tends to ground the viewer and lowering it elevates the point of view, you can make a considered choice. But once the paint starts flying decisions are much more intuitive. Who's got time to ponder with a brush in each hand and another between his teeth? Trusting your feelings is the foundation of developing your own style. It is certainly riskier than following the rules, but it is also much more fun.

If the painting feels balanced, it probably is. When something seems wrong, however, there are some simple devices that may reveal the problem.

ACTIVATE THE CORNERS

Do you tend to leave one or more of the corners of the page empty? This can throw the whole composition off. Thinking minimally, you can add a soft-edged stroke or two to activate the empty area and see if that is enough. If not, turn up the value of a stroke, or make an edge harder. Increase the impact of your additions by increments until you have done enough. You can play it even safer by painting a scrap of paper and placing it where you think something is needed and moving it around until something clicks.

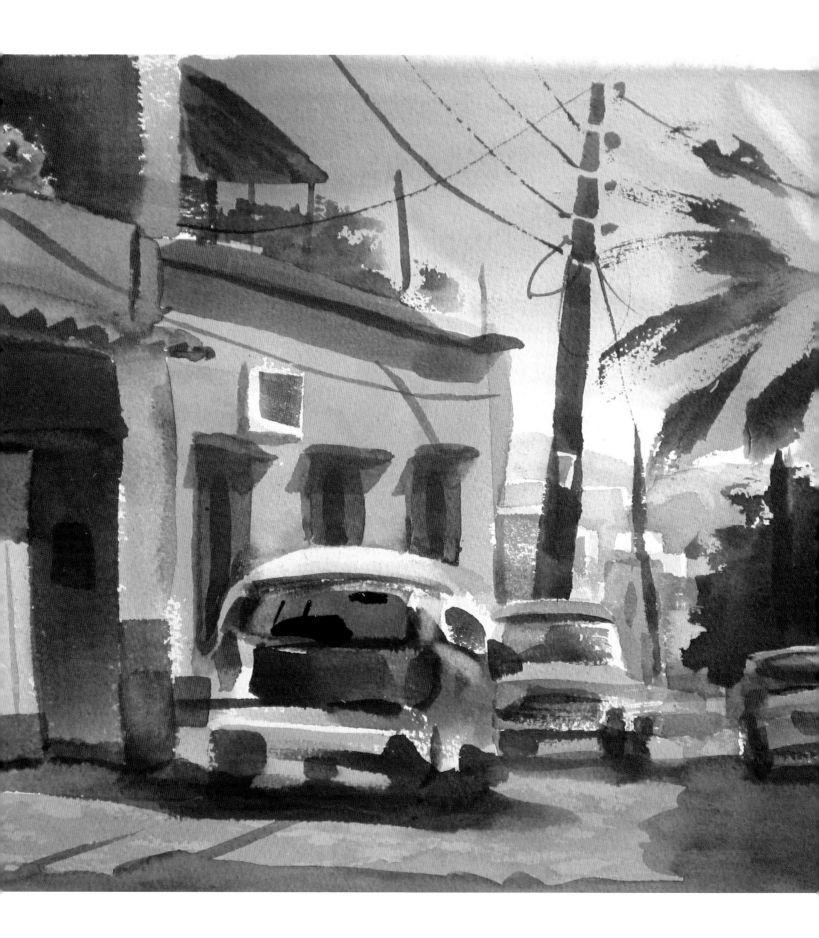

COVER THE PAGE IN SECTIONS

Putting a plain piece of paper over part of the painting will often reveal where the problem lies. If the uncovered area looks fine, or better, the imbalance is probably in the covered part. See if you can use this device to reveal issues of both form and content. Cover a section and assess the feeling of balance, or color distribution—both formal qualities. Then consider how the same cropping affects the illusion of space—a content concern.

Above:

TOM HOFFMANN, *LAKE UNION DRYDOCK*, 2010
WATERCOLOR ON ARCHES HOT PRESS PAPER
11 × 15 INCHES (28 × 38 CM)

I have never been one to put the prosaic seagull in a water scene, but in this case the temptation to launch one in the upper-right-hand corner is strong. Or maybe a small airplane.

Opposite:

TOM HOFFMANN, *XOCHIMILCO, OAXACA*, 2011
WATERCOLOR ON ARCHES ROUGH PAPER
11 × 15 INCHES (28 × 38 CM)

Try covering this image in quarters to see if the balance improves.

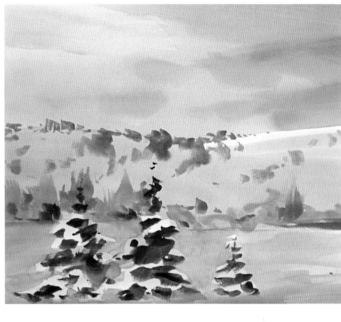

TOM HOFFMANN, *NEW SNOW*, 2010
WATERCOLOR ON ARCHES HOT PRESS PAPER
21 × 22 INCHES (53 × 56 CM)

This picture always seemed a little heavy on the left. The foreground trees congregate on that side, and the background hill has many more trees on the left side than the right.

As soon as I flipped a digital version of the image I could see that the balance would have been improved by having either the trees or the bushes moved to the right. The shapes on the hill would then have offset the ones in the foreground.

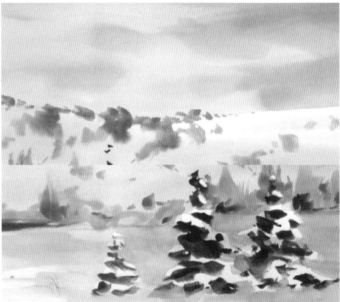

Now I really wanted to see how it would have looked, so I manipulated the digital file, giving the image a half twist. With the foreground trees pushed over to the right the overall balance was greatly improved. Oh well . . .

LOOK AT THE PAINTING IN A MIRROR

Reversing the entire composition helps you see the painting with fresh eyes. Flipping a digital version does the same thing. Simply turning the picture upside down offers the benefit of abstracting the scene, which frees you from the dictates of content. The detachment you achieve by means of these simple acts allows you to weigh the relative dominance of form and content. Ideally, you will be able to adjust that balance to your complete satisfaction.

ESTABLISH A CENTER OF INTEREST—OR NOT

Some rules are so persistent they take on the aura of gospel. The idea that every picture must have a clear center of interest looms menacingly over all of us puny painters. Granted, having a focal point is a really good idea, but does every picture need one? Must we always tell the viewer where to linger? In fact, the whole idea of the artist directing the viewer's eye has always bothered me a little. When I read an analysis of a painting that describes the "eye path," I'm never sure that's where my eye has traveled.

We are all used to looking at the world in a broad way from time to time. It is possible, for example, to take in the entirety of Niagara Falls as a vast phenomenon without focusing on just one spot. This same kind of gaze is just as appropriate for some paintings as it is for observing the real world. If you deliberately put a focal point in every picture, you will never learn the other ways of composing a scene.

The main job of a center of interest is to organize an otherwise busy surface. It offers the viewer a home base from which the relative subtleties of the rest of the page can be explored. Whether there is a consciously designed focal point or not, it is important not to pull the viewer's attention in too many different directions. Allowing more than one center of interest is asking for trouble.

If you choose to have no focal point, therefore, it is best to keep the composition simple and avoid the conflict of too many insistent areas. The image below features only three major shapes. The center strip, with its saturated paint and hard edges, stands out against the soft-edged sky and the simply stated water. Instead of a single center of interest, a picture can offer the viewer an opportunity to stand where the artist was standing, allowing their eyes to go where they will. The viewpoint becomes the focal point.

TOM HOFFMANN, *SOMETIME*, 2010
WATERCOLOR ON ARCHES COLD PRESS PAPER
10 × 16 INCHES (25 × 41 CM)

Where is the center of interest in this scene? On the site, there was no one spot that drew the eye more than any other, but the scene still wanted to be painted. The simple "flag" composition (three horizontal bands) allows the viewer to take in the whole scene at a glance, so the image does not need to be held together by a focal point.

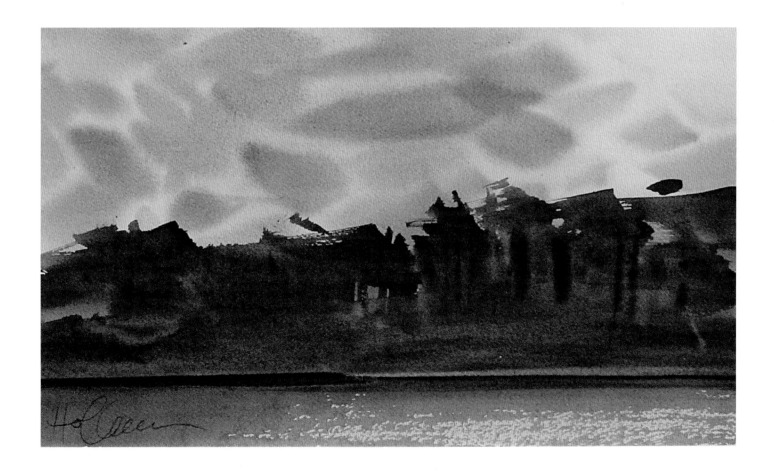

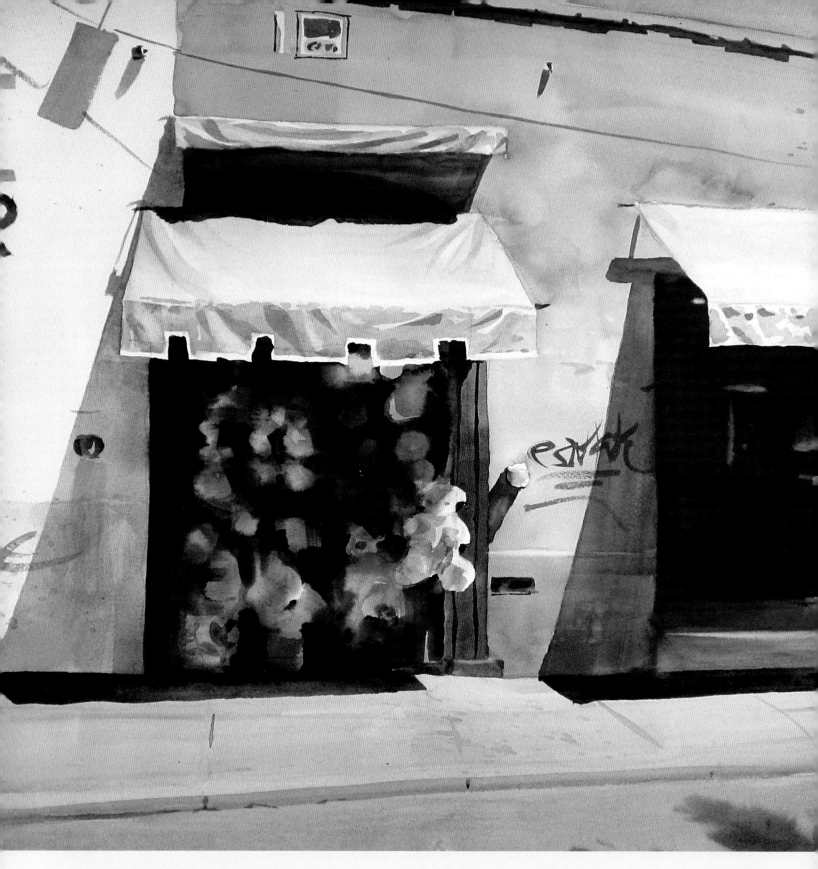

TOM HOFFMANN, *PINO SUAREZ, OAXACA*, 2011
WATERCOLOR ON ARCHES COLD PRESS PAPER
22 × 29 INCHES (56 × 76 CM)

What started as the watercolor equivalent of practicing my scales went on for the whole morning. I had not painted this carefully for many years. It was surprisingly satisfying.

~ CHAPTER EIGHT ~

BECOMING YOUR OWN TEACHER

Although I try to be a detached observer of my own work, I often overlook the weak points of a new painting. It can take a while before I can see what is really there on the page. At the end of a day of painting I may head home believing I've got a few beauties, only to discover the next morning that they have been transformed into beasts.

As painters, we are eager to see the positive results of our efforts, projecting the harmony we *wish* to see onto our work. Although this leads to disappointment, it may not be entirely a waste of time. If we can convince ourselves that we have painted the picture we intended, we must have a sense of what that would be. Our job, then, is to get that vision to hold still long enough to use it for comparison. Ideally, as we progress from sketch to study and on to however many versions we need to make, we are bringing our intention into sharper focus. This chapter is designed to provide some tools for shortening the process.

Identifying the Qualities of a Good Teacher

It takes practice to gain the detachment of an objective observer, but, over time, you can become your own best teacher. A good place to start may be to list what you consider the qualities of a good teacher. My list is below. What would you add?

PATIENT

Progress takes time. We all want to make great strides, but, realistically, you must expect some of them to be backwards.

KIND

Pay at least as much attention to your strengths as to your weaknesses.

HONEST

Someone has to be willing to tell you to get another piece of paper and do it again.

ENCOURAGING

Do not give up! (At least not until you have put in the darkest darks.)

DEMANDING

Do not settle for less than your best. If you really mean to become a better painter, now is the time to do the work.

LIGHTHEARTED

By all means, be a serious painter, but don't take yourself too seriously. The whole business of putting little wet marks on fancy paper is pretty funny, really.

Establishing Who Is in Charge

We all benefit from time spent with a good teacher, and much of our learning comes from exposure to other painters. The benefits of being part of a community of artists are real and meaningful. But in the day-to-day practice of taking risks and assessing results, we must rely on our own awareness to keep us moving forward. *Who is in charge?* You know the answer.

What do you do when something feels not quite right with a painting? Do you have a way of getting some distance on the work? On a good day, I will stand back and look at the painting as if someone else had painted it, taking the time to question and discover what worked well and what did not. But if I am distracted by the need to see some immediate return for all the time I've put in, I'm more likely to launch right into a new version, hoping to get lucky.

This impatience often causes me to miss the obvious flaws and make the same mistakes in the next version, or to keep adding information until the painting is overloaded. It can also undermine my ability to see what is worth repeating. A painting that feels like a flop can be hard to even look at, let alone analyze, but it may not be as bad as you think. If you tend to want your failures out of your sight as soon as possible, you are missing a valuable opportunity. When you manage to forestall the embarrassment long enough to see what is really on the page, you may find that very little needs to be changed. Sometimes the whole problem may be a lack of emphasis in a certain spot that can be resolved with a single stroke.

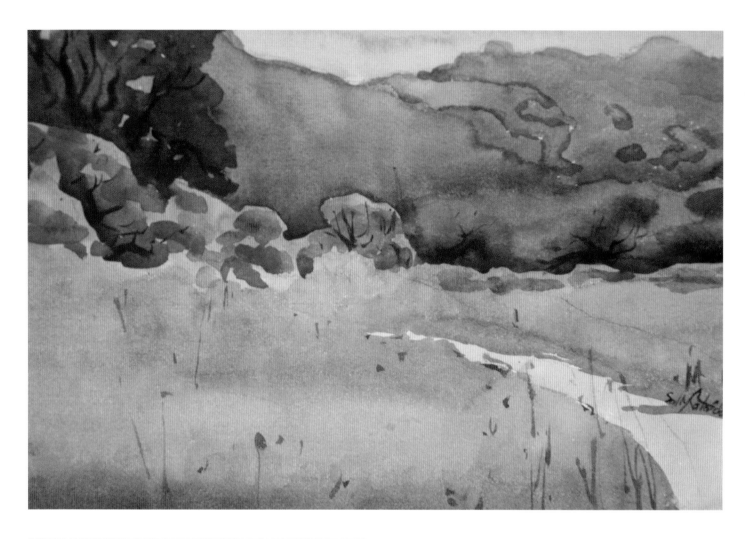

If I indulge in passing the blame for my results onto the weather or the brush, I am essentially saying, "What can I do? It's not my fault." This attitude makes it hard to see a solution to the problem.

SALLY CATALDO, *FLUID LANDSCAPE*, 2009
WATERCOLOR ON PAPER
16 × 12 INCHES (41 × 30 CM)

In this very personal interpretation, the artist has chosen to describe the feeling of the place rather than specific information. The individual leaves may have been asking to be painted, but they were not ultimately in charge.

TOM HOFFMANN, *TIDAL RIVER, CLOUD* (IN PROCESS), 2011
WATERCOLOR ON ARCHES COLD PRESS PAPER
15 × 11 INCHES (38 × 28 CM)

The cloud was what stopped me in my tracks, but the painting did not do it justice. It doesn't *loom* as it should. At the time, I lacked the detachment to see what could be done. Fortunately, I did nothing.

TOM HOFFMANN, *TIDAL RIVER, CLOUD,* 2011
WATERCOLOR ON ARCHES COLD PRESS PAPER
15 × 11 INCHES (38 × 28 CM)

One month later, I could see that darkening the sky might give the cloud more presence. Not wanting to overdo it, I changed just the top, knowing I could darken more, if necessary. That little bit seemed enough.

> Painting always involves attention to both process and product. The difference is that letting process dominate has a positive effect on product, while the opposite is not always true.

The objectivity that allows me to see my own work clearly is directly related to my willingness to take responsibility for the painting. If I indulge in passing the blame for my results onto the weather or the brush, I am essentially saying, "What can I do? It's not my fault." This attitude makes it hard to see a solution to the problem. But if I really take charge of my own progress, I become the person looking over my shoulder who can see my strengths and weaknesses, and suggest how to use the former to develop the latter.

Whenever I identify a consistent problem in my work, like not getting the darks dark enough on the first try, I suspect that I am avoiding something. Perhaps I am afraid of making the darks *too* dark, and keep leaning away from that danger, for instance. If so, the solution is to push my practice in the opposite direction and try to make those darks too dark deliberately. In the process, I usually find out what the true range of the medium is and create a wider comfort zone for myself.

PAINTING FOR ITS OWN SAKE

If you think a lot about how painting fits into your life, it is natural to find yourself asking: *Am I painting or making art?* This is a subject that makes me feel like the cartoon protagonist with an angel on one shoulder and a devil on the other. The inner dialog goes something like this:

Angel: "Real artists paint because it is inherently satisfying. They are not trying to make impressive paintings. Striving for Art is too product-oriented."

Devil: "Give me a break! Since when is it a crime to want to make good paintings? I'm a painter, after all. It's what I do. And I'd like to do it sooner rather than later. In fact, today would be good. I'm trying to make a living at this. Besides, aren't you striving when you try not to strive?"

Angel: "You only do what you know will impress people."

Devil: "And you only *pretend* not to care whether other people like your work."

Angel: "Hack!"

Devil: "Phony!"

And so on. Fortunately, it is not necessary to choose which voice to listen to. The two sides are aspects of the same activity. Painting always involves attention to both process and product. The difference is that letting process dominate has a positive effect on product, while the opposite is not always true.

Directing your painting toward clarity and cohesiveness requires staying aware of the big picture, which *is* a kind of product awareness. Painting with no guidelines at all may feel good for a while, but with no element of challenge it becomes pointless. The result we aim for, ideally, is becoming a better painter, rather than producing a prize-winning picture.

When we are inspired, or even just curious, we simply paint. When we lose sight of our inner motivation we tend to look around for some external measure of the worthiness of our output. Before long, we are focused on how to make each piece of paper into an impressive product, which actually slows our progress. Efforts tend to be guided by what we already know will work. Mistakes are disguised as soon as possible, before the lessons they offer can be learned.

To make the most rapid progress, it is necessary to be willing to allow the painting you are working on now to fail. Ironically, most of the decent paintings I have made were the result of being engaged in just painting.

On those inevitable days when nothing calls out to be painted, I recommend simply working on the craft of watercolor. I often set out a single object, like an onion or a teakettle, and paint it several times. After a short time the interpretations become more expressive, and my eyes are awakened to possibilities around me. Sometimes I get to work on a literal translation of a photo, like the image that resulted in the painting that appears on page 188.

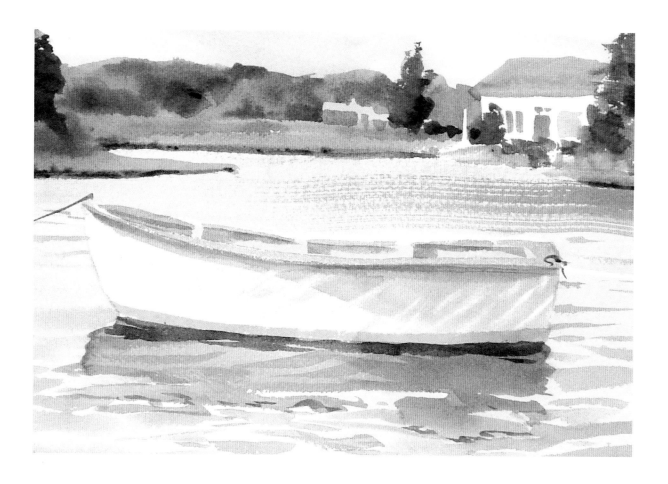

DEVISING ALTERNATE STRATEGIES

If you are unsure of part of your subject, or if something you have tried looks wrong, you can either practice it on a separate piece of paper or attempt something on the painting in progress. If your experiments don't lead to increased confidence, slow down and make sure you understand the problem. Go down the list: value, wetness, color, and composition. Ask yourself: *What is my revised strategy?* When the dust has settled, you should have a plan for what you will do differently. Limit the changes to just a few, so you can see whether you have resolved those issues. Taking on too much at once obscures your progress and increases the odds that you will be overwhelmed.

TOM HOFFMANN, *FLOP*, 2010
WATERCOLOR ON PAPER
9 × 12 INCHES (23 × 30 CM)

What interested me in this scene was the unexpected color of the dory's reflection. Once I had explored that, I tried to turn the painting into art, squeezing in a background and leaving very little room for the water beyond the boat. I swept a big brush across the page in that section hoping that I would get lucky, and that the result would stand in for what was actually a complex transition. If I had really wanted a good product I should have studied that passage and then painted the scene again. I would at least have learned something.

When I finished painting the image below something did not seem quite right. Even though I thought I was being deliberate in my choices, the painting just wasn't as peaceful I had intended it to be. Going down the list, I started to assess color first: Are there too many colors? No, that's not the problem. Is color temperature an issue? Hmm . . . could be. The mountain may be too closely related to the blue and orange in the buildings, pulling it forward in space. And the big orange building on the right is too insistent. Maybe ease off of the complementary palette. It seems a little harsh.

How about wetness? The big building is all in shadow. Maybe the doorway should have a soft edge. That would make the whole shape less intrusive. I like the soft, blue shadows on the mountain, but maybe soften the profile a bit to make sure it stays back. That's enough for now. Time for another try.

Make sure you are clear about how you intend to revise a painting before you begin a new version. At some level I seem to believe that I should trust entirely to instinct and not analyze my efforts at all, so I often rush through my assessment. There may be some wisdom in this, since painting is largely done from the gut, but, realistically, there is no danger that I could eliminate instinct, even if I wanted to. Homing in on one or two issues that need to be clarified will not make the next painting a dry, intellectual exercise. As soon as you make the first stroke, the current begins to flow.

Luckily, the process of making the first painting of Barrio Azucenas was quick enough painting that I did not have to think twice about making a new version. If it had taken longer I may have been tempted to try to rescue the first one. Actually, I'm glad I left the study alone. After some time passed, I found that I liked them both.

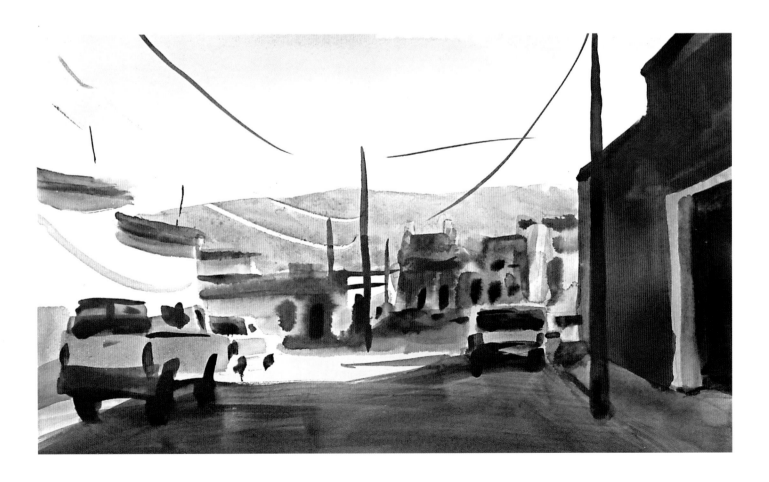

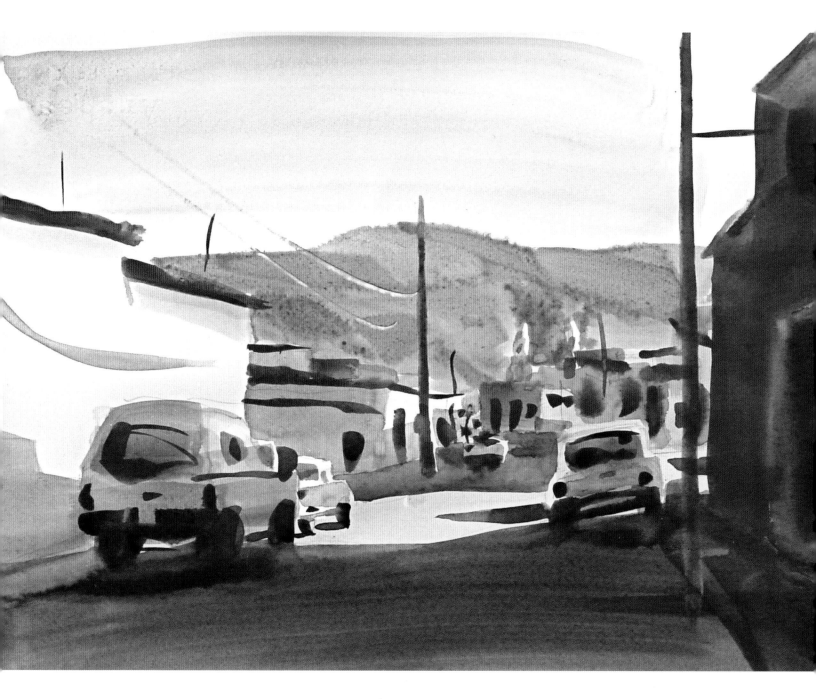

Opposite:

TOM HOFFMANN, STUDY FOR
BARRIO AZUCENAS, OAXACA, 2010
WATERCOLOR ON ARCHES HOT PRESS PAPER
11 × 15 INCHES (28 × 38 CM)

There is a mountain at the end of every street in Oaxaca. I wanted this
one to feel distant, but I also wanted to display the afternoon light. A
hard edge for the profile of the mountain but soft edges for the shadows
seemed right, as did carrying on the blue/orange palette from the rest of
the picture. When it was finished, though, something was not right. The
scene did not feel as peaceful as I intended.

Above:

TOM HOFFMANN, *BARRIO AZUCENAS, OAXACA, 2010*
WATERCOLOR ON ARCHES HOT PRESS PAPER
11 × 15 INCHES (28 × 38 CM)

Softening the blue doorway was definitely a good move. As a separate
bit of painting, I liked the orange mountain better than the green one,
but it didn't work as well in the big picture. In all, I'm satisfied, and don't
feel the need for another version. But do you think I should put in the
rest of the phone wires?

IDENTIFYING WHAT WORKED WELL

Refining a painting is more than a process of solving a succession of problems. At the same time that we are untying knots, we are also building on our strengths. The parts of the painting that work well are what keep us hopeful, after all, so it is good for morale to acknowledge them. If we intend to create a feeling of harmony in the painting, as is usually the case, it makes sense to identify the successful aspects and use them as a guide. So by all means ask yourself: *What worked well?* In the plein air season, this assessment happens right on the site and often involves a series of versions of the subject. Each interpretation lends its successes to the next.

At the end of the outdoor painting season, I look through my plein air work for images that might make good studio paintings.

By definition, this activity focuses on positive aspects of the work. Sketches, studies, and paintings that were not entirely successful can still stand out as good source material in the studio. It is informative to see what the pieces that rise to the top of the heap have in common. By the time you have sorted through the pile, you may have discovered that something you now do quite well was hidden among the blunders.

Since I value economy of means in my work, I usually respond to the paintings that are full of the feeling of the location but have relatively few brushstrokes. I want these qualities to also be present in the studio paintings, but working from a secondary source, like a sketch, is very different from painting on site. For me there is always the danger that I will get wrapped up in copying my own strokes and lose touch with what I saw when I was on location.

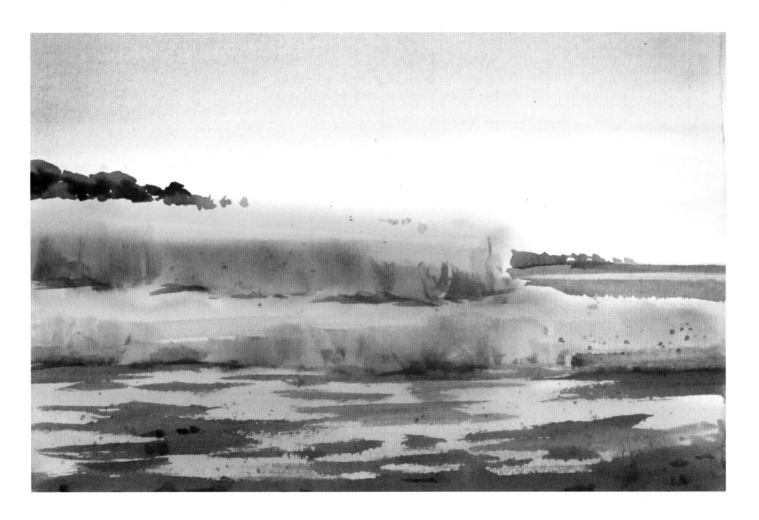

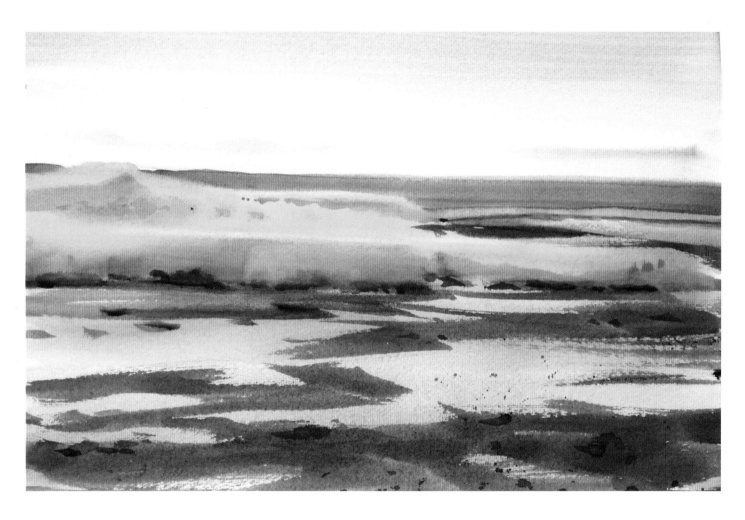

Opposite:
TOM HOFFMANN, STUDY FOR *BEACH GRASS*, 2011
WATERCOLOR ON ARCHES COLD PRESS PAPER
11 × 15 INCHES (28 × 38 CM)

This study of the beach grass at the outermost edge of land seemed to have potential. I especially liked the abstract qualities of the image—the pattern of gray strokes overlying the green and blue wash, the long horizontal rectangle of yellow-green. I wondered how it would work to amplify the features I most enjoyed and tip the form/content balance more toward form.

Above:
TOM HOFFMANN, *BEACH GRASS*, 2011
WATERCOLOR ON ARCHES COLD PRESS PAPER
11 × 15 INCHES (28 × 38 CM)

The feeling of solitude suggested by the preliminary work has been developed in the second version. The simplicity of treatment is intended to allow the viewer to see the brushstrokes as both subject matter and paint at the same time.

TOM HOFFMANN, *DRIFT*, 2011
WATERCOLOR ON ARCHES HOT PRESS PAPER
11 × 15 INCHES (28 × 38 CM)

In this plein air sketch, the complex shore and wooded hillside have been distilled to a handful of strokes. This is what pleases me most about the piece, so I want to be sure to keep the larger studio version very simple.

As you can see from examining the painting opposite, I'm struggling with the process of turning my plein air study into a larger painting. I still haven't been able to pinpoint exactly what the problem is, but here's what I come up with when I go down the list:

COLOR: Warmer, especially the greens. And I want the shadows to be more purple. That might make the sunshine believable.

VALUE: Ease off the darks in the big shadow area.

COMPOSITION: The big version is too rhythmic overall. The verticals in the reflections and the green patches on the hillside are too evenly spaced.

WETNESS: The first layer of the reflections could be mixed hard and soft, instead of all soft.

That is a lot to take on in one try. If I get this to come together before the book goes to press, I'll include a photo. Otherwise, wish me luck.

I am very good at convincing myself, for a while, that what I have just painted is quite good. I impress myself with how effectively I have translated a subject into paint. When some time passes, though, I can see that I have gone only a little way

toward a convincing representation. Somehow, even a small step in the right direction can briefly seem like the whole journey. I can look at the painting from across the room, turn it upside down, or view it in a mirror, and if not enough time has passed, I am still susceptible to an overly rosy assessment. This happens often enough that I am skeptical of my first impressions of fresh paintings. If I want to see the strengths and weaknesses clearly, I have to wait a while. Or, I can bring them in to class. As soon as I know other painters will be looking at them, the veils are lifted, and I can see objectively. Isn't *that* interesting?

Why is detachment so elusive? Ideally, we would have that precious objective clarity in the instant that we are watching the brush make its stroke. Wouldn't the painting process be more effective then? It would certainly be more efficient.

Or perhaps not. Maybe it is best that we paint half blinded by delusion and confused by contrasting emotions. Could it be that we need to feel equal parts of enthusiasm and disappointment to remain passionate about painting? Coming back for more despite the setbacks does seem like good practice for life. Still, it would be nice not to waste so much paper.

TOM HOFFMANN, *SORRY EXCUSE #5*, 2011
WATERCOLOR ON HOT PRESS PAPER
15 × 22 INCHES (38 × 56 CM)

This is the fifth try at making a big version of my plein air painting. So far, nothing is gained and much has been lost. I seem to be painting *in the manner of* Tom Hoffmann, but the spirit is missing. I need to slow down and identify the aspects of the painting that need refinement. You probably have the detachment to see just what is eluding me.

EXPANDING YOUR RANGE

In my painting practice there always seem to be subjects I am putting off till some later date. For example, I keep meaning to take some time to focus on the finer points of transparent and opaque pigment, but it somehow hasn't ever been the right occasion. And then there's the question of people. The world my paintings describe is strangely uninhabited. Even all the animals seem to be in the barn when I come around.

You may be perfectly content with the range of your subjects. There is no law, after all, that says we all must be adept at painting everything. But there may still be images and scenes you reject even though they attract you, simply because they look too hard. Ask yourself the tough question: *Am I avoiding something?* If there is something intimidating that you would really like to know better, I strongly recommend getting around to it sooner, rather than later.

I live within walking distance of Puget Sound and spend much of every summer on an island, but I managed to spend my first twenty years here avoiding painting water. It was such a daunting subject, I would push the horizon down to within an inch of the bottom of the page to keep from taking it on. As a teacher, it became increasingly difficult to justify not practicing what I preached. I finally had to get to work on water.

It was every bit as hard as I thought it would be, but it turned out to be fun. And, after a couple of years of staring hard at the bay and countless sheets of paper, I began looking forward to scenes that included water. Expanding the range of subjects that engage you is like making a new friend. The world feels larger and more promising.

An important part of the process for me involved looking at the work of artists whose water I especially admired. If you identify a subject or an aspect of the medium that challenges you, take advantage of the resource that other artists represent, and don't be shy about copying their work. Studying the water in the paintings of Winslow Homer, John Singer Sargent, Anders Zorn, and Eliot O'Hara revealed a succession of layers that added up to an effective illusion, and copying their work gave me a glimpse into how they knew that it would work.

The layers often progress in this order: an overall wash representing the reflection of the sky; a series of darker, often soft-edged, horizontal strokes representing the side of the wave or ripple that faces the shore; then reflections of offshore objects (such as boats, landforms, clouds, and so forth). Now, when I consider a scene that includes water, I look for the layers. More often than not, some variant of the familiar progression is there.

Opposite Top:
TOM HOFFMANN, *NOW ROW*, 2008
WATERCOLOR ON ARCHES HOT PRESS PAPER
14 × 20 INCHES (36 × 51 CM)

Water is a daunting subject because of its complexity and its refusal to hold still. But once it becomes visible as a series of layers, it is possible to predict where all those components should be located.

Opposite Bottom:
TOM HOFFMANN, *LOW WATER*, 2007
WATERCOLOR ON ARCHES COLD PRESS PAPER
7 × 13 INCHES (18 × 33 CM)

Not long ago, to me a narrow strip like this along the bottom of the page represented a daring venture into water as a subject.

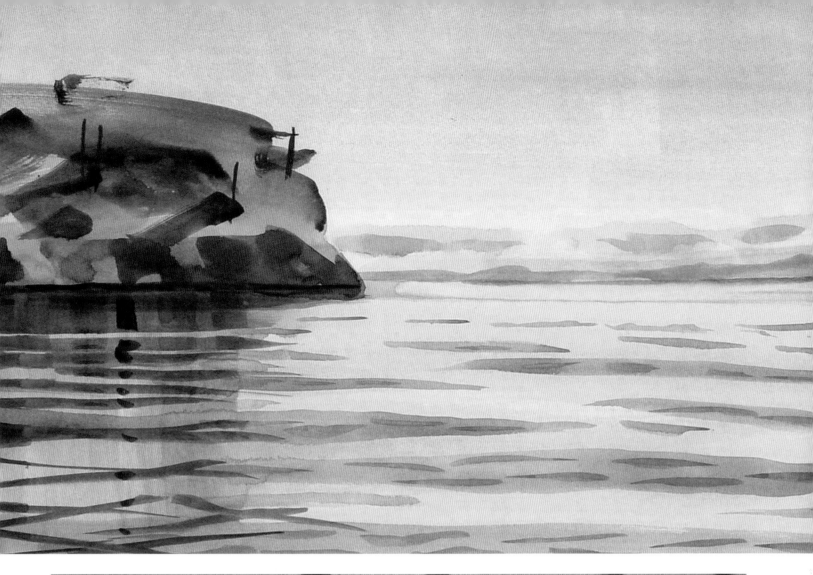

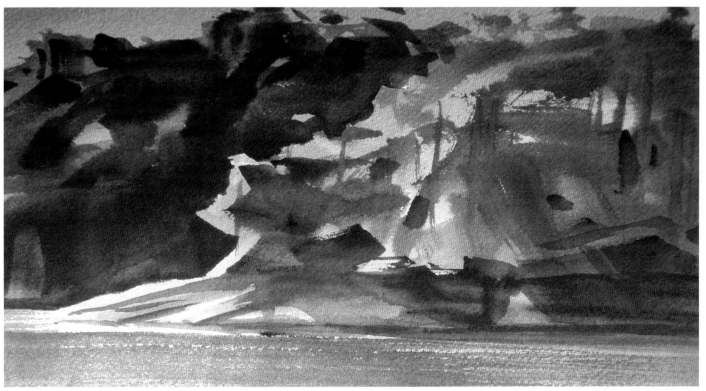

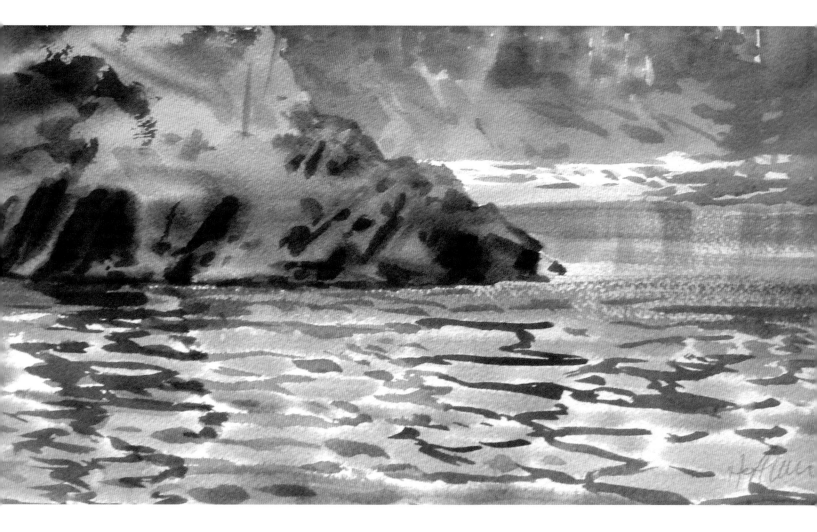

TOM HOFFMANN, *WATER STUDY*, 2009
WATERCOLOR ON ARCHES COLD PRESS PAPER
10 × 18 INCHES (25 × 46 CM)

Here we are again. This is the same headland from pages 103 and 109. The water changes so much from day to day the paintings seem quite different to me.

Asking the Questions

Each chapter of this book lists a number of questions that help focus your awareness. I don't expect you to memorize them or write them all down on a checklist to carry with you. More than a long list of specific questions, I hope you will take with you a habit of making deliberate choices when you paint. Meanwhile, it may be useful to highlight a handful of the most important questions, trusting that they will call forth the others. For example, when I ask *What is the lightest part of the picture?* it automatically makes me also wonder about the darks. What follows are seven essential questions drawn from the first seven chapters of the book.

WHAT ATTRACTS ME TO THIS IMAGE?

Identify what must remain clear wherever your individual style takes you.

WHAT ARE THE MAJOR SHAPES?

If the painting does not work on the level of the major shapes, no amount of detail or drama can save it.

HOW WILL THE IMAGE RESOLVE INTO LAYERS?

Understanding the subject as a series of layers is half the job of translating it into watercolor.

WHAT IS THE LIGHTEST PART OF THE PICTURE?

Everything follows from this choice. The value of each element of the painting is assigned relative to the lightest light.

HOW WET IS THE BRUSH COMPARED TO THE PAPER?

Staying aware of this relationship is the key to creating the edges you want and staying out of wetness trouble.

WHAT COLOR CHOICES SERVE MY MAIN PURPOSE?

With your eye on what attracted you to the image, check to see if it is supported by the colors you choose.

IS THE MESSAGE CLEAR?

When form and content are working together, communication is ensured.

Parting Thoughts

By now you know that you are involved with a medium that is equally rewarding and demanding. Throughout the book I have compared working in watercolor to a high-wire act, a maze, and a juggling routine. It's easy to get lost in the complex interplay of variables, forgetting to pay attention to one essential factor while another distracts you.

The inquiry-based approach that is outlined here offers a way to put the variables in sequence so that, as much as possible, you can focus on one at a time. There will always be an element of chance when you work with paint that wants to flow, and that is as it should be. Without risk and surprise, the finished paintings would be lifeless. What we seek, therefore, is a balance between thoughtfulness and spontaneity.

Take the time to discover where and when you need to be careful, so that you have room to be carefree. It is up to you. Take charge, and take chances. And have fun.

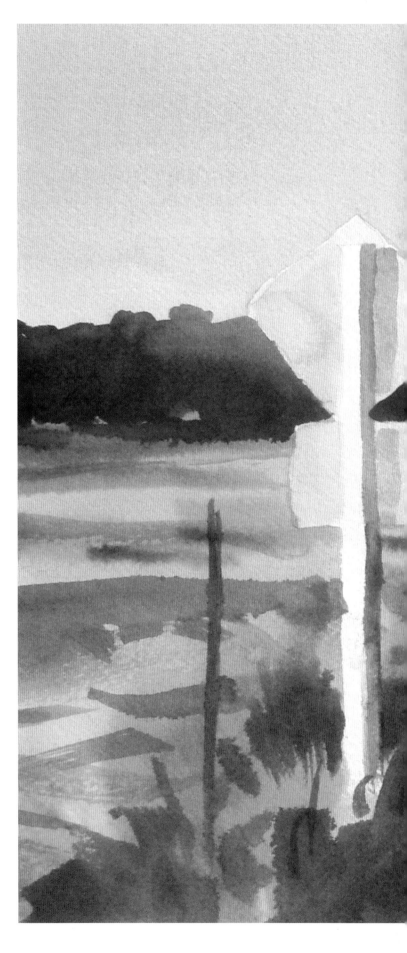

TOM HOFFMANN, *APPROACH*, 2010
WATERCOLOR ON ARCHES COLD PRESS PAPER
11 × 15 INCHES (28 × 38 CM)

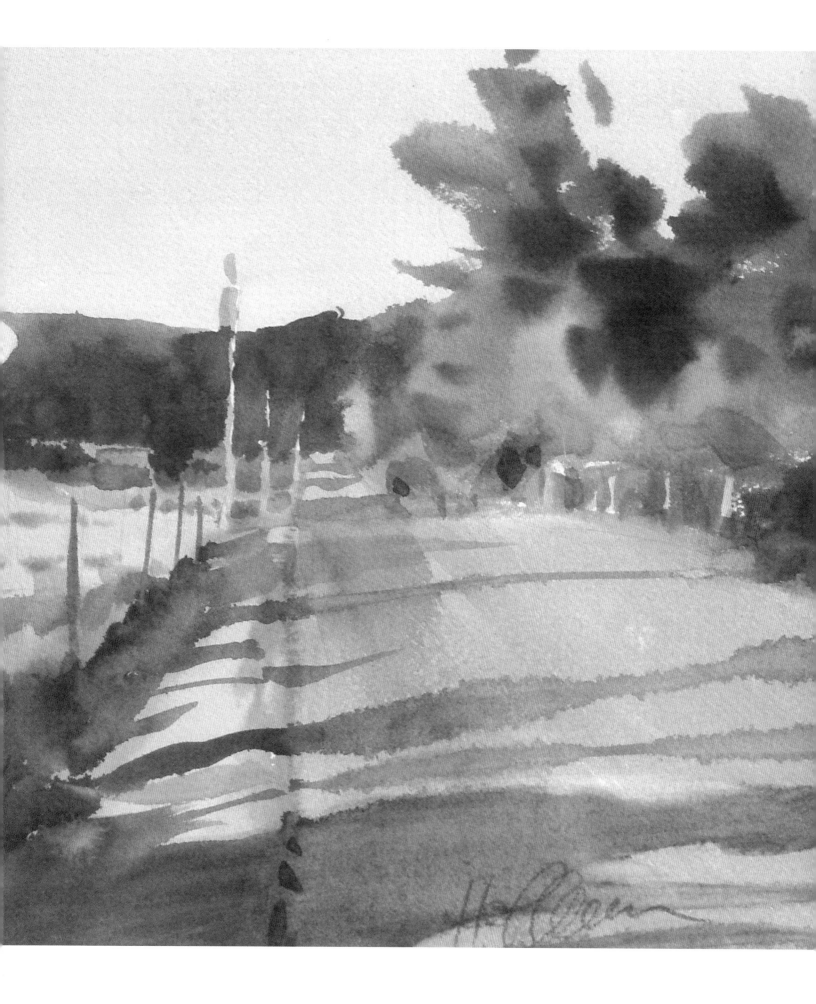

GENERAL INDEX

INDEX OF PAINTINGS